Tall-Tale Postcards

TALL-TALE POSTCARDS

A Pictorial History

Roger L. Welsch

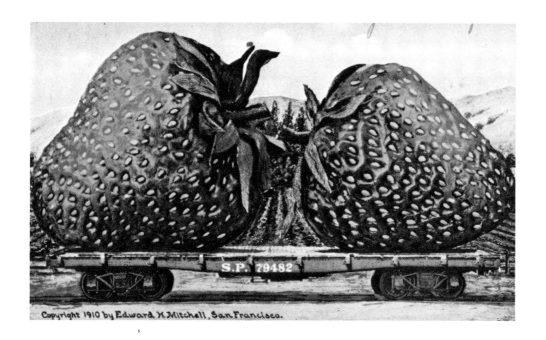

Copyright 1910 by Edward H. Mitchell, San Francisco.

SOUTH BRUNSWICK AND NEW YORK:
A. S. BARNES AND COMPANY
LONDON: THOMAS YOSELOFF LTD

© 1976 by A. S. Barnes and Co., Inc.

A. S. Barnes and Co., Inc.
Cranbury, New Jersey 08512

Thomas Yoseloff Ltd
108 New Bond Street
London W1Y OQX, England

Library of Congress Cataloging in Publication Data

Welsch, Roger L.
 Tall-tale postcards.

 Bibliography: p.
 Includes index.
 1. Postal cards—History. I. Title.
NC1872.W44 769'.5 · 74-9303
ISBN 0-498-01606-4

PRINTED IN THE UNITED STATES OF AMERICA

For Vic Lane

Contents

Acknowledgments

Any folklorist who publishes his work has to offer his gratitude to the artists who create the materials he studies and admires, and I must do that too. Though they are now gone, I thank the late William H. Martin; Alfred Stanley Johnson, Jr.; F. D. Conard; Archer King; George B. Cornish; H. W. Brown; Oscar Erickson; Edward H. Mitchell; M. L. Oakes; C. C. Slack; Leigh (whose first name remains unknown); J. Herman, and all of the other, unnamed postcard publishers, photographers, and collectors who applied their talent, imagination, and humor to the tall-tale postcards I have used and enjoyed in this study.

There is a second link in the chain of bringing this book together, to which I also offer my most sincere thanks. "Without whom this would not have been possible" is an old, nearly trite saw, but trite or not, it certainly remains true for the many friends who for the past four years have helped me assemble a representative collection of over a thousand tall-tale postcards. It would never have been possible for me to visit every antique shop or sale or to thumb through the shoeboxes and stacks of dusty, mixed postcards myself. Terry and Patti Schmitt, my good friends, have probably suffered permanent eyestrain and lung congestion from the hours spent huddled in the dark, dusty corners of antique shops, where the postcard box is inevitably relegated. For their help I offer my sincere thanks. Terry's mother, Mildred Schmitt, is also a dedicated deltiologist, which is the fancy word used to describe collectors and students of postcards, and I appreciate very much the fact that she always looked for and bought any cards she thought might be of use or interest to me as she pursued her own work; Mrs. Schmitt also permitted me to photograph and use whatever tall-tale postcards she had in her own collection.

Laura Turnbull of Table Rock, Nebraska, very kindly provided me with facts about her grandfather, Archer King, and samples of his work. She is justifiably proud of him and I thank her for her cooperation. Mr. and Mrs. Neal Chism picked up cards for me whenever they encountered them and have provided me with some of my most interesting examples.

The staffs of the Nebraska State Historical Society, Kansas State Historical Society, and Colorado State Historical Society were helpful and generous in allowing me to examine and copy tall-tale postcards and newspaper accounts in their archives.

Introduction

The American Golden Age of picture postcards was very brief, extending only from 1905 to 1915, but what a glorious, exciting age it was. Parts of the country were just being opened for homesteading, photography was in its full maturity, America's postal system was developing into Everyman's news system, and new forms of transportation—especially the automobile and the airplane—were beginning to promise to bring cross-country travel into the realm of the ordinary. A short, simple message could be carried across the entire country within a few days time for less than a penny, so that Harold, at college on Monday and away from home for the first time, could send an I'm-here-and-everything-is-fine-Mom letter so fast that on Wednesday Mom would feel assured that Harold was indeed probably still all right and not yet debauched.

Ironically, it would also be the new systems and efficiency of communications that would bring about the decline of the postcard's Golden Age. Soon it was faster to drive fifty miles or call one thousand miles than to send a postcard.

The picture postcard was a social phenomenon. That is, it reflected social attitudes and values of a certain—probably very large—proportion of the American public. Like tastes in music or art, what was successful in picture postcards determined what directions the manufacturers took. If one type of card sold well, that type was further developed, expanded, and experimented with; if another postcard failed, the idea was immediately abandoned. These photographers were businessmen, not crusaders or pedagogues. Therefore the prominence, the frequency, the great number of different types of tall-tale postcard are more than curious observations, for they tell

us something about the very personality of that class of people who used them in the first two decades of the century.

The more successful one type of postcard was, the more were printed, sold, and mailed—and the more have come down to us today. In addition, the cards went through a second social filter that attests to us today that they were indeed popular then: not only were these cards attractive and attention-catching enough to be bought, they were also interesting and important enough to be saved by collectors, and then tucked away in underwear drawers or scrap books thus sparing the cards for us today.

Photography had been around a good fifty years by 1900, but for the general public, especially in the great, rural center of the country, between the Appalachians and Rocky Mountains, it was still a mysterious and experimental concept that smacked of science and magic, culture and sophistication. And here, on a postcard, a real photograph could come right to the family mailbox!

In many households the only photographs were a family portrait or two and a velvet-bound book of carefully preserved postcards. In fact, during the last half of the nineteenth century the awe in which photographs and photography were held by the rural population provided the stuff for a genre of jokes:

An old farmer. from one of the rural districts—we may be allowed to say, from one of the very rural districts—recently came to town to see the sights, leaving his better-half at home, with the cattle and the poultry. Among various little keepsakes which he brought back to his wife on his return to his Penates was his own daguerreotype. "Oh! these men, these men! what creturs [sic] they are!" exclaimed the old lady, on receiving it; "just to think that he should fetch a picture of himself

all the way from New York and be so selfish as not to fetch one of me at the same time!"[1]

During this Golden Age the postcard enjoyed its broadest expression. Today, an extensive rack of postcards in a drugstore or bus depot will contain ten or twenty different cards, mostly scenic views or cartoons. But in those days there were hundreds and even thousands of choices, from theater stars to human interest poses, from art reproductions to gross obscenity, scenery, history, culture, and humor.

Humor is an integral part of life. Laughter has always been welcome, and the picture postcard presented the possibility to inventive practitioners of the photographic art to extend the traditional oral or theatrical jokes to the photographic plate, and, what is more, to devise entirely new forms that were possible only through photography. Just as television has made

Solomon D. Butcher was a pioneer Plains photographer who used his imagination to "correct" scars and scratches on his glass negative plates. In this picture from his book *Pioneer History of Custer County, Nebraska,* he has added a dog chasing a deer to an otherwise undistinguished photograph.

1. "The Editor's Drawer," *The Harpers Magazine* Volume 5: Number 26 (July 1852): page 275.

possible theatrical effects that were only dreams to Shakespeare or Ibsen, photography brought into being visual effects that tall-tale tellers through the centuries had seen only in their fertile imaginations.

Solomon D. Butcher, a pioneer photographer in Kearney, Nebraska, had a large number of plates damaged, for example, in a fire that nearly completely destroyed his studios. On several of the salvaged glass plates he "doctored" imperfections or burn scars by transforming the clear defects into something more in keeping (sometimes!) with the rest of the picture. In one photograph of a treed gully, for example, Butcher scratched in a dog chasing a Santa-Claus style reindeer. In another picture of some cattle grazing on Nebraska's vast and treeless Plains, he scratched in some trees, perhaps wistfully.

Photography was particularly attractive to adventuresome men who were willing to try totally new and different ideas and techniques. The very novelty of the science demanded a spirit of adventure and an open mind. Still, the majority of photographers by the turn of the century were content to follow the safe line—portraits, news photos (many picture postcards of that day depicted disaster and historical moment), and scenery. Some were called upon to employ some imagination in correcting defective negatives or prints, like Butcher, but even this direct contact did not always open to them the potential of photography in pictorial humor. Others did grasp the humorous potential but could not extend it to the idea of actual photographic manipulation, actual juggling and juxtaposing figures from one photograph to another for humorous effect—again, like Butcher.

But we are concerned here with those few photographers and postcard publishers who did have the imagination and vision of photography that gave us a particular kind of postcard—the tall-tale or "freak" postcard as it was called then.

To make a freak card took more work than the less imaginative photography. The photographer first had to have an idea. Then he took two pictures— say, of a man holding an ax, as if chopping wood, and then another, a close-up of an ear of corn hanging on the stalk. Then he carefully cut out the picture of the man with the ax and just as carefully glued it to the picture of the corn. If he had done the job well, had judged the perspective accurately, and cut and glued carefully enough, the resultant combination looked as if the man were chopping off

Here Butcher has penned a number of trees into a Plains wilderness. Photograph courtesy of the Nebraska State Historical Society.

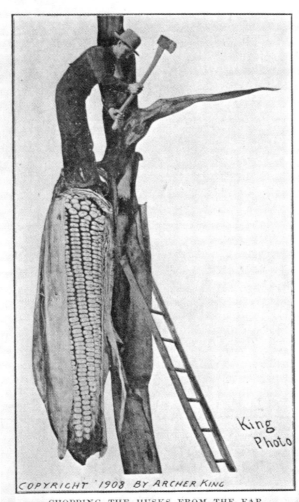

COPYRIGHT 1908 BY ARCHER KING

CHOPPING THE HUSKS FROM THE EAR

This juxtaposition of man and corn by Archer King is a classic example of the successful photographic manipulation that resulted in a tall-tale postcard. Postcard courtesy of Laura Turnbull, King's daughter.

a gigantic ear of corn. The photographer added a short, usually laconic legend, and took a picture of the resultant combination, thus creating a freak photograph that could then be printed as a postcard.

The first postcard came into being on October 1, 1869, at the Austrian Post Office at the instigation of a young Austrian economics professor, Emanuel Herrmann. The idea was resisted by authorities because it was felt that an open message on a card would encourage the reading of other people's mail by domestic servants and postal authorities, but the concept caught on and spread, and postcards went on sale in England on October 1, 1870, and on May 1, 1873, in the United States. The first picture postcard however did not appear on the scene until 1894 in England.

It can be seen from this that the development from postcard to picture postcard to freak picture postcard (beginning in about 1905) was rapid indeed. Furthermore, there must certainly have been some delay

in the idea reaching hinterland villages like Garden City, Kansas, and Table Rock, Nebraska. Then the photographers in these towns had yet to conceive their own ideas, take their photographs, cut and splice them, copyright them, and publish and distribute them. Therefore, when a freak postcard bears a postmark dated 1908 it provides evidence that these small-town—indeed, frontier!—businessmen were in the forefront of the photographic postcard frontier too.

I have made an effort to date the freak postcard phenomenon by plotting in graph form the postmark dates (where available) and copyright dates on over a thousand tall-tale cards that have passed through my hands during the past five years. Obviously, the date of the sending of the cards lags a short way behind the publication date, but the curve is striking and leaves little doubt regarding the brief span of interest in the cards and the clarity of the limits and peak of that span.

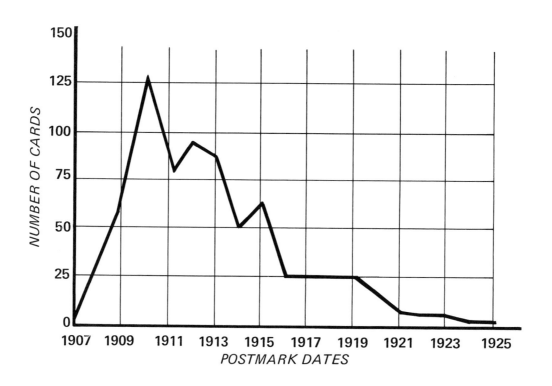

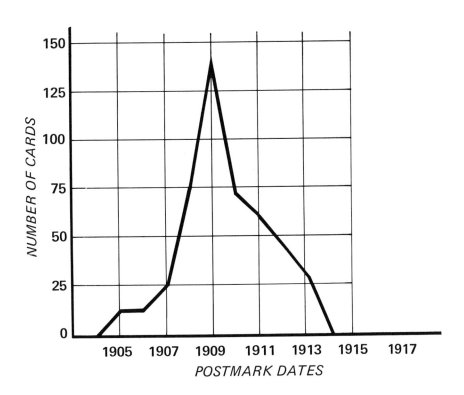

Tall-Tale Postcards

1

Humor and Exaggeration:
The Making of Tall-Tale Postcards

My own interest in tall-tale postcards came from my earlier work in folklore studying oral tall tales. When I first ran across one such card while shopping in an antique store, it occurred to me that such photographs are visual analogues for their oral cousins. But as I learned more about oral tall tales and collected and examined more of the postcards, it became increasingly clear that while there are some analogous characteristics, there are also some very important distinctions.

Oral tall tales are usually short, have one theme, and only suggest any real, extended narrative. For example, these tall tales from the pages of *Harpers Weekly*:

> A baker has invented a new kind of yeast. It makes bread so light that a pound of it weighs only twelve ounces.[2]
> An Illinois chap, in describing a gale of wind, says, "A white dog, while attempting to weather the gale, was caught with his mouth open, and turned completely inside out."[3]

And finally from the pages of the *Harpers New Monthly Magazine*:

> We have heard of the man who was so stingy that he put green goggles on his horse and fed him on shavings . . .[4]

The tall-tale postcards are like that. There is a hint of the story, but we see only a small, truncated fraction of it. So the *form* of the postcard tall tale and the oral tall tale are very much alike.

The oral tall tale is usually told in the folkmouth in a dry, laconic style. When old-timers exchange such stories there is seldom the sound of laughter— at most a supressed chuckle or snort. Then someone else tries to top the tale, again with a straight face and a sober reaction from his audience.

This is also true of the great majority of the tall-tale postcards, especially in legends that photographers have added to the photographs. For example, a photograph showing two men struggling to haul an enormous onion up a ramp into a wagon bed might bear the legend, "A fair crop of Kansas onions."

The degree of exaggeration in both the tall-tale card and the oral tall tale is gross. In only a very few cases could there be any question as to whether the picture is simply a large rabbit, a strawberry, a watermelon or an outrageous, humorous lie. The exaggeration is broad-gauged. An overwhelming propor-

2. "Humors of the Day," *Harpers Weekly* Volume 10: Number 495 (23 June 1866): page 395.
3. "Humors of the Day," *Harpers Weekly* Volume 10: Number 500 (28 July 1866): page 471.

4. *Harpers New Monthly Magazine* Volume 33: Number 118 (November, 1866): page 810.

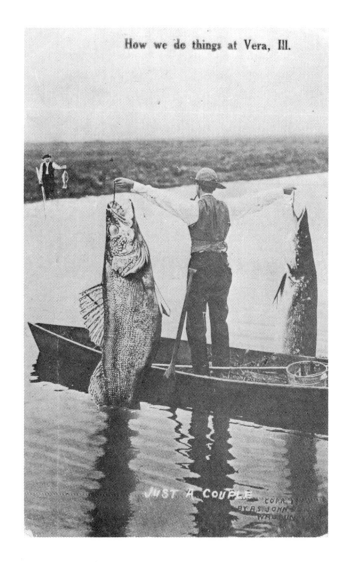

How we do things at Vera, Ill.

JUST A COUPLE
COPR.
BY A.S. JOHN
WAUPUN

Laconic delivery—apparent disregard of the incredible audacity of the portrayed lie—is a characteristic of both the oral tall tale and the tall-tale postcard. This card was made by one of the wryest labelers, Alfred Stanley Johnson, Jr., of Waupun, Wisconsin, in 1910.

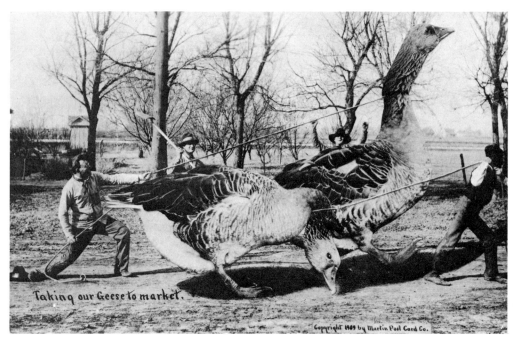

Taking our Geese to market.

Copyright 1909 by Martin Post Card Co.

Another master of the casual delivery was William Martin of Kansas City, Missouri, who produced this card and its understatement in 1909.

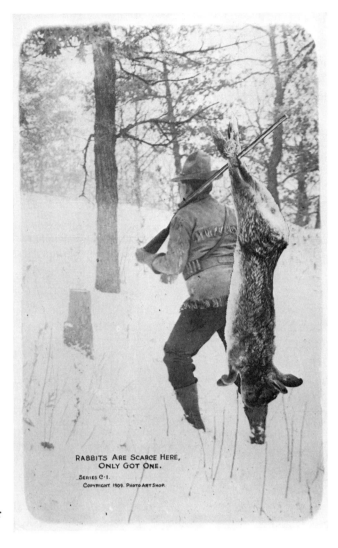

RABBITS ARE SCARCE HERE,
ONLY GOT ONE.

Series C-1.
Copyright 1909. Photo Art Shop.

Oscar Erickson sometimes published his cards under
the label "Photo Art Shop," as is the case here.

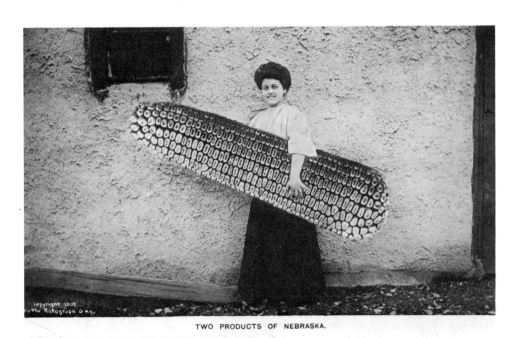

TWO PRODUCTS OF NEBRASKA.

Rotograph published few exaggerated postcards but
was highly successful in its photographic and literary
efforts. This card was published in 1907.

tion of the postcards show scenes so grotesque—a family living in a watermelon, a train halted by a huge grasshopper on the tracks, an ear of corn occupying an entire railroad flatcar bed—that there is no question of the exaggeration.

Similarly, oral tall tales can never be mistaken for everyday exaggerations or innocent fishermen's boasts:

> The winters were long and cold on the Plains. I once set a pitcher of water out to cool. It froze so fast that the ice was warm.[5]
>
> In a nearby lake I liked to fish. One day I caught a fish that was so big I had to go for the neighbors to get it out of the water and into the wagon. We took it home and there being no scale large enough in the neighborhood to weigh it, we got a block and tackle and hung it on the windmill tower while I took a picture of it. That picture weighed twelve pounds.[6]

Perhaps the principle difference and the clearest one is in the content of the two tall-tale types. Oral tales are most abundant in the areas of weather, heroes, and animals:

A pioneer farmer was fighting his way into a tough Plains wind when he met a neighbor coming out of the same wind. He noticed that the friend tied his horse's saddle blanket under his tail. "What's the idea of that?" he asked.

"Damned wind keeps blowing the bridle right out of the horse's mouth!" the friend replied.[7]

It was reported in a *Time* magazine article about the southern drought of the past few years that an Abilene, Texas, resident told a reporter there was one light snow the winter of 1971, ". . . But that snow was so dry we swept it up and burned it."[8]

Similarly, in the oral tall tale, a man can run so fast that he simply runs alongside jackrabbits and feels if they are fat enough for the soup pot, and the hoopsnake, with a barb at the end of his tail, rolls at great speed along the prairie, his tail in his mouth.

But the tall-tale postcard never deals with weather. There would be inherent difficulties, of course, in dealing photographically with high winds, heavy snow, or great cold. No pictures, for example, could

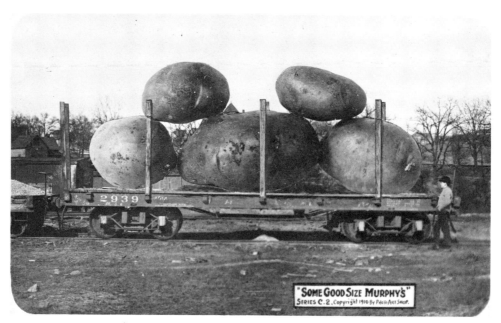

Erickson's Photo Art Shop issued a postcard in its series that captures one of the most typical of tall-tale postcard themes—the railroad car overwhelmed by only a few pieces of produce—here potatoes. This card was made in 1910 and is numbered Series C-2.

5. Roger Welsch, *Shingling the Fog and Other Plains Lies* (Swallow Press: Chicago, 1972), page 28.
6. Ibid., p. 97.
7. From my unpublished private collection of Plains humor.
8. *Time* (26 April 1971).

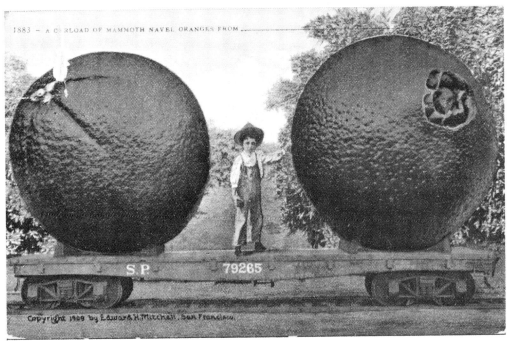

S.P. 79265

Copyright 1909 by Edward H. Mitchell, San Francisco

Mitchell cards concentrated on one theme (with few exceptions)—California fruit dwarfing a railroad car. This Mitchell card, bearing his index number 1883, was issued in 1909.

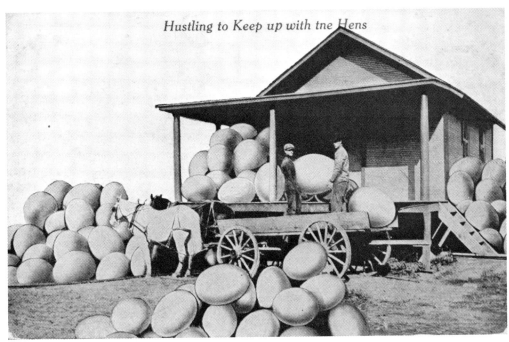

Hustling to Keep up with the Hens

Unfortunately this postcard bears no information about the photographer who skillfully wove eggs, men, wagon, and horses into a scene of incredible prosperity.

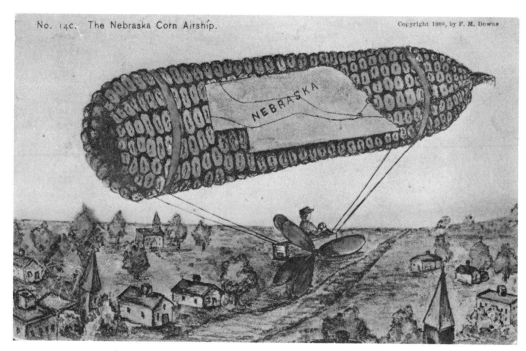

Air travel was a new form of transportation in 1908 when this card was produced, but F. M. Downs managed to work the new dirigible into an agricultural exaggeration.

easily be fabricated that would immediately communicate the following:

> . . . A farmer's dog fell into one [of the deep ground cracks] and in his efforts to locate the dog the farmer dropped a logging chain into the crack. The next morning, when he returned to renew his rescue efforts, he could hear that chain clanking as it was still falling.[9]

> It got so cold . . . that the fire froze on the candles and they had to bury them to get it dark enough to sleep.[10]

> This one man's girl had a wooden leg and so he gave her a garter and a box of thumbtacks for Christmas.[11]

But others, it would seem, could certainly have lent themselves to pictorial treatment:

> . . . The wind was blowing so hard that it took four strong men just to hold a blanket over the keyhole of [my] father's sod-house door.[12]

> A pioneer was once caught in an Indian raid and nearly died of thirst. Seems he was so poked full of holes by arrows and bullets that he wouldn't hold water any more.[13]

The tall-tale postcards do treat animal subjects—rabbits and grasshoppers primarily—but they rarely have oral parallels. I have found, in fact, no orally circulated tales that deal with huge rabbits or hoppers or the situations depicted in the pictures shown of unnatural battles.

Only two postcards within my corpus carry themes that might have come from orally circulated tales. One, shown earlier, portrays a man with an axe standing at a huge cornstalk, cutting away an ear. There was a popular folktale of that same period that told of a man who climbed a Plains cornstalk to cut off an ear with an axe but because the thing grew so fast he was unable to hit the stalk twice in the same place and just as soon as he took one slice it healed over. It was also reported in the same story that the stalk grew so fast that it took the would-be harvester out of reach of his helpers and they had to

9. Welsch, op. cit., p. 36.
10. Ibid., p. 28.
11. Ibid., p. 77.
12. Ibid., p. 17.

13. Ibid., p. 124.

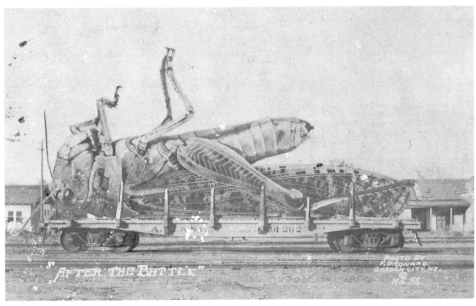

F. D. Conard specialized in postcards featuring gigantic
grasshoppers. This one, bearing his index number 56,
is used courtesy of Terry and Patti Schmitt.

feed him by shooting biscuits to him out of a shotgun.

The card entitled "Scene on the Road near Ban-croft, Minn." (see picture) seems hard to understand, in fact, without the probably accompanying folktale, again popular at about the same time that this card was produced in 1916. It seems that in a quiet Plains town there was very little for the young men and boys to do during the day, so they devised a game whereby they would stand in front of the village store and wait for a wagon or carriage to roll down the main street. They would then wait until the last possible moment and then run across the street in front of the wagon. The man who left the curb last —and made it across the street without getting run over—won the game.

One old-timer watched this game for a while and decided that it might be fun to give it a try, so he asked the boys if he might join them in the next dash, and they welcomed him, certain that they were about to see a splendid disaster.

As luck would have it, one of those new-fangled Fords drove into town about that moment and as it rattled down the street, a big brown dog ran out ahead of it, barking and snapping at the tires just as dogs would feel it their duty to do for the next seventy years too. The boys dashed out ahead of the car and just made it, but the old man misjudged both the speed of the car and his agility. The dog ran under his feet and tripped him up and then the car bounced him along the dirt street for a few yards before finally rolling him off into the gutter.

The boys all ran over to see how the old man fared in his adventure and when they got to him he was already on his feet, dusting off his overalls, and muttering, "I wouldn't have minded getting run over by the damn dog so much but that can tied to his tail certainly played Old Ned with me [i.e., tossed me around]!"

On the other hand, this card might only be a ref-erence to the same popular tales that centered on the Ford's tin can reputation. For example, there were common stories about the farmer who had a patent corrugated iron roof on his shed that was torn off and mangled in a tornado. He sent the wreckage back to the manufacturer for replacement, but it made its way to Dearborn, Michigan, by mistake and three weeks later the farmer received delivery of a Ford with a note reading, "Excuse the delay, but had some trouble repairing the automobile since it was so badly damaged. Charges: $15.60."[14]

Some stories continue that a neighbor decided to try the same thing himself and sent in a year's col-lection of sardine and bean cans only to receive, as

14. Ibid., p. 8.

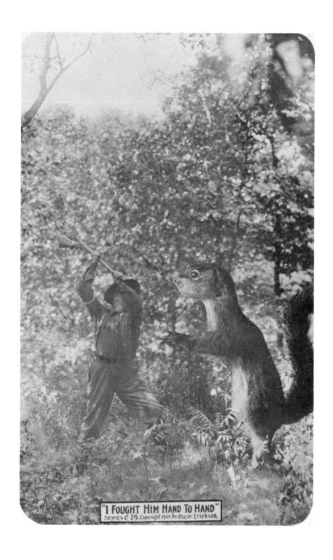

"I FOUGHT HIM HAND TO HAND"
SERIES C 29. Copyright 1909 By Oscar Erickson.

Oscar Erickson concentrated his efforts on wild life and was not afraid to try any kind of exaggeration, including squirrels!

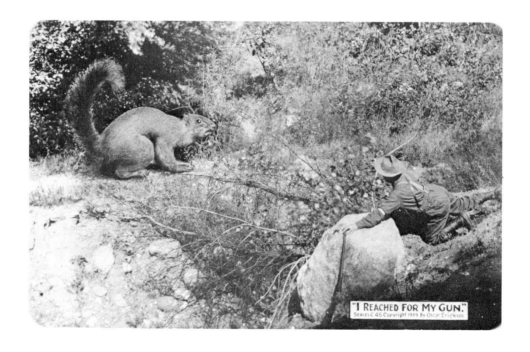

"I REACHED FOR MY GUN."
SERIES C 45 Copyright 1909 By Oscar Erickson.

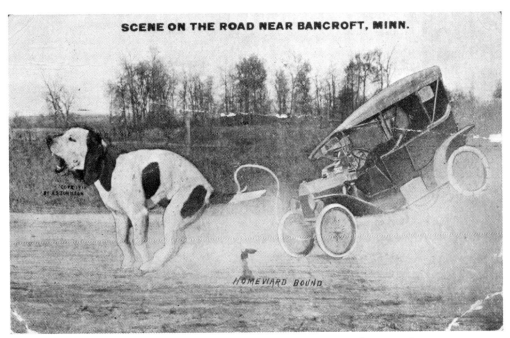

HOMEWARD BOUND

This A. S. Johnson card, published in 1915, is one of
the few tall-tale cards suggesting a narrative element.

he had hoped, a Ford along with seventeen cans that a note explained were "spare parts that we are not using in our latest models."

A second clear difference between the subjects of oral tall tales and postcard tall tales is the emphasis of the exaggeration. Oral tall tales generally stress the negative aspects of the nature and geography of the area being described while postcards overwhelmingly underline the positive element. This is not to suggest that they are a latter-day form of booster literature.

For one thing, booster literature was still nothing to laugh at. Today we can disregard chamber of commerce enthusiasm as harmless enough but in 1905, when these postcards were produced on the Great Plains (where most of these cards were produced) people all too often remembered with biting bitterness the promises and promotions made to them in Norway, Germany, Vermont, and New Jersey, promises and promotions that had proven tragically overblown. They had believed what they were told about the rain following the plow, the unbelievable fertility of the soil, and the benificence of the railroads, only to find once they had made their commitments that the rain didn't always come when it should, that the soil was marginal, and that once the railroad had their money the smiles disappeared.

Indeed, the very extreme nature of the postcards from the Plains may very well reflect an ironic recognition of the unreality of the promises that had brought settlers to the Plains. The nineties, it must be remembered—the decade that preceded the production of these cards—were not called the "Gay Nineties" on the Plains. They were a period of disaster, drought, blizzard, grasshoppers, hail, bank failure, and inflation. In short, perhaps what the Plains photographers were sarcastically saying, along with their rural compatriots, was: "Sure the crops are great out here, of course the livestock are unbelievable, you bet everything is great, and the streams run with milk and honey."

Exaggeration was the mode of American humor and it is not at all surprising that it appears here, even if the above suggestion is correct. Today such humorous exaggeration would be unthinkable, but then it was indeed "the way we do things here."

American humor was a well-developed and noted phenomenon by the year 1900, but always it was and still remains a mystery to Europe, England, and substantial portions of America's East. The humor columns of the *Harpers New Magazines* are magnificent examples of the two sides of American humor, that of the East and that of the West of the line of "civilization." The "jokes" included in the *Magazines*

for the enjoyment (certainly never anything so unruly as the laughter) of its readership are absolutely Germanic in their weight, stolidness, and bluntness of the explanations that often accompany them so that the point might not be lost on anyone at all.

The contrast becomes all the more vivid when a delver into the mysterious attempts—once more Germanically—to plumb the depths of Western humor, dissect it, and thereby analyze it. The examples wind up being substantially funnier that the humor column's offerings. Through it all I have the distinct impression that while the Hon. S. S. Cox, a special writer for the *Harpers Magazine,* knows that his examples are funny he cannot for the world of him figure out why: The following is a sample of Cox's writing.

In the previous article on this theme I considered our humor in its general phases, and especially its exaggerations. I now come to consider the distinctive and peculiar qualities of our humor.

We have not a little humor, especially among the more cultivated portion of our people, common to all men—a translatable humor, quite as enjoyable in French as in English. But we have veins of our own as rich and varied as our mines. I propose to prospect for a few of these veins. In all of them the salient quality—exaggeration—appears.

But *first*, there is a little silvery vein which runs through our newspapers, and which Prentice, of Louisville, first worked successfully. It consists in adroitly garbling a brief extract from an opponent's article, and diverting the meaning into a dash at some frailty of the opponent. The manner in which this is done is humorous, though the matter generally has the pungency of sarcasm and wit. Near akin to this species of humor is that which has recently become a part of our newspaper paragraphs. It consists in giving a comic account of a catastrophe, and then by a sudden and serious turn leaving a suggestive hiatus, making a conclusion which connects the premises. A woman undertakes to foment a fire by taking observations with a kerosene lamp near it. The comment is: "Wet day, or there would have been a larger funeral."

Mr. Jones was observed by his wife through the window to kiss the cook in the kitchen. Comment: "Mr. Jones did not go out of the house for several days, and yet there was no snowstorm."

A young man in Pennsylvania attempted to stir up several rabbits out of a hole with the butt end of his gun the other day. Twenty-three shots have been picked out of his shoulder. and the doctor is still probing. The young man thinks the rabbits must have escaped.

A woman put her tongue to a flat-iron to see if it was hot. That household is remarkably quiet these days.

A dear good fellow at the South telegraphs to his affianced in Maine, "To ———: Your life is a rich bouquet of happiness, yourself the sweetest flower. If Northern winds whisper southern wishes, how happy you must be! Good-night. Happy dreams, sweet love, Frank." Four

doctors are in attendance upon the telegraph operator.

"If George had not blowed into the muzzle of his gun," sighed a rural widow at the funeral of her late husband, "he might have got plenty of squirrels, it was such a good day for them."

"He handled his gun carelessly, and put on his angel plumage," is a late obituary notice.

At Middletown, New York, a youth showed his father's pistol to little Dicky Snell. "Eight years of age," was the inscription they put on his little casket.

A good little boy tried to lift himself up by a mule's tail. The doctor thinks the scar on his forehead is permanent.

A man in Memphis undertook to get a mule off the steamboat by twisting his tail. The man landed. Another mistook the headlights of an engine for a fire-bug. He subsequently joined the temperance society.

A young man fixed himself up for hunting; he would call on a young lady, and let her see how nice he looked. He stood near the fire, with a pound of powder in his coat pocket. He was seen going through the roof with a pensive smile.

A young man in Louisville thought a circular buzz saw was standing still; he felt it. Several fingers are preserved in the best of spirits.

A young lady, aged only seventeen, raised a large family. She used a keg of powder in the cellar.

A well-dressed person saw a beautiful damsel at a window in New York City [*sic*]. It was a New-Year's and he rang the bell. He may thank the beautiful snow at the foot of the steps that only his hat was mashed!

As illustrative not only of [the] tendency to coin new phrases but fresh and exaggerative metaphors, I might quote from Lowell several of our oddest expressions. The backwoodsman prefers his tea "barfoot," meaning without cream and sugar; a rocky piece of land is heavily mortgaged; hell is a place where they don't cover up their fires o'nights; a hill is so steep that in the language of the stage-driver, lightning couldn't go down without being shod; the weather was so cold that a fellow who had been taking mercury found his boots full of it.

Our unlettered people have the same strain: mean enough to steal acorns from a blind hog; cold as the north side of a gravestone in winter; quicker than greased lightning; handy as a pocket in a shirt; he's a whole team and a dog and tarbucket under the wagon." Sometimes this tendency is subdued in the quaintest way. An American was asked if he had crossed the Alps. He said he guessed he had come over some "risin' ground."

Another advised a man with big feet, who wanted a bootjack, to go back to the forks in the road and pull his boots off!

The American acts upon the principle which physiologists have remarked, that there is something besides the nutritive quality requisite in food, that a certain degree of distention of the stomach is required to enable it to act with its full powers and that it is for this reason hay and straw must be given to horses as well as corn and oats, in order to supply the necessary bulk.

The opinions of our people are always aggrandized, not only by intense language, but by superadding to them other ideas, until they tower up beyond all verisimilitude. The sober hue, the faithful outline, the correct perspective, and mellow shading which give relief by contrast are discarded for the glare and distortion which suit our humor.

Pick up a Southern newspaper. The editor wishes to say that the Mississippi is very low. How does he say it? "The cat-fish are rigging up stern-wheelers."

Another wishes to give an idea of the attitude of his Shanghai [domestic fowl imported from the Orient] "He is so high that he has to go down on his knees to crow."

A strange genius, describing a lake in Minnesota: "It is so clear that by looking into it you can see them making tea in China."

An Illinois enthusiast wishes to give you his idea of heaven: "It is an endless prairie of flowers, fenced in with pretty girls."

A Mississippian brags to a Yankee about a big tree he chopped at for ten days, took a walk around it on Sunday, and found a man who had been chopping on the other side for two weeks! This was before the mammoth conifera of the Pacific were discovered. We know now that the only mistake in this description is in the location.

A horse travelled so fast that his rider fancied he was passing through a graveyard from the rapid succession of milestones.

Many years ago I was one of a party in Washington city [sic], when South and North vied with each other in convivial life. Another of the party was General Dawson, member from Western Pennsylvania, whose homestead was Albert Gallatin's old home. He was an admirable storyteller. I recall somewhat sadly, now that he is gone, how well he illustrated the laziness of a class of Virginians. The story was a part of his congressional canvassing. On one occasion he got across the Pennsylvania line into a little village of Virginia. He was in the midst of a group around the tavern. While treating and talking, a procession approached, which looked like a funeral. He asked who was to be buried.

"Job Dowling," said they.

"Poor Job!" sighed the general.

He was a good-natured, good-for-nothing, lazy fellow, living on the few fish he caught and the squirrels he killed, but mostly on the donations of his neighbors.

"So poor Job is dead, is he " [said the general.]

"No, he ain't dead 'zactly," said they.

"Not dead—not d— Yet you are going to bury him "

"Fact is, general, he has got too infernal all-fired lazy to live. We can't afford him any more. He's got so lazy that the grass began to grow over his shoes—so everlastin' lazy that he put out one of his eyes to save the trouble of winkin' when out a-gunnin'."

"But," says the general, "this must not be. It will disgrace my neighborhood. Try him a while longer, can't you?"

"Can't. Too late—coffin cost $1.25. Must go on now."

About this time the procession came up and halted, when the general proposed, if they wouldn't let Job out, he would send over a bag of corn. On this announcement the lids of the coffin opened, and Job languidly sat up; the cents dropped from his eyes as he asked, "Is the corn shelled, general?"

"No, not shelled."

"Then," said Job, as he lazily lay down "go on with the funeral."[15]

The humor existed then, even if it remained a puzzlement to eastern analysts. Nor did that strain of humorous exaggeration that so characterized American rural humor cease at the end of the nineteenth century. Witness the following relatively recent story from the pages of the Lincoln, Nebraska, *Star*.

Sutherland, Nebraska, is not precisely Paul Bunyan country, but a recent story out of there had a bit of the flavor of the mythical Minnesotan.

It had to do with one Bert Shoup, native, and one unchained rattlesnake, whether native or not it was not stated. Probably not, local leash laws being as stringent as they are.

The latter, it seems, was basking contentedly in the midday sun when the former decided to do a bit of lawnmowing. When Mr. Shoup came into sudden awareness of the reptile, it was reported that his eyebrows raised abruptly, as did his hat and the hair under it. Mrs. Shoup, it was reported further, set up a hullabaloo which could be heard even above the power mower.

The uninvited guest rattled a bit and showed his teeth, but the stout-hearted homeowner rallied to the battle and "with nohing between him and the rattler but a 75-pound, four-and-one-half horsepower lawnmower with a 22-inch blade," Old Sidewinder moved to the attack.

At the first frontal pass the snake lost twelve inches off its tail and three fingers off its right hand. But it too rose to the fray and "converting four exposed vertebrae into temporary rattles, prepared for the next assault."

Overwhelmed by the mighty mechanical juggernaut, the serpent sank its fangs deep into the blade, wrapped its stumpy tail around a clump of crabgrass and managed to bring the mower to a complete halt.

Well, the tension on the blade was too much. It snapped from the shaft, flew over the house, across the backyard and on up over the Sandhills. The venom was doing its work and the blade, badly poisoned, swelled up until it presented a strange spectacle in the sky. UFO reports poured into the sheriff's office for three days. A special committee out of Washington declared it to be a contraption sent by the GOP to spy on prairie dogs.

The snake, meanwhile, went all to pieces. Old Sidewinder and his wife gathered up said pieces and using the rattler's fangs as substitute blades for the mower, finished their chore.

The infected blade has not as yet been accounted for. Assuming perhaps that the heat of the sun drew out the poison, it may be that "somewhere between Sutherland and Thedford there lies a rotary lawnmower blade, perfectly good except for a couple of puncture marks."

Anyone finding the blade is urged to return it to Mr. Shoup. He needs it to authenticate his story.[16]

15. The Hon. S. S. Cox, "American Humor," part II, *Harpers New Monthly Magazine* Volume 50: Number 300 (May 1875): page 847.

16. "Old Sidewinder Shoup," *Lincoln, Nebraska, Star*, 30 July 1973.

2

How We Do It Here:
The Stuff of Tall-Tale Postcards

The postmarks, addresses, and locations of the publishers of tall-tale postcards show that they were primarily a phenomenon of the northern and central plains, the huge agricultural area stretching from the Mississippi to the Rockies, from the Mexican to the Canadian border. It is not surprising then that the principal topics of tall-tale postcards are also rural and agricultural, for example, corn.

The most common of corn themes (and one found most often) of all tall-tale postcards motifs was that of one or two ears of corn comprising a full wagon load. Most tall-tale postcard producers tried their hand at at least one such picture.

A variation on the huge corn theme, was the pictorial exaggeration that only a few pieces of fruits or vegetables were large and heavy enough to prevent an ordinary wagon from carrying them sucessfully.

Laura Turnbull, the daughter of pioneer postcard photographer Archer King, has in her father's collection a number of paste-ups like this, which were clearly meant to become postcards, but which were never issued apparently, since no such postcards have been found in King's collection or among other private collections.

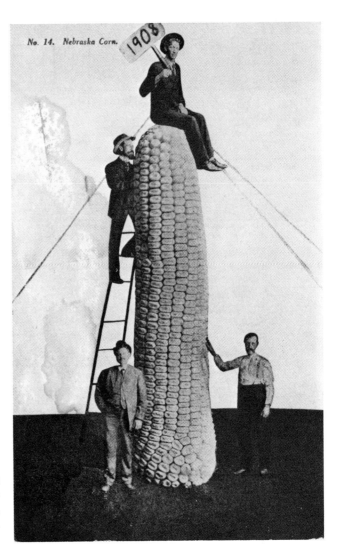

No. 14. Nebraska Corn.

King worked within an agricultural environment at Table Rock, Nebraska, and he used rural themes to appeal to his rural midwestern audience. This postcard, courtesy of Laura Turnbull, was published by F. M. Downs of Lincoln and bore his index number 14.

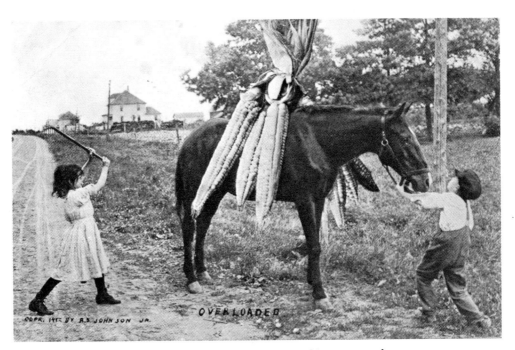

OVERLOADED

A. S. Johnson also used the theme of huge ears of corn, but, with his extraordinary skill, he wove into his postcards vitality and action. Note especially how he has cut and manipulated his materials so that the corn appears to be hanging on the side of the horse away from the viewer too.

[31

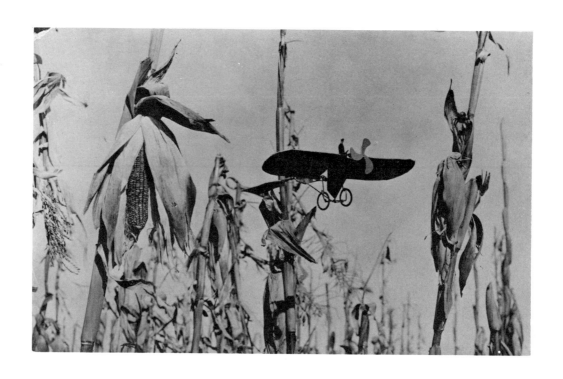

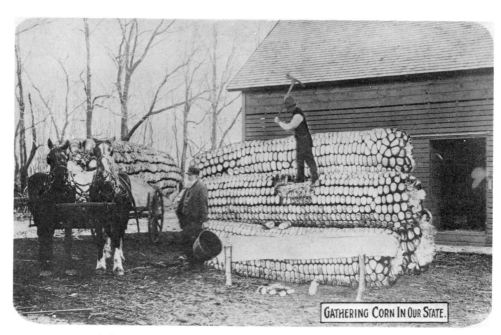

GATHERING CORN IN OUR STATE.

The photographer, publisher, and date of this card are unknown, but the general technique suggests that it might have been the work of Oscar Erickson.

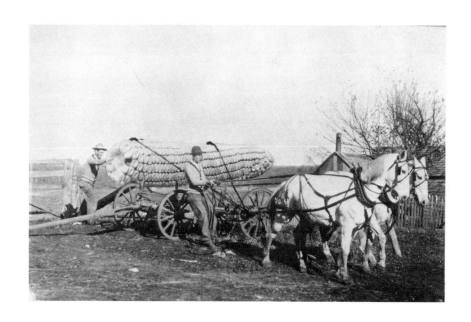

These two photos were doctored and trimmed to be made into postcards, but Archer King never did issue them commercially. These models were loaned by Laura Turnbull.

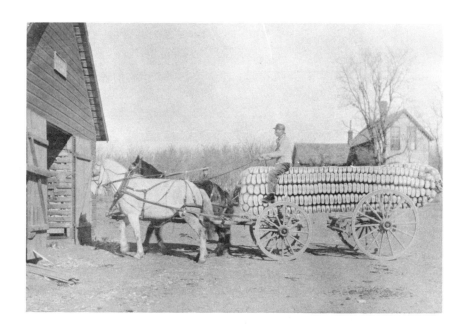

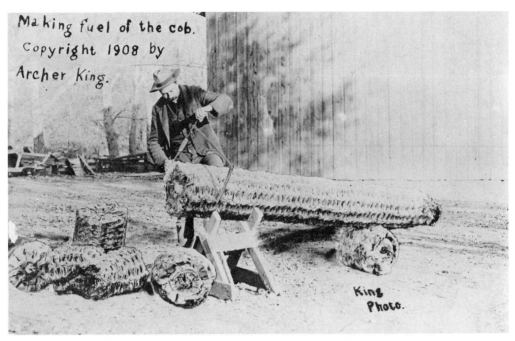

King found a way to exaggerate not only the agricultural benefits of corn, but even the secondary advantages of the huge cobs on the treeless Plains. Card courtesy of Laura Turnbull.

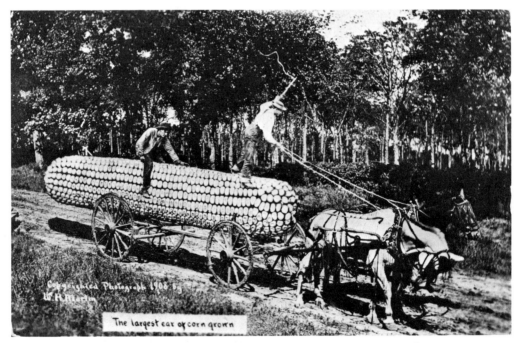

William Martin, like so many other tall-tale postcard producers, used the theme of one or two ears of corn constituting a full wagonload, but with his customary skill he also added the further convincing evidence of the obvious strain of that load on men and animals. Published by the North American Post Card Company of Kansas City in 1908.

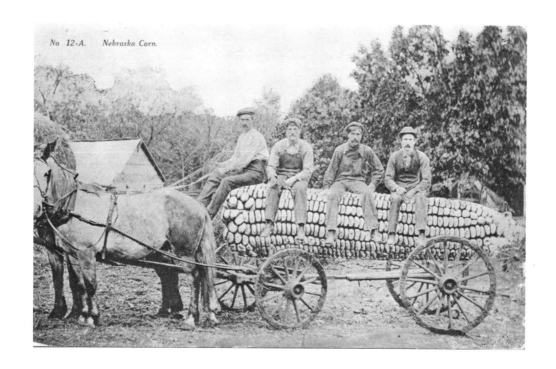

No 12-A. Nebraska Corn.

King was especially fond of the wagon-and-corn motif and experimented with it widely and freely. The first of this series of three cards was published by F. M. Downs of Lincoln, Nebraska. The second was issued by King himself in 1908. The third was never published, but was found in King's files after his death and is used here courtesy of Laura Turnbull.

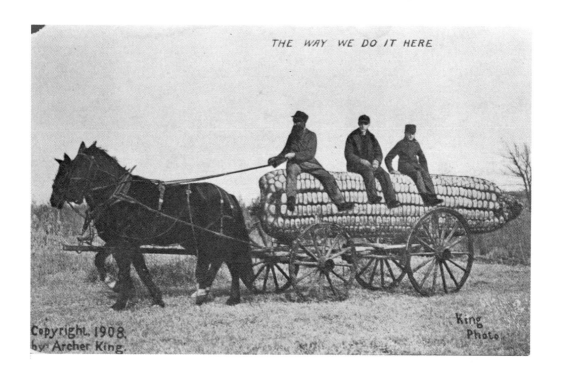

THE WAY WE DO IT HERE

Copyright 1908 by Archer King.

King Photo.

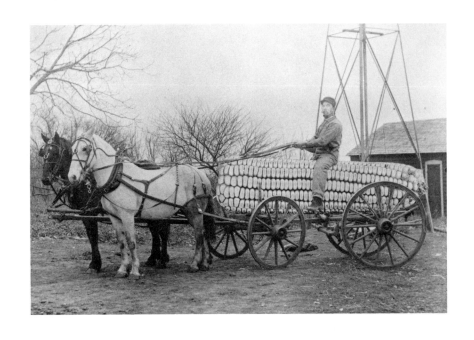

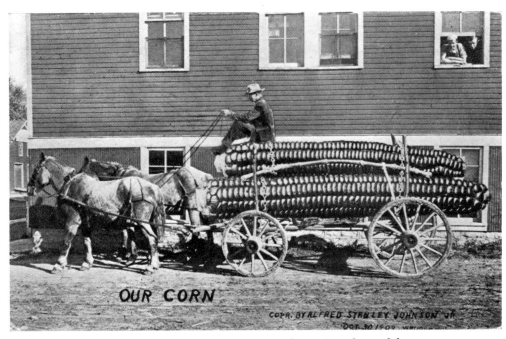

Johnson's variation on the corn theme is enhanced by
the addition of two observers in an upper-story window.

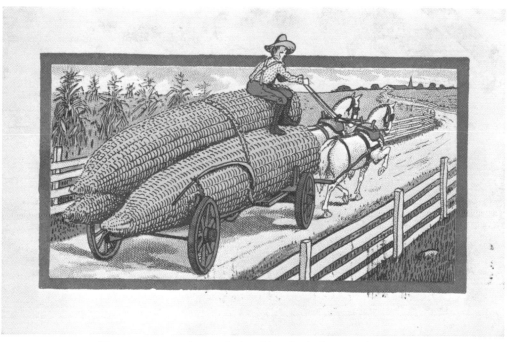

Drawn postcards used the identical theme, this one produced by a company identified only by the logo.

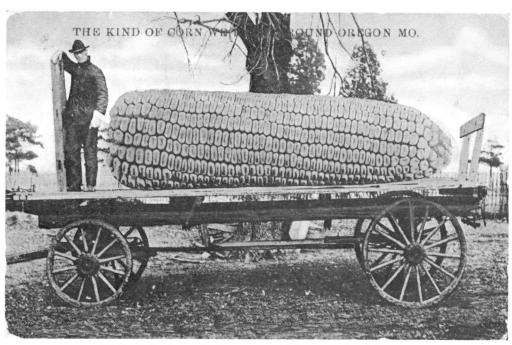

THE KIND OF CORN WE[...]ROUND OREGON MO.

M. L. Oakes's work is not as well done as that of most other photographers but his topics fit the tendencies of the genre. This particular example was published by the Rock Island Post Card Company, date unknown.

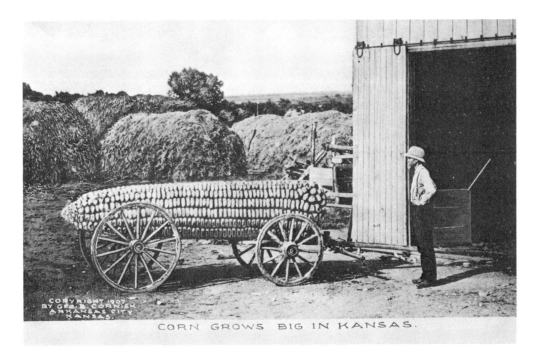

George B. Cornish did not publish many tall-tale postcards so it is all the more significant that he used the most popular of themes—the wagonload of one ear of corn.

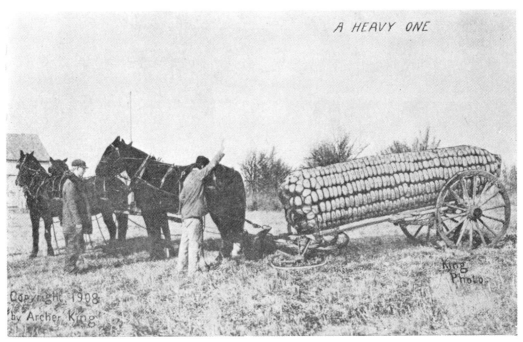

The impact of the enormous size of the fruit was frequently dramatized by addition of the motif of a wagon *over*load by one or two pieces of produce. This Archer King card is used here courtesy of Laura Turnbull.

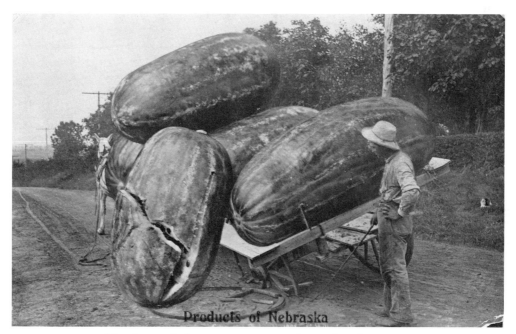

Martin used the same wagon and perplexed teamster
in a number of postcard scenes with a variety of gigan-
tic fruits and vegetables. This card was published in
1908.

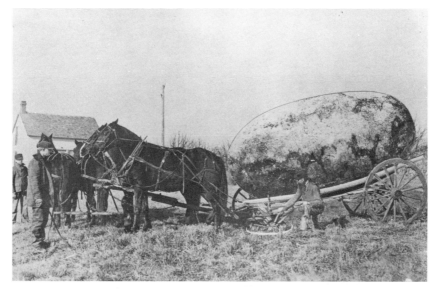

It is unfortunate that this card by Archer King was
never published because it is one of his best efforts.
It is interesting that the broken wagon in this photo-
graph is not the same one in another King postcard
of the same type, shown in a previous illustration.

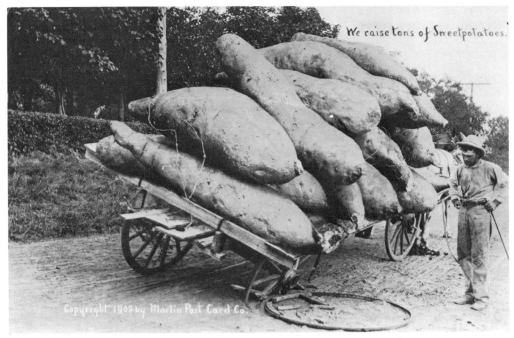

Martin, however, did use the same wagon picture in several different scenes. This photo is in part a reversed print of the wagon shown in another illustration.

Potatoes were a common crop on the Plains during the first several decades of the century and were the subjects of a good many tall tales. I was once told by an old-timer about the day that his father sent him to a neighboring farm to borrow a hundred pounds of potatoes but returned empty handed because his neighbor said he wasn't about to cut up a potato for anyone.

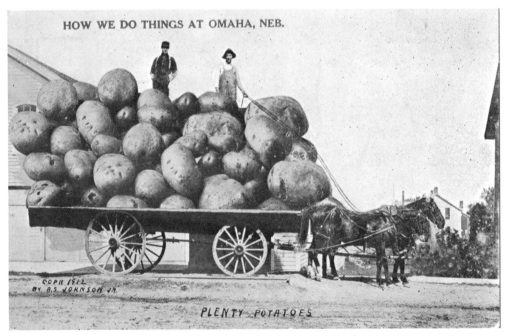

Potatoes were a popular tall-tale postcard theme, one that A.S. Johnson, Jr., found especially attractive. Johnson's labeling is a fine example of the laconic delivery so typical of the American tall tale. "Plenty potatoes," he notes, apparently without the slightest amazement at their incredible size.

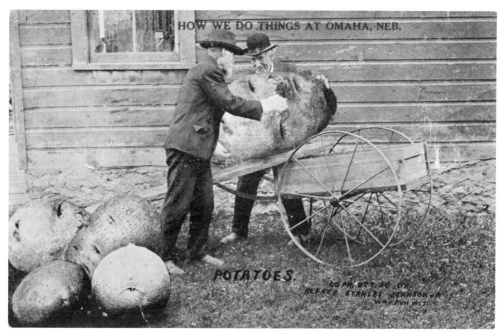

The copyright notice for this card reads only "October 30," but a number of Johnson's other cards were registered on October 30, 1910, which is probably the correct date for this card too.

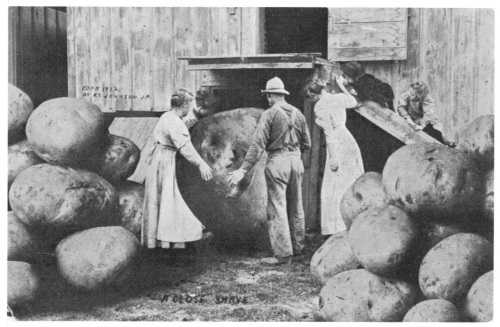

A good part of Johnson's skill, as can be seen in almost every one of his postcards, is his very effective use of human forms in conjunction with the exaggeration, particularly as bystanders, casual observers, and children.

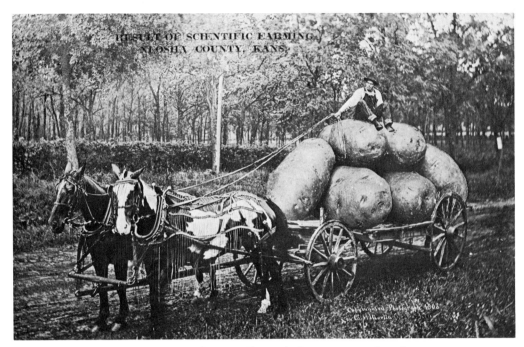

Most tall-tale tellers attribute their success to the phenomenal fertility of the soil but in this case Martin gives credit to "scientific" farming. This card was copyrighted in 1908.

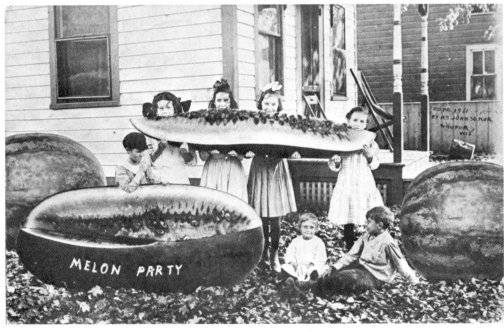

Again, Johnson uses children to produce an even more attractive card than might be the case otherwise—and a more interesting card for us today because of the rare view of children's dress of 1911.

Four examples of watermelon pictures (see photos) also provide some insights to the photographer's production of the tall-tale postcards. In each of the following two pairs of photographs, the same watermelon pictures have been used for two different pictures. In the Mitchell photographs the melon was simply turned ninety degrees but in the Cornish photographs, the larger, striped melon was moved to the other side of the picture and the smaller, striped melon was moved down somewhat in relation to the darker, background melon.

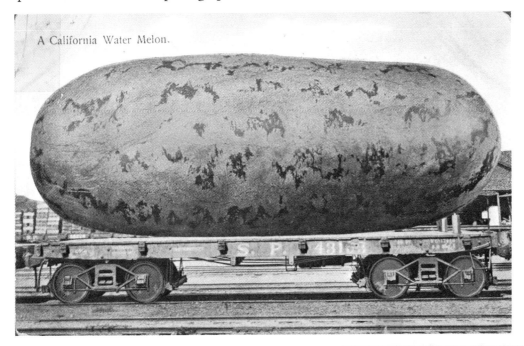

A California Water Melon.

Mitchell used nearly every conceivable kind of produce in his railroad flatcar format. An insight into the tall-tale photographer's techniques can be found in these two cards, however, since the same watermelon picture has been used in both.

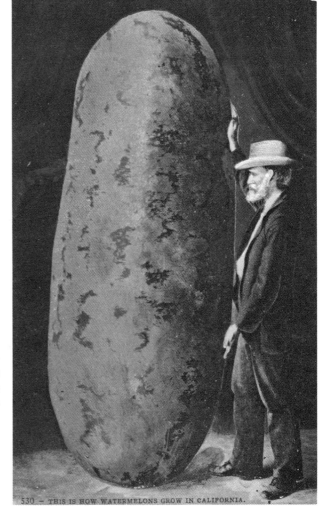

530 — THIS IS HOW WATERMELONS GROW IN CALIFORNIA.

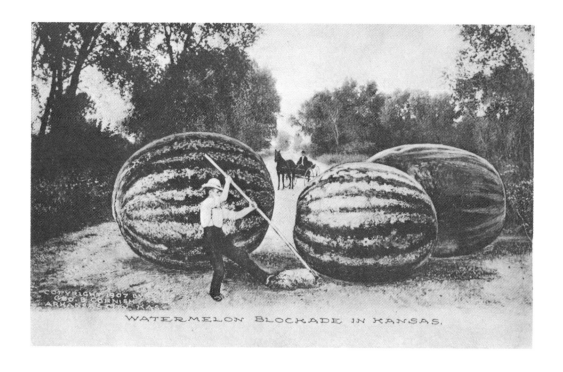

WATERMELON BLOCKADE IN KANSAS.

Basically, the same watermelon picture was used in this pair of postcards produced by George B. Cornish in 1907, a very early date for tall-tale postcards.

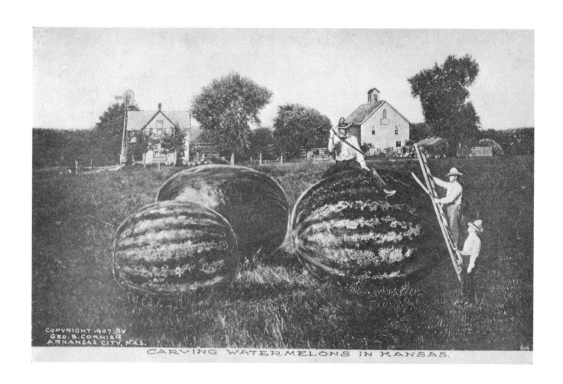

CARVING WATERMELONS IN KANSAS.

Blacks rarely appear in tall-tale postcards except in those depicting watermelons, an implied racial slur that certainly had some appeal with the public of the early twentieth century, with little regard for whatever discomfort it might have caused blacks.

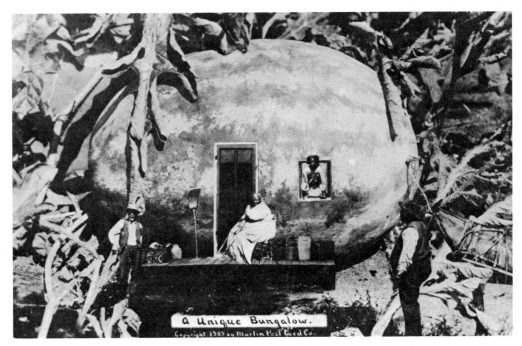

a Unique Bungalow.
Copyright 1909 by Martin Post Card Co.

Blacks rarely appear on tall-tale postcards except in the stereotypical context of watermelons. This postcard by William Martin required particular care in production because of the fine cutting and pasting necessary for the window and door in the melon.

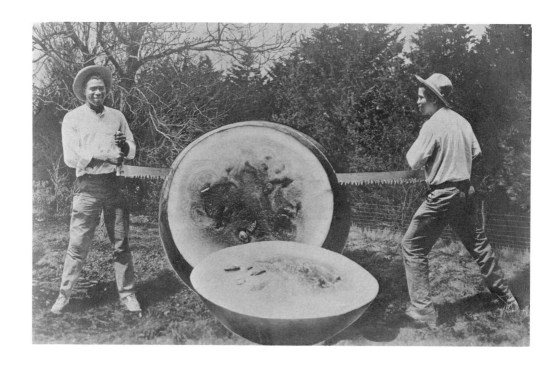

Both King and Martin used the theme of blacks cutting giant watermelons with lumbering saws. The Martin card is dated 1909; the King example is undated and is used here courtesy of Laura Turnbull.

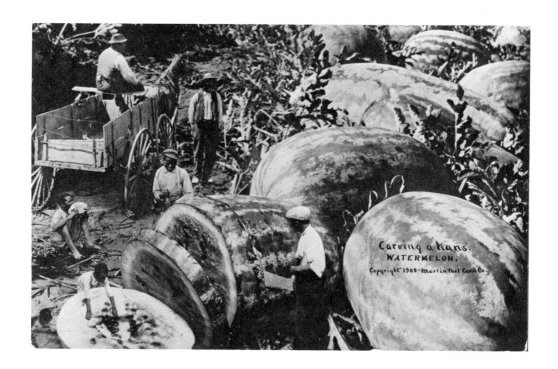

Eventually everything from strawberries to grapes, from wheat to beans came to the tall-tale photographer's attention and rare was the neglected crop.

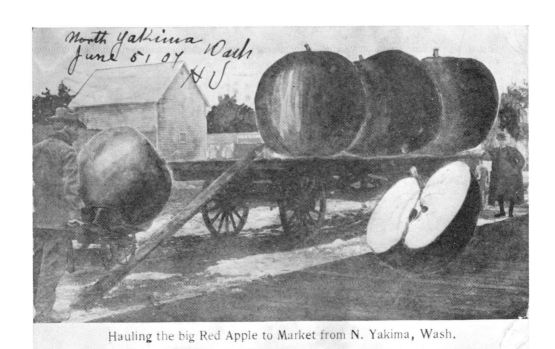

Hauling the big Red Apple to Market from N. Yakima, Wash.

No theme, it seems, could escape the imaginative photographer's scissors, pastepot, and lens. Here an unidentified photographer used a local Washington state favorite, apples.

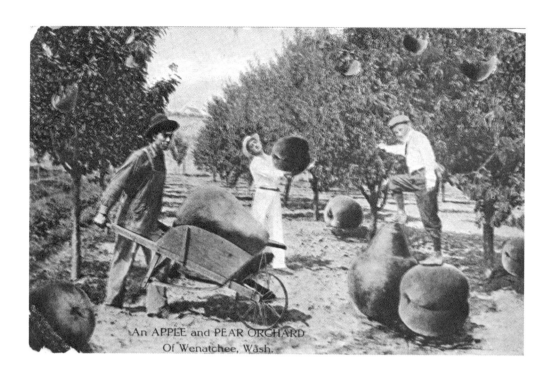

An APPLE and PEAR ORCHARD
Of Wenatchee, Wash.

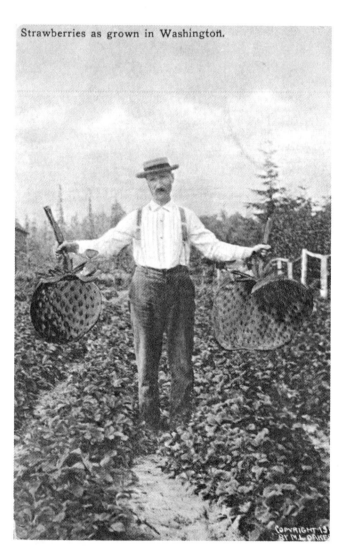

Strawberries as grown in Washington.

M. L. Oakes similarly turned to typical Northwest coast produce—pears, peaches, and strawberries—just as Plains publishers had concentrated on corn. Oakes, unlike better-known and more productive publishers like Martin, Johnson, and King, used color in his cards, but the process tended to detract from the clarity of his cards, especially in human facial features. These cards were published in 1909, both by the Portland Post Card Company, Seattle and Portland.

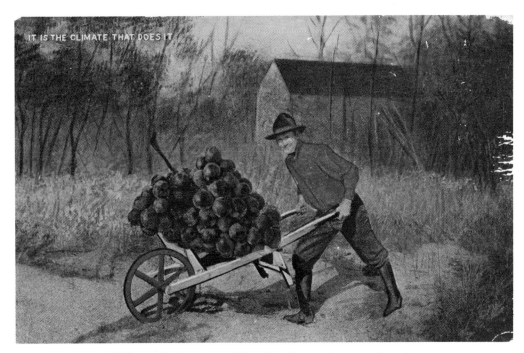

This card bears no identification whatever, but its
color, the subject of grapes (so clearly identified with
California), and its frequent appearance in postcard
collections suggest that it is one of the popular
Mitchell cards. If so, it is unfortunate that it is not
identified as his, because it is so well done.

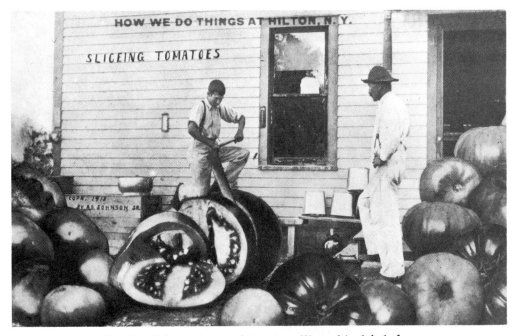

Despite Johnson's painful misspelling, his label for
this card is typical of his straightforward delivery. He
was indeed a master of the art of the tall tale.

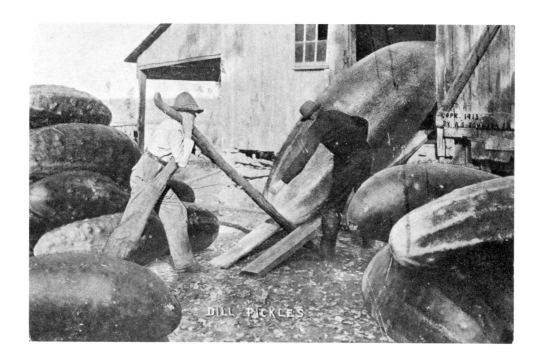

DILL PICKLES

It is remarkable that A. S. Johnson could deal with so many and such disparate subjects as tomatoes, cucumbers, pears, string beans, and cabbage and still maintain a high level of quality in his productions. The dates for these cards are 1913, 1911, 1910, and 1913.

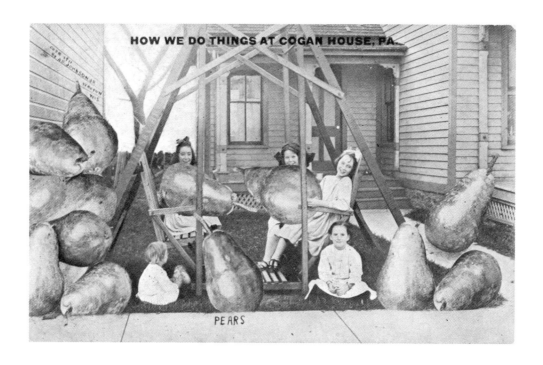

HOW WE DO THINGS AT COGAN HOUSE, PA.

PEARS

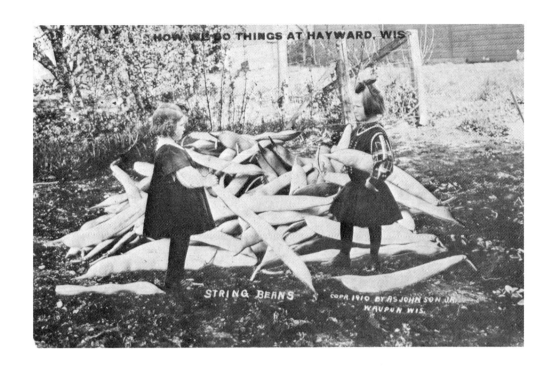

HOW WE DO THINGS AT HAYWARD, WIS.

STRING BEANS COPR. 1910 BY A.S. JOHNSON JR.
WAUPUN WIS.

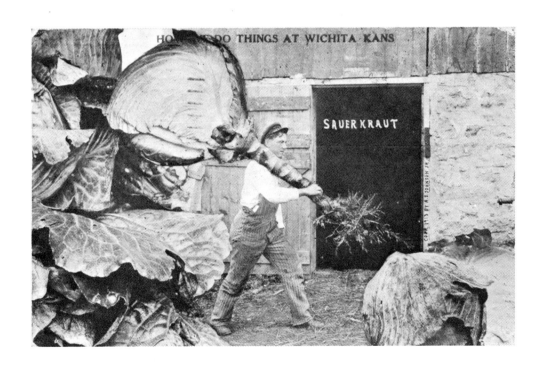

HOW WE DO THINGS AT WICHITA, KANS.

SAUERKRAUT

COPR. 1913 BY A.S. JOHNSON JR.

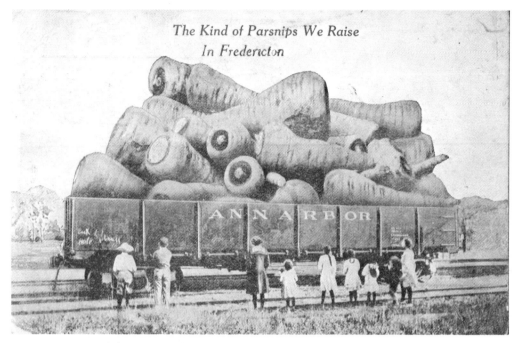

*The Kind of Parsnips We Raise
In Fredericton*

There is no identification for the publisher of this card featuring, of all things, parsnips, but despite the fact that it was produced for a Pennsylvania market, it is worth noting that the train is apparently from Michigan.

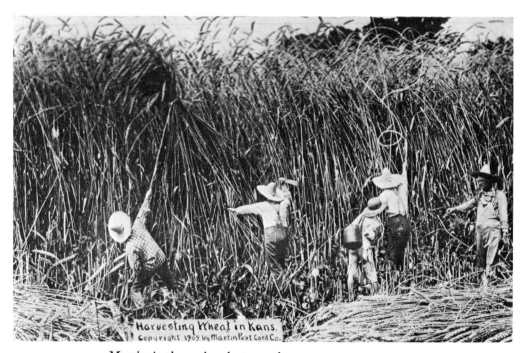

Harvesting Wheat in Kans.
Copyright 1909 by Martin Post Card Co.

Martin is the only photographer to attempt an exaggeration of so difficult a theme as wheat, and, as is typical of his consistent performance, he handled the assignment very well. He has apparently drawn in the uncoiling lariats, which he also did on a card depicting the roping of Kansas jackrabbits, with extraordinary effect.

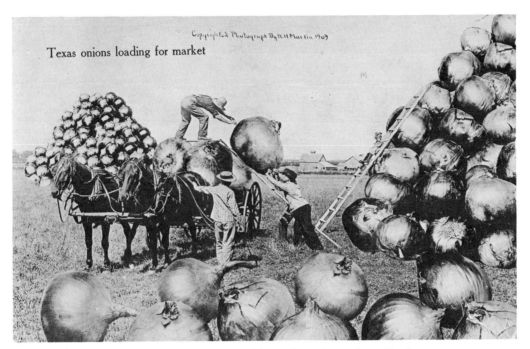

Texas onions loading for market

Copyrighted Photograph By W.H Martin 1909

Even with an ordinary subject like onions, the tall-tale master like William Martin could develop drama by depicting the great effort necessary to handle such unbelievable produce.

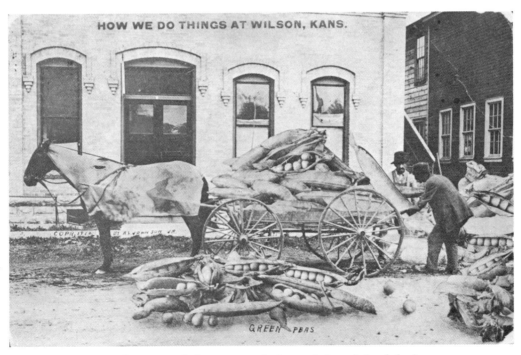

HOW WE DO THINGS AT WILSON, KANS.

GREEN PEAS

Johnson used the same technique of the trials of dealing with such monsters in this card produced in 1912.

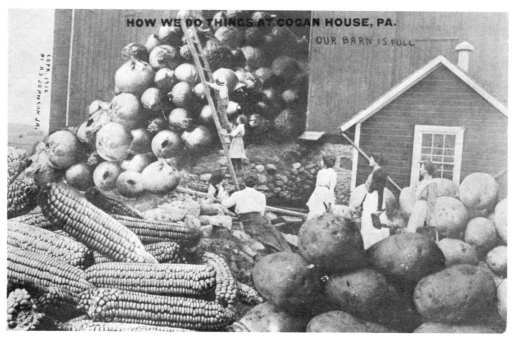

A photographer like Johnson would not feel obligated to restrict himself to one kind of produce in his postcard themes. Here he has pictured a farm deluged and drowned in its own superabundance.

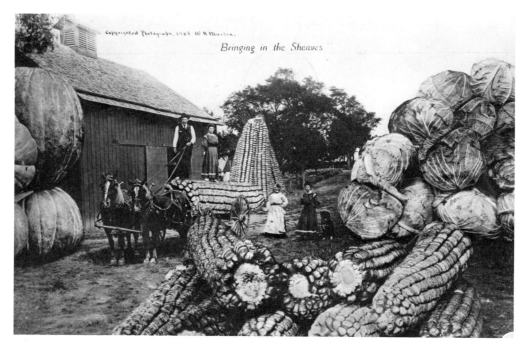

"Bringing in the sheaves,
Bringing in the sheaves,
We shall come rejoicing,
Bringing in the sheaves."
Those lines of the old, familiar hymn are usually thought of as an allegory for the redemption of lost souls, but here Martin has developed the idea in a literal interpretation, with a variety of exaggerated items of Plains produce.

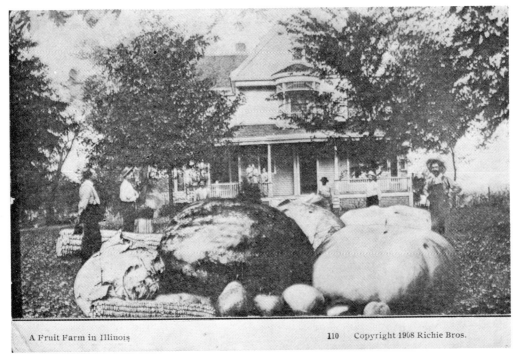

A Fruit Farm in Illinois 110 Copyright 1908 Richie Bros.

The well-done format of this card showing a variety
of fruits and vegetables is marred by the misspelling
of the photographers' name on the front. The back
however bears the accurate legend, "Made for dealers
everywhere by Ritchie Brothers, Centralia, Illinois."

Insects certainly could not have been the most promising of postcard subjects, but again because of their central interest to the rural Plains population that used the cards, insects did receive some truly artistic treatment, especially grasshoppers:

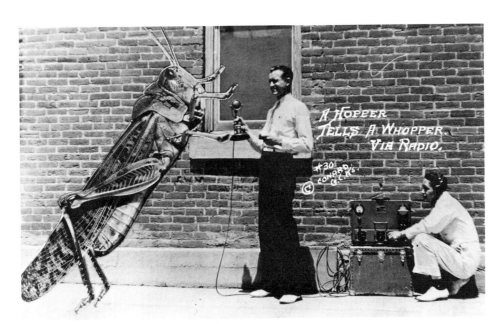

F. D. Conard produced his cards some twenty-five years
after the peak of popularity for the tall-tale postcard,
but the only dated item in this series is number 67,
which bears the date 1936. They are however clearly
within the same tradition of humor and photography.
His cards feature grasshoppers, a frequent Plains pest,
in part because he had unpleasant encounters with them.
Thus, the postcards wind up expressing Conard's
trauma.

[55

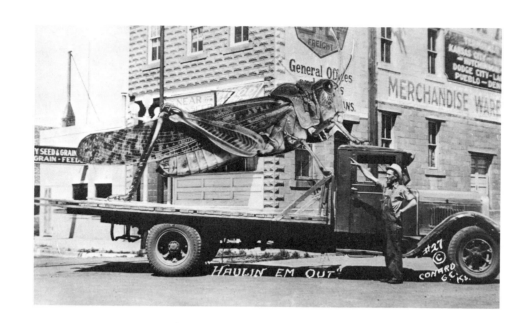

"HAULIN EM OUT" #27 © CONARD G.C. Ks.

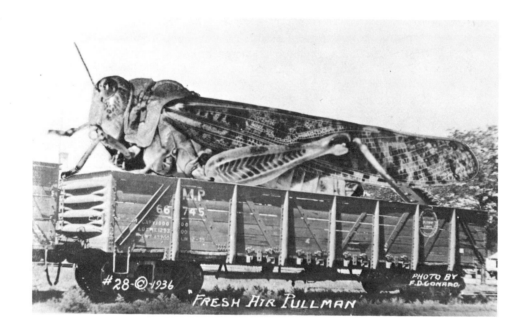

#28 © 1936 FRESH AIR PULLMAN PHOTO BY F.D.CONARD.

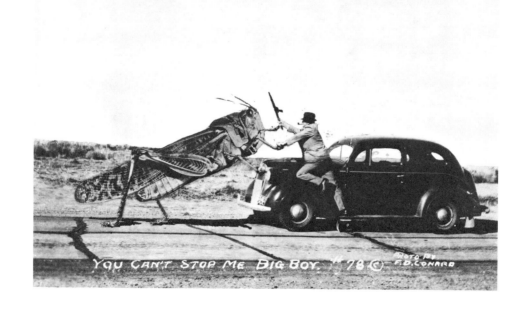

YOU CAN'T STOP ME BIG BOY. #78 © PHOTO BY F.D.CONARD

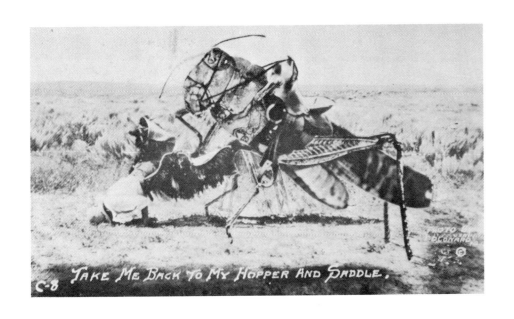

TAKE ME BACK TO MY HOPPER AND SADDLE.

C-8

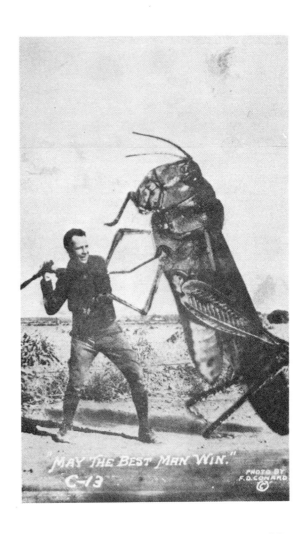

"MAY THE BEST MAN WIN."

C-13

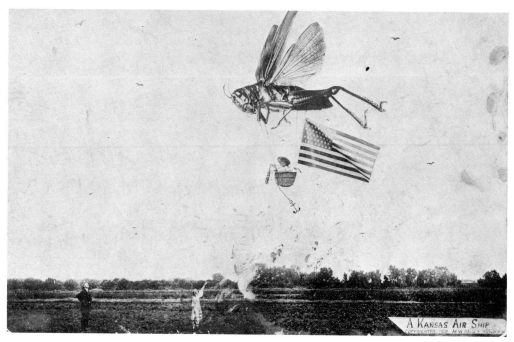

This is the only card I have found by this producer,
M. W. Bailey of Hutchinson, Kansas, dated 1909, but
it is a good example of the tall-tale postcard and it
capitalized on the contemporary enchantment of the
public with flying machines.

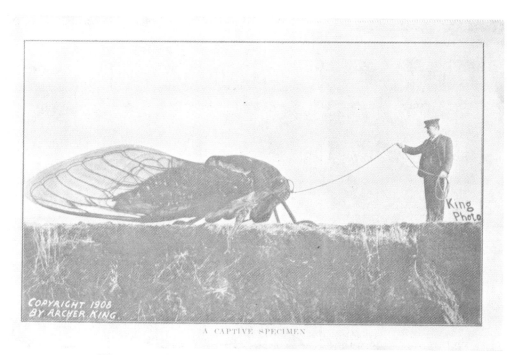

King was the only photographer who attempted to
work with a giant cicada, as shown here in a card
copyrighted in 1908, which is on loan from Laura
Turnbull.

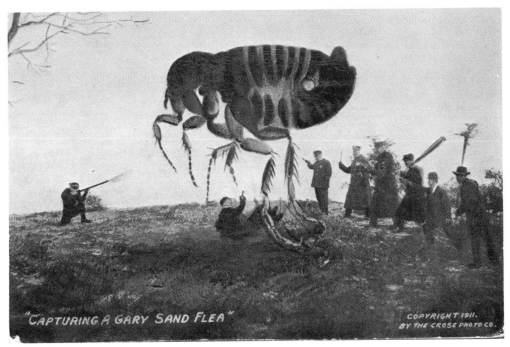

"CAPTURING A GARY SAND FLEA"

COPYRIGHT 1911.
BY THE CROSE PHOTO CO.

This card is the only example I have found of a photo-
graphic exaggeration of a flea, and it is the only card
I have found published by Cross Photo Company.

The word "fisherman" has become virtually syn-onymous with the epithet "liar." What a joy it must have been, however, for the vactioning fisherman to be able to send home one of these cards, documented evidence that his wildest stories had a foundation in photographic "fact."

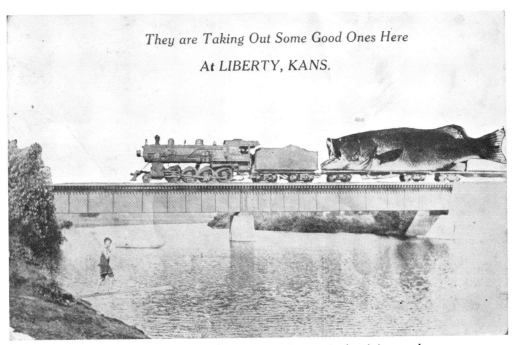

They are Taking Out Some Good Ones Here

At LIBERTY, KANS.

Fish have always been a popular topic for lying and
the tall-tale postcard was no exception. This card bears
no identification, but I have classified it as a part of a
series called "red print" because of the use of red inks
on the face legend of the cards.

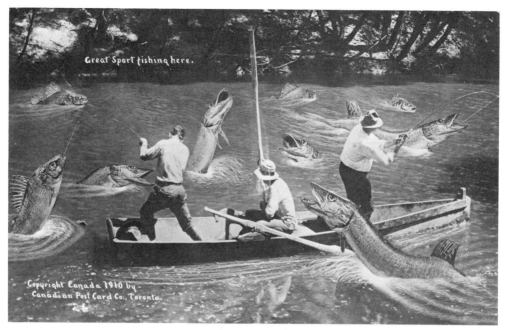

This card is labeled "Canadian Post Card Company, Toronto," but the work and handwriting is clearly that of William Martin of Kansas City.

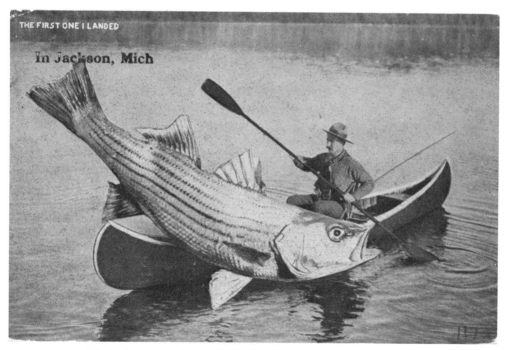

No information is available for this card, but it does bear the index citation "Series 86," a label found on many tall-tale fishing cards.

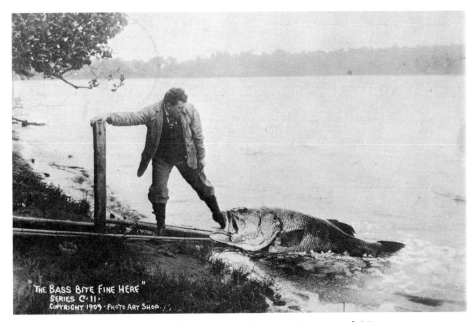

Oscar Erickson's Photo Art Shop used many fishing themes in its tall-tale postcards. Such cards were clearly favorites for people on sporting vacations.

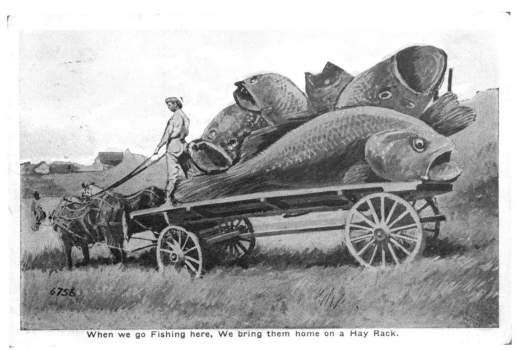

When we go Fishing here, We bring them home on a Hay Rack.

No information is available on the producer of this card but on the reverse is the legend "Series 608 Fish Cards 12 des. #6756."

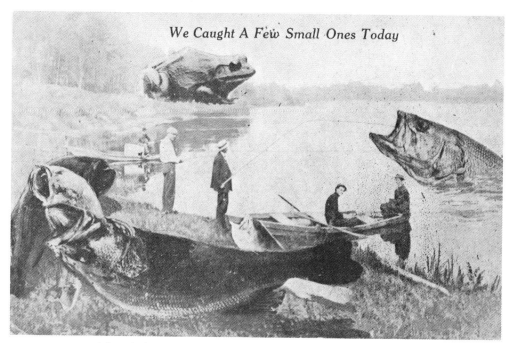

We Caught A Few Small Ones Today

The Auburn Post Card Manufacturing Company of Auburn, Indiana, specialized in fishermen's exaggerations, and, while the photographic work was often clumsy, the restrained humor of the publisher's captions are classic examples of folk, laconic delivery.

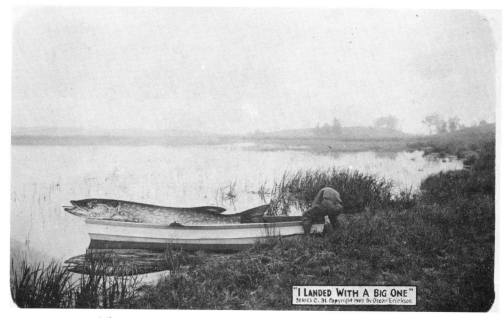

"I LANDED WITH A BIG ONE"
SERIES C. 31. Copyright 1909 By Oscar Erickson.

The range of Oscar Erickson's own card index numbers—here as high as C-31—suggests that he produced substantial numbers of tall-tale cards, many of them with fishing themes.

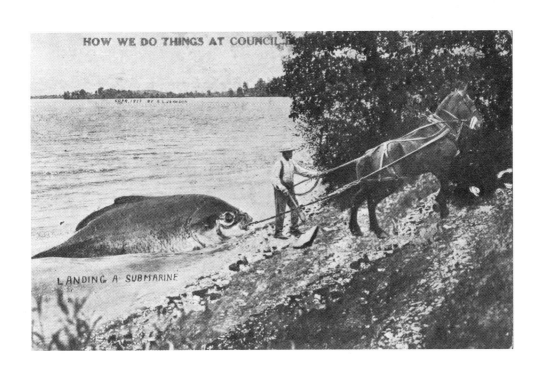

Alfred S. Johnson, Jr., produced several dozen fishing themes in his cards, as befits a Wisconsin enthusiast. The first of this pair is one of the latest of Johnson's cards; it is dated 1917.

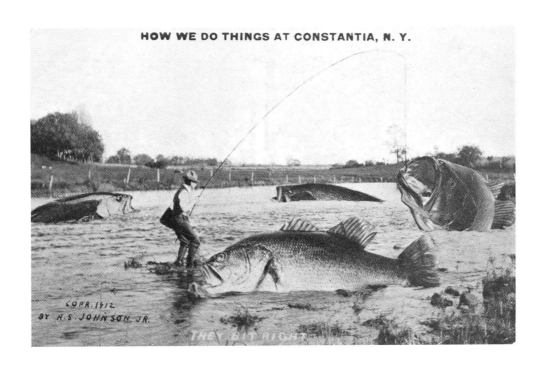

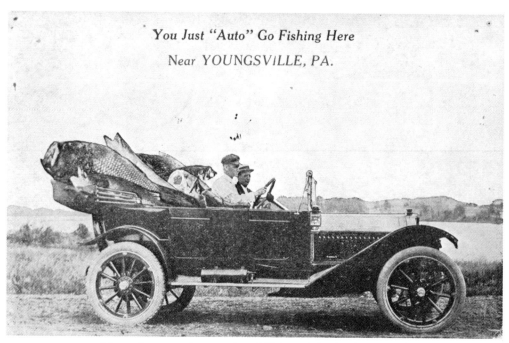

You Just "Auto" Go Fishing Here

Near YOUNGSVILLE, PA.

Most photographers and publishers left the humor of
their cards to the photographic content, but in this
"red print" card (otherwise unidentified), a rare pun
is used in the caption.

And rarely could a fisherman's tale reach beyond
the capabilities of the tall-tale postcard producer.

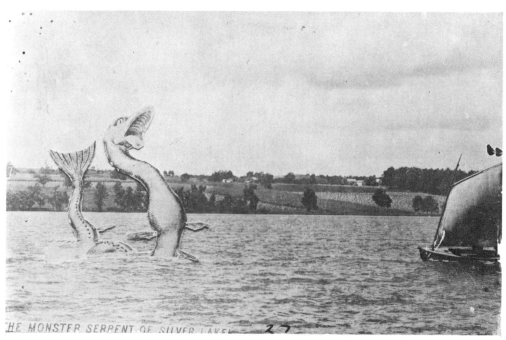

THE MONSTER SERPENT OF SILVER LAKE 27

This is not the customary form of the tall-tale card
since the exaggerated feature has been drawn rather
than photographed, but it does fit the general character
of the tall-tale family. The card is identified only with
the number 27.

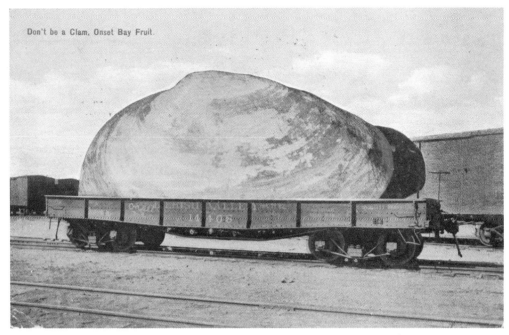

Don't be a Clam, Onset Bay Fruit.

Nothing escaped the photographer's imagination. This card is labeled, on the reverse, "This is Holmes, Brockten and Onset Bay, Mass.," but it is not dated.

Hunters found their exaggerations covered by evidence available from the drugstore or hotel postcard stand.

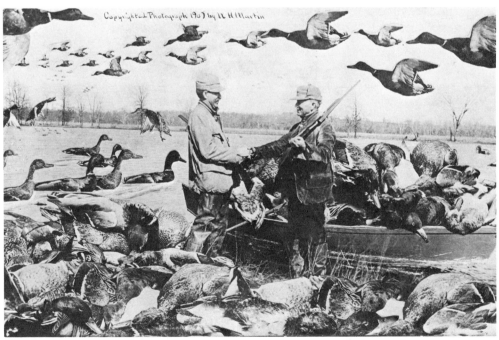

Copyrighted Photograph 1907 by W. H. Martin

William Martin has two hunters congratulating each other while the swarms of giant ducks flying and swimming about them show the concerned observer that their carnage has in no way diminished the Kansas abundance.

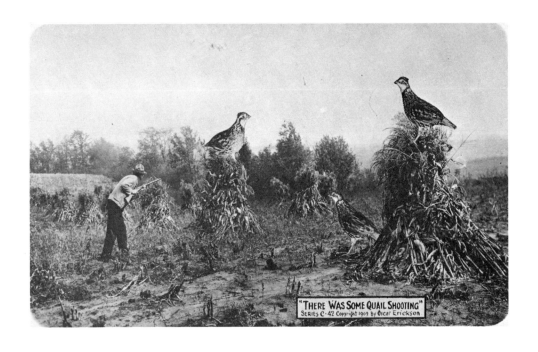

Oscar Erickson's casual captions take little notice of
the gigantic size of the birds his hunters are stalking.

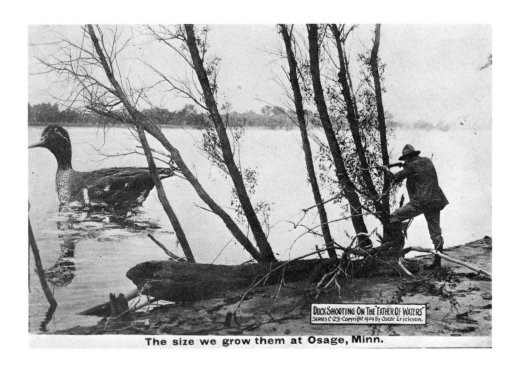

The size we grow them at Osage, Minn.

While this card was obviously produced for a Texas market, it was made by E. C. Kropp of Milwaukee, Wisconsin. It is not dated.

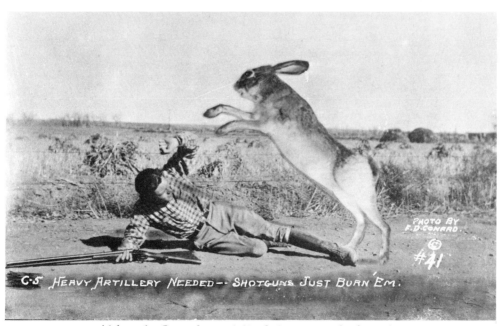

Although Conard specialized in postcards featuring giant grasshoppers, he also worked with the reknowned Plains jackrabbit, and the dangers of hunting it.

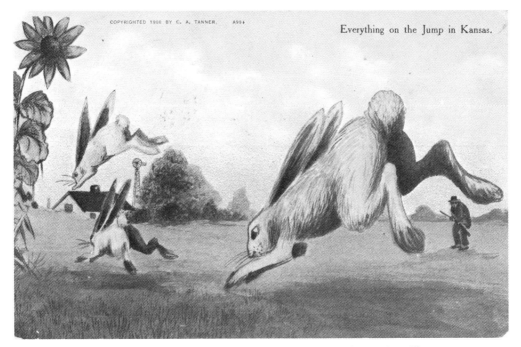

Everything on the Jump in Kansas.

It is difficult, because of perspective, to determine if this card is meant to be a tall-tale card, but the perplexed look on the hunter's face recommends that interpretation.

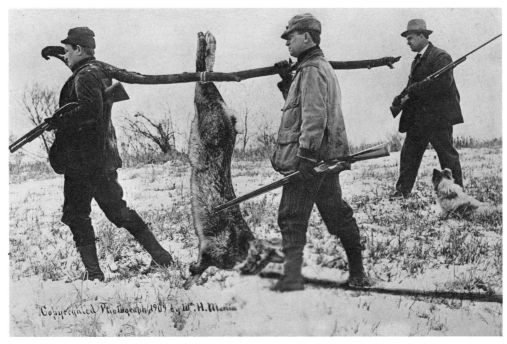

Postcard collectors who haunt antique stores might well recognize this William Martin card, for it was one of his most popular items, and it therefore constitutes a common item in any representative collection.

It seems only logical that that the livestock that feasted on enormous heads of wheat and ears of corn should also swell to unheralded size, and on postcards they did.

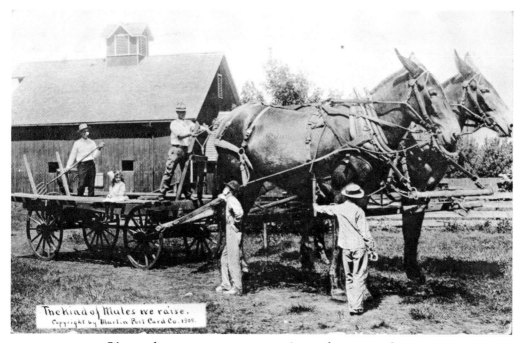

Livestock was not a common theme for postcard exaggeration, but William Martin, with his characteristic flair for the tall tale, was apparently afraid of nothing. Note in this pair of cards how well Martin has adapted the king-sized mules to the normal wagon or how, in the second example, he has woven the people and animals into a harmonious and convincing combination.

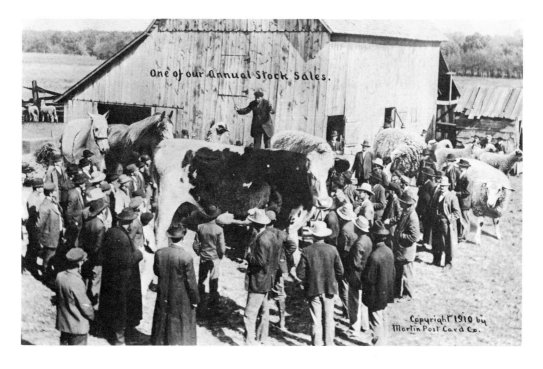

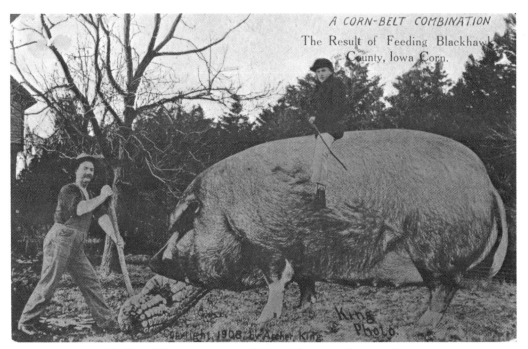

Archer King exaggerated two features here—giant corn to feed giant hogs.

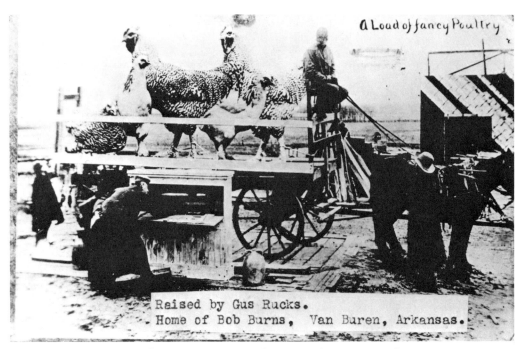

Martin has lent special credence to this exaggeration of farm poultry by having his characters weigh them on a farm platform scale normally used for livestock or loads of produce. This card was provided by Neal Chism.

Indeed, it sometimes appears as if nothing could escape the tall-tale photographer's magnifying glass, including his fellow human beings!

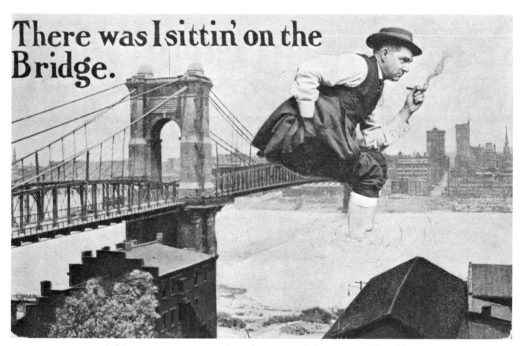

This strange, green-tinted postcard bears no identifying mark or information. The reference is obscure.

Some tall-tale postcards are so miscellaneous in their subjects that they defy any categorization whatsoever! The following examples juxtaposed features ascribed to the "Big City"—subways, airships, trollies, and elevated railways—on pictures of obviously very small, bucolic towns in Vermont, New Hampshire, and Kansas. The techniques and concepts used suggest that the two eastern cards were done by the same card producer. What a thrill it must have been for the citizens of Sawyer, Readsboro, and Farmington to see their little towns adorned by the trappings of New York, Boston, or Chicago.

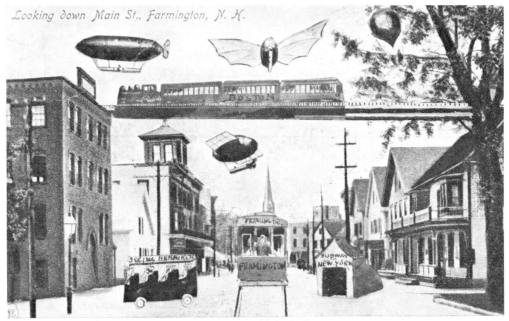

W. W. Roberts's dream for the future of Farmington,
New Hampshire, was probably popular when the card
was produced—about 1907—but today many citizens
probably yearn for the quiet days when the airships
and buses were only drawn in at a photographer's
desk.

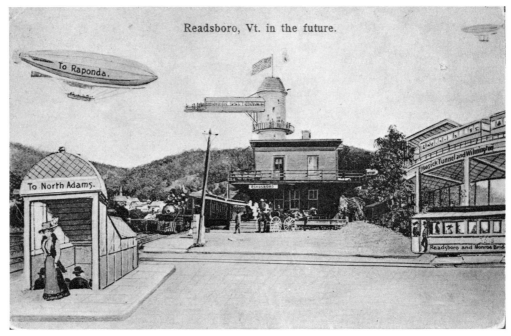

C. H. Faulkner and Company envisaged bustling days
for Readsboro, Vermont, in the air, under and on the
ground.

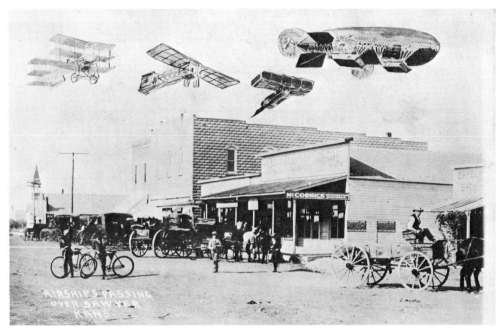

We are not told the name of this town, where on the ground a conventional snarl of bicycles, pedestrians, and horse-drawn wagons is contrasted with a more modern air-control problem like Chicago's.

And if the same postcards defy definition, others appear to defy understanding.

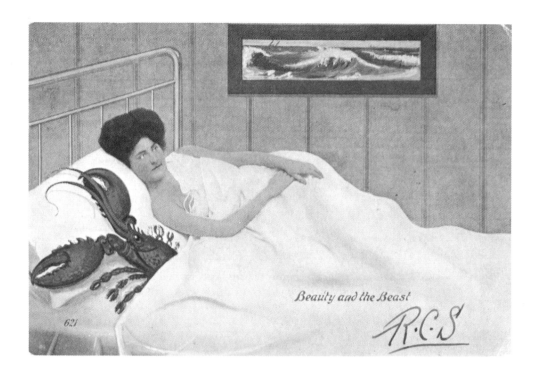

Sometimes the themes of postcard exaggeration are so bizarre that they remain obscure for the modern viewer. The themes of these two cards may be quasi-sexual. The first of the pair is identified only with the printer's number 621; the second bears the label "/K/ Semi-photo, #58."

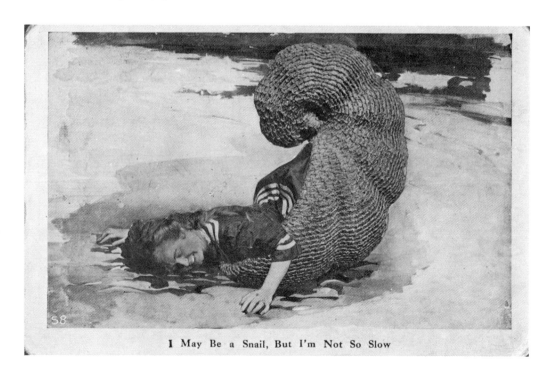

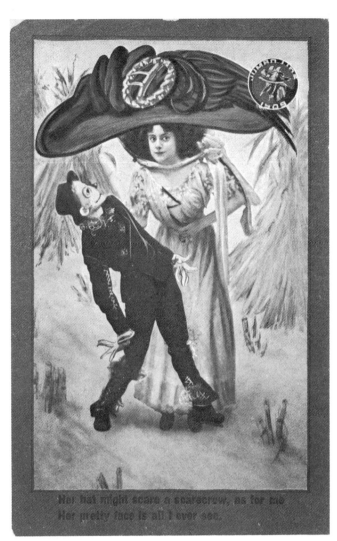

Her hat might scare a scarecrow, as for me
Her pretty face is all I ever see.

The proported helplessness of the love-struck man in the hands of a beautiful and designing woman, here shown with an exaggeration of her stereotyped weakness for hats, is almost legendary, and so was an appropriate subject for photographic exaggeration.

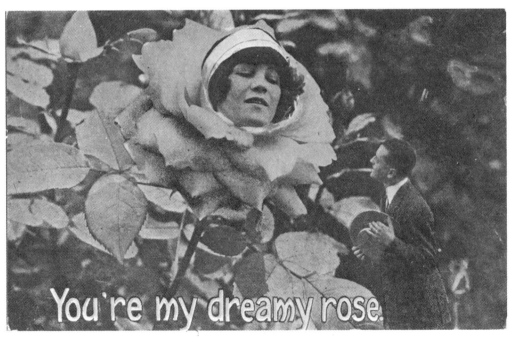

You're my dreamy rose.

The photographer's ability to cut and paste and thus superimpose one feature on another permitted the literal interpretation of romantic metaphors like this. The publisher and date are not indicated on the card.

Even today's liberated woman might be flattered by a card like that bearing the legend, "You're my dreamy rose" likening one's love to a rose. And this kind of depiction was a very common style of superimposition. But another kind of photographic exaggeration which must be mentioned in any treatment of tall-tale postcards even though it was scarcely flattering—at least in terms of today's standards—were those that featured women's heads attached to—of all things—enormous chicken bodies. Curious indeed.

A literal rendering of the allusion of a woman as a "bird" or "chick" however is considerably less flattering than the romantic cards, especially remembering the generally unattractive nature of chickens! However, the large number of such cards found in antique store and private collections attests to their popularity from 1905 to 1915.

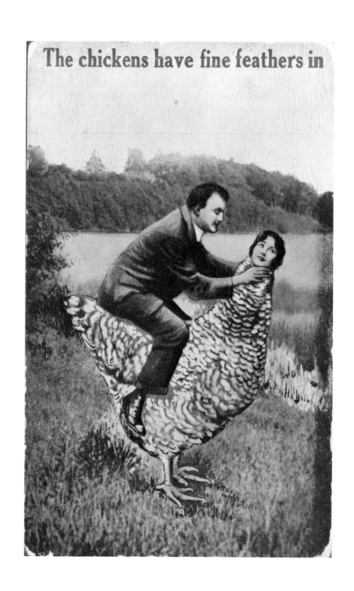

The chickens have fine feathers in

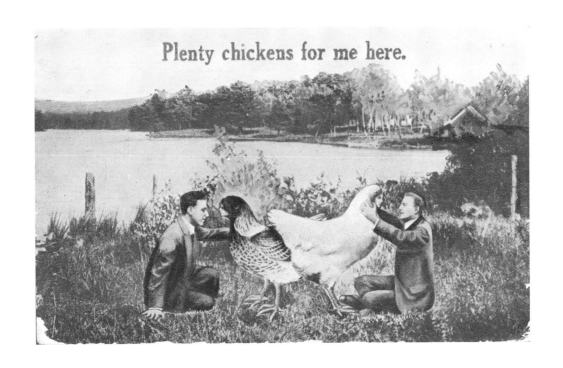

Plenty chickens for me here.

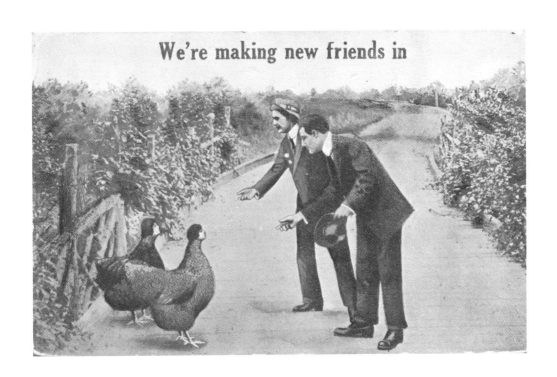

We're making new friends in

An interesting history surrounds one tall-tale animal depiction, the jackalope or warrior rabbit. This creature first arose in the mind of some inventive taxidermist who spliced a pair of small deer or antelope horns on a large, stuffed jackrabbit and *voilá* a jackalope! It eventually became a favorite decoration for barroom walls, where it doubtless confused greenhorns and drunks for some time to come.

Next, jackalopes were borrowed from taxidermists by photographers who took straightforward photographs of the fabricated creatures for postcards (a clear departure from the superimposed exaggerations using a combination of two photographs). But then, as the photographers and postcard publishers added ever more imaginative texts to the cards, a narrative legend began to grow about the mythical creature, resulting ultimately in a jackalope capital (Douglas, Wyoming) with a large monument dedicated to the beast on the main street, hunting licenses for the elusive creatures; and other taxidermically devised splices, like fur-bearing trout, discussed in more detail later.

Legend has it that the jackalope was first seen and captured around Douglas, Wyoming, in 1829. They are reputedly very fierce, belying the heritage of both sides of their lineage, thus giving rise to their second name, "warrior rabbit."

They are said to have excellent voices and they echo the songs of cowboys singing to herds at night, mimicking even the tone and pitch of the voice. When they are surrounded, they call on their knowledge of English to shout, "There he goes, over there" and "He's there by that bush to the south" to throw pursuers off the correct track. Jackalope milk is in special demand by men all over the world (but women, it should be noted, are cautioned against drinking jackalopess milk for an unknown, or unadmitted, reason).

The milk is already homogenized from the animal's great and rapid leaps. Storms seem to have some particular effect on the strange little animals, for many people claim that they sing only before violent prairie thunderstorms, and indeed, some observers claim that jackalopes copulate only during lightening flashes (which may well account for the milk being denied decent Plains womenfolk).

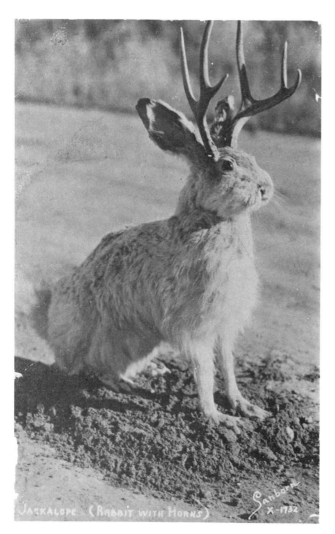

The jackalope is a fairly recent tall-tale postcard theme, most of the cards having been published within the last twenty years. This card, however, appears to be about forty years old, even though it is not dated or identified.

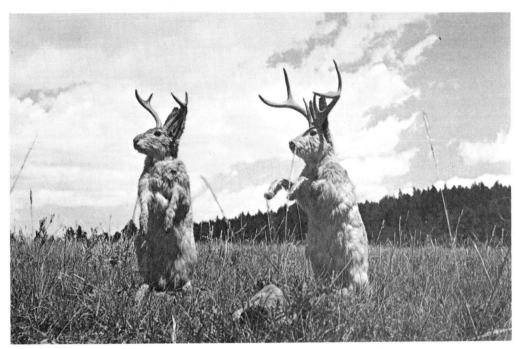

This card, distributed by the Triangle Distributing Company of Colorado Springs, Colorado, is not dated, but is quite recent. It is an especially good example of the jackalope card because the animals are in an unusual pose and are a handsomely matched pair.

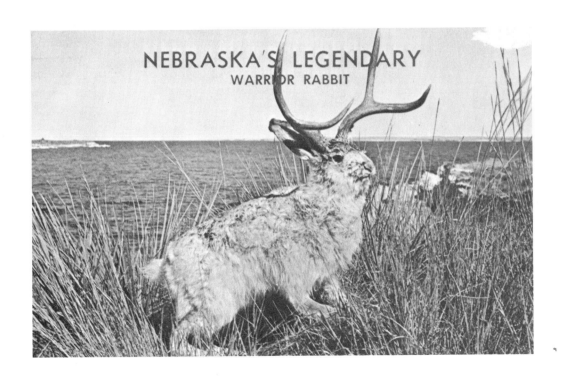

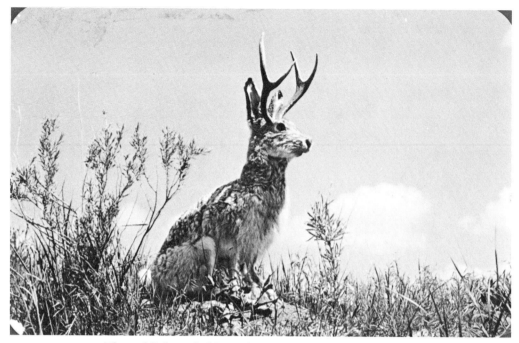

The publisher of this card is not known, but the postcard indicates that the photograph was provided by the Wyoming Travel Commission. The card was given to me by Robert Pierce.

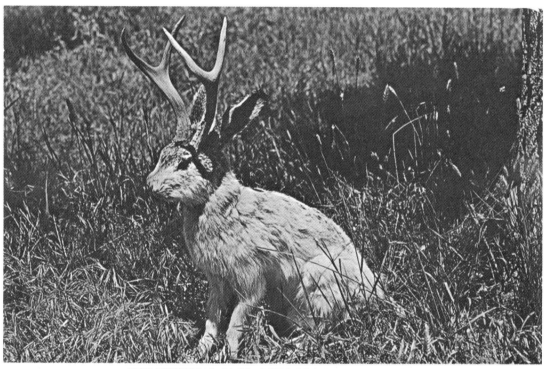

THE MYTHICAL JACKALOPE OF NORTH AMERICA

This card bears the label "The **Mythical Jackalope** of North America" and was distributed by Kontinental Kards of Colorado Springs, Colorado.

Several counties in Wyoming have issued restricted licenses for hunting the elusive jackalope, two examples of which are shown.

NON-RESIDENT JACKALOPE HUNTING PERMIT No. _____

This permit authorizes _____

of _____, to hunt, pursue and take one (1), one-tailed Jackalope within the boundaries of Converse County, Wyoming, on the 31st day of June, between the hours of 12:00 midnight and 2:00 a. m. only. The holder of this license is hereby attested to be a man of strict temperance and absolute truthfulness, except that in cases where the number of Jackalope he has seen or slain is under investigation, he may occasionally, at his discretion, take such lingual evasion or loud rebuttal as the occasion requires.

 WARNING! The laws of the State of Wyoming prohibit the killing of two-tailed Jackalope under any circumstances. Penalty: $1,000 fine and/or sentence of

six months residence in _____

Subscribed and sworn to before me this _____ day of _____, 19___.
 ADAM LYRE, Chief Licensor.

_____ By _____ Deputy
(Signature of Licensee)

(A limited number of these permits may be obtained from the Douglas, Wyoming Chamber of Commerce, for the nominal fee of $1.00)

The tall tale of the jackalope has been extended beyond the stuffed examples on barroom walls and postcards to the issuance of mock hunting licenses for the creature. The first example is courtesy of the Douglas, Wyoming, Chamber of Commerce and the second was given to me by Durrett Wagner of Evanston, Illinois.

1970 Jackalope Permit No. 00001 1429

U S A

No License Will Be Honored In Which the Printed Form Has In Any Way Been Changed

This permit authorizes ___DURRETT WAGNER_____

of ___EVANSTON, ILLINOIS_____, To hunt, pursue and take one (1),

one-tailed Jackalope within The State of Wyoming, on

the 31st Day of June, between the hours of 1200 midnight

and 2:00 A.M.

ALWAYS CARRY THIS LICENSE WITH YOU

JOHN B. HUISMAN
ORIGINAL—THIS LICENSE CANNOT BE TRANSFERRED.
LARAMIE COUNTY CLERK CHEYENNE, WYOMING

While the jackalope was occupying the curiosities of the citizenry of Nebraska and Wyoming, Coloradans were considering the weighty question of the beazle, or fur-bearing trout. One story was that the mountain waters were so cold that the fish grew fur coats by way of natural protection, but before long Colorado newspapers were filled with controversy, part of which I offer to you here as evidence of man's eternal search for knowledge:

A VANISHING AMERICAN: QUESTION OF "FUR-BEARING" TROUT IS SETTLED—OR IS IT?

With the buffalo, the non-syndicated American Indian, and real maple syrup, Colorado's own famous fur-bearing trout . . . are rapidly nearing extinction, it was revealed Monday. Upon receipt of a telegram from a Pratt, Kans., resident, the Salida Chamber of Commerce was unable to find anyone who knew for sure exactly where any of the unusual inhabitants of the Arkansas River could be found. Only [a] photograph, and the memory of some of the region's oldest liars—uh, beg pardon—residents—were available for evidence that the ermined worm-worriers still exist. (The fur-bearing trout, sometimes incorrectly known as the sabled salmon, is not to be confused with either the cat-fish or the dog-fish. They are believed to have been introduced by the same old salt who first achieved fame with his sea-lyin', however.)

Old timers living along the Arkansas River near Salida have told tales for many years of the fur-bearing trout indigenous to the waters of the Arkansas near there. Tourists and other tenderfeet in particular have been regaled with accounts of the unusual fish, and Salidans of good reputation have been wont to relate that the authenticity of their stories has never been questioned—in fact, they're willing to bet it's never even been suspected.

Then last week, out of Pratt, Kansas, where water in any quantity large enough to hold a trout—fur-bearing or otherwise— is a rarity, came an urgent request for proof of the existence of the furry fin-flippers. Directed at the Salida Chamber of Commerce the message read, "Answer collect by Western Union if you have fur-bearing trout in Arkansas River there."

Upon the sturdy shoulders of Wilbur B. Foshay, secretary of the Chamber of Commerce, fell the delicate task of telling the credulous Kansan, without detracting from the obvious tourist-attracting qualities of the pelted piscatorial prizes.

With admirable diplomacy, and considerable aplomb, Foshay dispatched posthaste a photograph of the fish, obtained from a Salida photographer, and then told the Kansan to use his own judgement as to the authenticity of the species. The photograph sent has been available in Salida for some time.

Foshay's cautious letter accompanying the photograph left nothing to be desired—except maybe a little more evidence of the authenticity of the trout. So a survey of real old-timers of the area was conducted and the following corroborative evidence uncovered:

From Narrow-Guage Ned of Poncha Gap came this report:

"Fur-bearing trout? We used to have 'em around here, but I haven't seen any lately. My pappy had some over at the Hot Springs but the steam ruined all their fur in the course of several generations, and they finally left. We were mighty sorry to see them go, but it was a shame to see such valuable furs being spoiled, so we finally agreed. Last I heard, they'd settled up at Iceberg Lake."

Texas Creek Tess, at one time impressario of the naughty can-can dance at the Owl-Ear Bar, recalled:

"The boys tell me that them pesky trout got to carrying on over around the silver fox farms on moonlight nights, and the fox-growers had to shoot 'em to protect their valuable fox strains."

Willie Axletree, the Hermit of Wet Mountain valley, had another explanation:

"Tess only told you one side of the story. The trout got to running about with the foxes, all right, but they weren't silver foxes until *after*wards .It was that trout strain that accounted for the silver coloration to begin with, and as the silver foxes came in, the fur-bearing trout just naturally moved out, rather than play second fiddle to their own descendants."

Agate Creek Andy, however, insisted:

"You ain't heard the real tale of them fur-bearing trout yet. They left after they lost their race to the Spiral Mango-bats around Tenderfoot Mountain. The trout claimed a victory in the first two laps, but they got bested on the home stretch when the Mango-bats really got their side-hill leg-action going. Then there was just no beatin' 'em. That's where that 'S' up thar [an "S" spelled on a hillside in white rocks for "Salida"] come from," he declared, lapsing into the vernacular. "Hit don't stand for Salida at all, like they tell ya."

But to Harrison Hickoryhead, the Gorgemore graybeard, went the official award for the most logical explanation. He said:

"Wa-a-al, it just like y'said, pardner. Them leetle trouts was fur-bearing', shore enuff. In fact, that wuz whut brought on their downfall, as y'mought say. They wuz just *too* fur-bearing' and folks got to imposin' on them, t'beat anything, knowing the leetle trouts wouldn't retaliate. Things wuz bad fur a long time, but 'twasn't till them eastern cappytalists got to settin' beaver traps for them that they got real discouraged. Then it just seemed like their little hearts busted wide open.

"And after that, they wan't near so fur-bearin' as they had been.

"There's still some of 'em around, if you know where to look, which I do, but I ain't tellin', but their fur is pretty few and fur between compared to whut it wuz. And they ain't near as fur-bearin' as they wuz. Not near"[17]

As the title of the pervious article suggests, the question was indeed not laid to rest so simply. Only a few months later another Colorado newspaper carried yet another trout tale:

STORY OF THE ORIGIN OF FAR-FAMED FUR-BEARING TROUT (*Salmo con epidermis muskwrattis*)

The fur-bearing trout, or beazel, is known to the trout streams of Colorado, Michigan, Pennsylvania, and Maine. The origin of this unusual trout in the Arkansas River of Colorado is a story peculiar in itself and follows thusly:

17. *Pueblo Colorado Chronicle*, 15 November 1938.

The town of Leadville was incorporated as a mining town in the year 1878. It was during the winter of 1877 and 1878 that meat was supplied to the miners in the form of venison by professional game hunters. Now, during winter months they ate so much venison and fried potatoes that the venison tallow became caked in the roofs of their mouths to the extent that they were unable to taste their coffee and other beverages. This was indeed distressing and often they eliminated this handicap by wiring a bundle of pitch splinters on top of their heads and setting fire to it. The result was that the tallow was melted and they again had the sense of taste, but the net result was that 97 percent of the miners in that camp became baldheaded.

About the middle of the spring a gentleman from Kentucky, who had been in the hair tonic business in that state, reached camp. He was a Republican and had left that state to avoid trouble with government tax agents who tried to collect the heavy tax on his product.

In time he started to manufacture his hair tonic from potatoes on a small creek south of Leadville and to sell his product to miners of the camp.

It was on a rainy summer evening that he was coming to town with four jugs of the tonic, one in each hand and one under each arm. It was necessary for him to cross a trout stream, which empties into the Arkansas River, on a foot log, and in so doing he slipped and had to drop two of the jugs to retain his balance. The result was that the falling jugs struck rocks in the stream and were broken, spilling the hair tonic into the water.

Not long after that trout fishermen of that vicinity changed their methods. Instead of the usual rod and reel, they would go down to the creek on Saturday afternoon, stick a red, white, and blue pole in the bank, put on a white coat, wave a copy of the *Police Gazette* in one hand, and brandish a scissors in the other, and yell, "Next," until they had the limit of these fine fur-bearing trout with full beards, etc. The trout would leap up onto the bank after these tonsorial lures and were picked up by the fishermen.

This practice continued until mine tailings from the mills riled the water so that the trout could not longer see the barber poles. Then catches of fur-bearing trout ceased to be made in the Arkansas River until recently the fishermen of our neighboring city has taken advantage of the clear water in midwinter and have discovered the snow worm as a successful lure.

I believe that will give a fairly good explanation of the origin of fur-bearing trout in the Arkansas River if the reader will keep in mind that fishermen are apt to throw their lines somewhat recklessly, . . .[18]

Four years later the journalistic battle was still being waged:

MYTH OF THE FAMOUS FUR-BEARING TROUT OF MONTANA IS NOW REVEALED

by Sigrid Arne

Whitefish, Montana, July 3, (Wide World.)

Maybe you were one who kept friends bug-eyed with the story of the fur-bearing trout. Remember? It burst on a startled world in the early 20's. It lived in Iceberg Lake in the Montana Rockies. It had a fur coat instead of scales to protect it from the burning cold of the lake. It hunted fat ice worms for dinner, and the men who fished for it had to heat their hooks first. It often exploded, once landed, just from the sudden change in temperature.

That fish was one of the minor national preoccupations of its time. The news streaked across the country, and scientists gave out statements. Startled fishermen streaked for Glacier Park and Iceberg Lake to land one. There were cooler-headed brethren who gave off sounds like "horse feathers!"

The horse-feathers boys, of course, were right. Various and sundry wits have repeated the stunt elsewhere, but in Montana they tell this story as the original one:

The fur-bearing trout was thought up by two brothers, taxidermists in Whitefish—G. H. and S. A. Karstetter, who still practice their art here. They'd just finished a trout dinner and chuckled over how funny the skeleton would look in a fur coat. So they fixed it up with a fur covering.

It was a local gag for a while. The late R. E. Marble, of Whitefish, took a picture of the oddity. The story spread, and finally reached St. Paul, where the late Hoke Smith, a newspaperman, decided to have some fun.

Smith, employed then to publicize Glacier Park, had just arranged to bring a party of eastern newspapermen to the Park. The trip was hilarious. So Smith stirred around to make it more so. He sent a telegram ahead to Minot, South Dakota, saying that Dr. Cook, the explorer was aboard.

The train stopped at Minot. Reporters met it. And Smith, naturally, had to meet the reporters, since he'd only dreamed up Dr. Cook's presence. He explained solemnly that the doctor was en route to investigate a fur-bearing trout.

The story raced in all directions. Plenty of people took it seriously and it created heated arguments. There's nothing left of the dream fish now except the picture postcard made by Marble.[19]

18. "Jay Bee Dee," *The Elk Mountain Pilot*, 23 February 1939.

19. *Trinidad Chronicle-News*, 3 July 1942.

HICKEN'S FUR BEARING TROUT

PHOTO BY R. E. MARBLE
BELTON, MONT.

ICEBERG LAKE

Published accounts and postcard depictions of furred trout, endowed by nature with a luxuriant hide to keep them warm in icy mountain streams and lakes, are found in Colorado, Wyoming, and Montana. This undated, but possible 1930 or 1940 example, is from Montana.

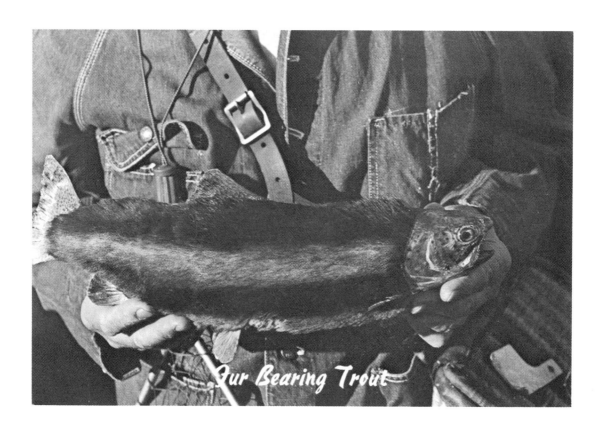

Fur Bearing Trout

3

The Men with Imagination: Tall-Tale Postcard Producers

I have previously outlined the substantial differences between eastern and western American concepts of humor, but in the case of postcards, and especially exaggerations, one must also consider European humor, for Europeans had a substantial headstart in the art of the picture postcard and they produced a plethora of what were intended to be humorous examples.

Often that intention has to be surmised because while European analogues and prototypes for photographic juxtapositions, montages of drawn materials with photographs, and incongruous contrasts were produced, they never approached the clear purpose of the tall-tale exaggeration as expressed on American postcards. Indeed, in some European models the point of the contrast or exaggeration is at best obscure.

A common theme for European comic cards is an abundance of children. The contexts and themes are universally obscure, clearing lacking the sense of humor and skill of American analogues. In these two typical examples, the perspective is bad and the thrust of the humor is difficult—if not impossible—to grasp. Both of these cards are from the same publisher, but are identified only with the label "Series 457."

In these two matched European cards, frogs have been enlarged and clothed like human beings, but no humorous theme other than the apparent inappropriateness of mountain-climbing frogs has been developed.

Robbins in the tree tops
Blossoms in the grass,
Green things agrowing,
Everywhere you pass.

Greetings from Otisfield

605-2

To my Valentine

On Wings of Love.

European and English postcards were frequently produced for an American market, but where the production was not an American development, any exaggeration remained a matter of whimsy rather than tall-tale surprise. The first of this set of three is identified only by the publisher's number 608-2, and the third bears no identifying mark whatever, but the second card is one produced by the famous Raphael Tuck and Sons, Series number 10, "Love Missives." Today such cards are in great demand by collectors.

Of this same genre, Frank Staff, in his study of the history of the picture postcard, *The Picture Postcard & Its Origin*, comments:

> Comic cards were of course also imported from the Continent, especially those which showed scenes of flirting and courting, but one type in particular for some peculiar reason was much in demand. This type showed groups of babies and small children usually with very little clothing, dressed in only their vests and often in the nude, and always posed in a variety of extraordinary postures. They were always depicted doing the same things together, such as performing in a band concert, washing and laundering, crowded in a motor-car together, or packed tightly in an airship. They would be shown as the hearts of cabbages in a field, and again, being gathered up and delivered as ordered. They were made to portray every sort of whim and occasion—even one entitled "A Public Sitting," when they are all shown sitting on their potties.
>
> These cards were usually in colour and, by photo-montage, actual photographs of babies were superimposed over drawings.
>
> This technique of photo-montage, whereby photographs were superimposed upon others, enabled many striking and extraordinary subjects to be shown.[20]

I find it reassuring that Staff is as mystified by the proported humor of these European tall-tale cards as I am. It might be mentioned, however, that putting the faces of children on cabbages *is* perfectly logical, for it reflects the story often told European children that babies are actually found in the cabbage patch.

The phenomenon we are dealing with here, photographic exaggeration for a clearly humorous effect, is distinctly American. Furthermore, while tall-tale cards were being produced all over the country, from coast to coast, east to west, the clear preponderance of the producers, as I have previously mentioned, was in the central part of the United States, on the Plains and prairies.

Furthermore, a plotting of the localities from which the cards in my collection were sent (as determined from the postmark) and to which they were sent (as determined from the addresses) indicate that this same geographical region was also the primary market for tall-tale postcards.

In previous studies of Plains-prairie tall tales,[21] I have suggested that the preeminence of tall tales in this region could have resulted from the extreme geographical conditions encountered there by settlers, and I suspect that it is that influence that carries on in the tall-tale postcard well into the late years of settlement or east of the Missouri well after the period of initial migration and settlement.

A brief look at a list of postcard photographers and publishers also shows clearly that the most talented and imaginative of them were operating within this same area. However, it is exceedingly difficult to find out much about these men who made the postcards; their art and skills were little recognized by the people who record such things while the artists are working. Indeed, aside from their rich imaginations and photographic skills, they were probably little more than ordinary, small-town shopkeepers, perhaps regarded as a bit eccentric because of their interest in photography and their choice of subjects.

The publishers and photographers are as follows:

Conard

More can be learned about F. D. Conard of Garden City, Kansas, than about all of the other photographers of his stripe, mostly because his period of activity was so much later than those of his colleagues. Conard began his work in 1935, about the same time he became owner and operator of a radio station, KIUL, in Garden City. A news item in the *Wichita Eagle* fortunately records for us the bizarre motivations of Conard and the history of his postcard work:

> The idea, Conrad reports, came to him after a flight of grasshoppers three years ago. "They came down into Garden City attracted by the lights and it was impossible to fill an automobile tank at filling stations that night.
>
> "I went home to sleep, but awoke at 3 a.m. and all I could think about was grasshoppers. By morning I had the idea of having fun with the grasshoppers, and took my pictures and superimposed the grasshoppers with humans.
>
> "I didn't do it for adverse impressions of Kansas, but as an exaggerated joke. I made four different cards and distributed them in town. They sold like hot cakes."
>
> Conard, native of Missouri, came to Kansas 54 years ago as a baby of six months. He lived in Rush County at La Crosse and became a photographer, moving in his youth to Colorado Springs. He has been in Garden City since 1914.
>
> "The first year I made ten different cards and sold 60,000, Kansans and tourists becoming customers," Conard reported. "Last year I had twenty subjects and sold 225,000, and this year my forty subjects have sold 350,000."

20. Frank Staff, *The Picture Postcard & Its Origins* (Frederick A. Praeger: New York, 1966), 74.
21. Notably *Shingling the Fog and Other Plains Lies* (Swallow Press: Chicago, 1972), *Treasury of Nebraska Pioneer Folklore* (University of Nebraska Press: Lincoln, 1966), and *Catfish at the Pump*, unpublished manuscript.

The year he started his "Munchausen" cards he purchased KIUL. The work keeps him busy, but he prefers the card distribution to radio.

"I guess the hometown folks liked the cards. They've bought 27,800 at Garden City," he commented. "A filling station at Geneva, Colorado, is another good customer, they've sold 6,700 in a season."[22]

Conard's cards clearly show the impact of the grasshopper experience; almost all of his cards deal with gigantic hoppers. A few, however, deal with another formidable Kansas varmint, the jackrabbit. Conard's work was average in terms of the action he managed to communicate with static photography and the skill shown in the production ranged from fair to good, but in no case were his efforts trite renderings of the earlier tall-tale postcards.

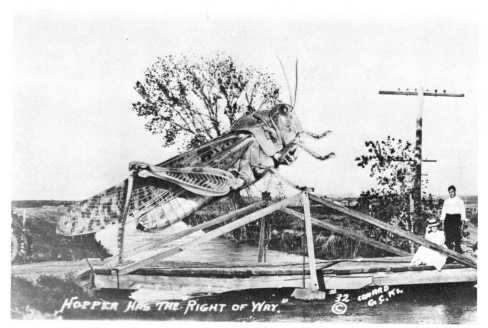

F. D. Conard's themes were of only two types, very common Plains phenomena, grasshoppers and rabbits. He produced his postcards during the late 1930s, and is therefore clearly outside of the heyday of tall-tale postcard production. His skills were uneven, as is the case here where a threatening grasshopper is ignored by a couple out for a stroll.

22. *Wichita Eagle*, 11 August 1938.

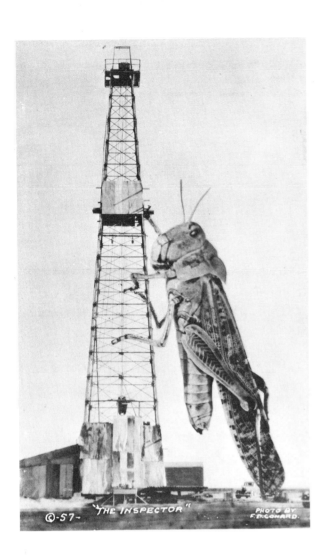

"THE INSPECTOR"

PHOTO BY
F.D.CONARD

©-57-

Here Conard took advantage of two common topics of 1930 Plains conversation—new discoveries of oil (and a promise of new wealth) and the grasshopper (and promise of new economic disaster).

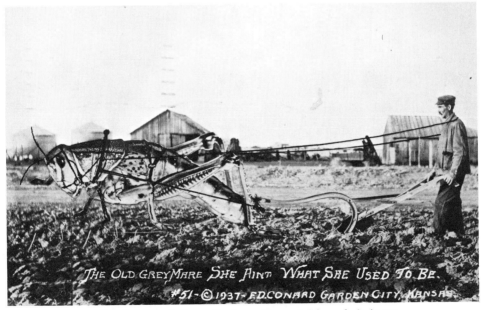

THE OLD GREY MARE SHE AINT WHAT SHE USED TO BE.
#51-©1937-F.D.CONARD GARDEN CITY, KANSAS.

This is one of Conard's late efforts (although it is undated, it bears the series number 57 while the illustrated cards immediately preceeding are numbers 55 and 32, for example), and it is one of his best. The imposition of the harness on the grasshopper posed special problems for the photographer and he handled them well.

A WINTERS SUPPLY.
#50-©-1937-
PHOTO BY
F.D.CONARD.

This precise theme can be seen in a number of other cards, including some by Martin, which pre-date this Conard card by some twenty-five years.

Archer King

It is only by remarkable chance that anything at all is known about another master tall-tale postcard craftsman, Archer King, of Table Rock, Nebraska. I once published an article on Plains tall tales in an Omaha, Nebraska, Sunday magazine and several of my tall-tale postcards were used as illustrations. King's daughter, Laura Turnbull, still of Table Rock, recognized the photographs and contacted me about them. She has since been kind enough to provide me with information about King and copies of his work.

King was born August 26, 1876, near Shubert, Nebraska, and died in February of 1944 at Pawnee City, Nebraska. His rich imagination extended well beyond the darkroom. Borrowing bits and pieces from farm machinery around the area as well as parts from washing machines, he fashioned at least four automobiles, from scratch, in a day when Detroit manufactuers were not altogether certain of the future of their baby. With his inventiveness, his sense of humor, four automobiles, and his dashing good looks, he must have been the heartthrob of many southeastern Nebraska girls in the early part of the century.

Archer King, a tall-tale photographer from Table Rock, Nebraska, also experimented with the new idea of the automobile. These four photos, the second dated 1907, show King with three autos of his own manufacture. Photographs courtesy of King's daughter, Laura Turnbull.

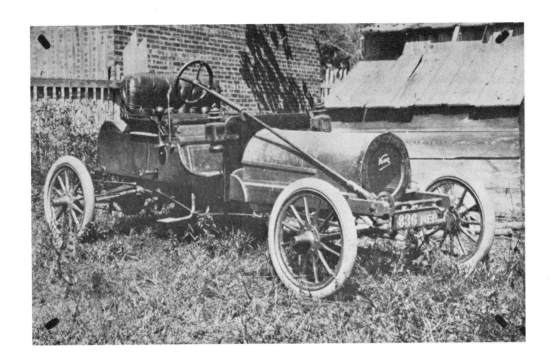

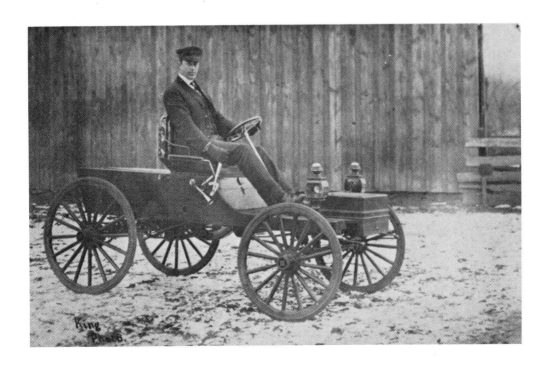

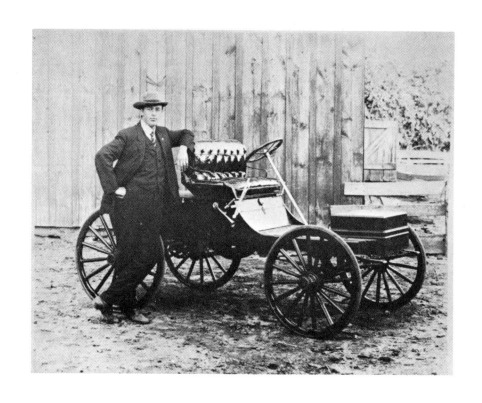

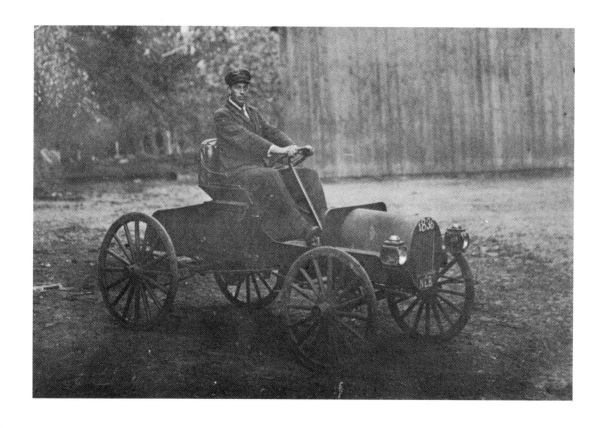

Laura Turnbull also provided several doctored photographs hitherto unpublished that show some of King's experimentation in other forms of photo- graphic trickery other than tall-tale exaggerations (See photographs).

King produced postcards featuring simple photographic juxtaposition as well as the exaggerated tall-tale type. The first of these three is merely a placement of one picture atop another. The second involves some playful manipulation, with the addition of wings to his model, and the enlargement of the corn. The third is a very effective splice with exaggeration. None of the three is dated.

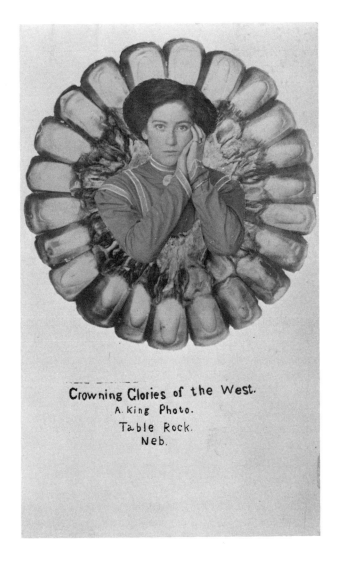

Crowning Glories of the West.
A. King Photo.
Table Rock.
Neb.

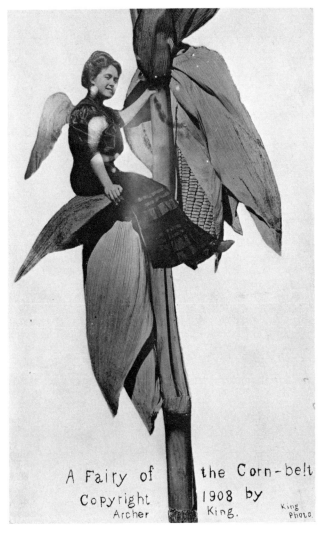

A Fairy of the Corn-belt
Copyright 1908 by
Archer King.
King Photo.

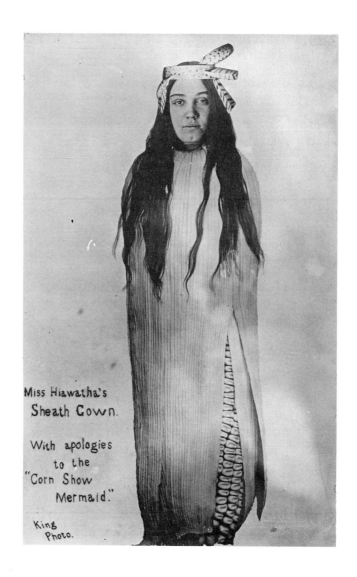

Miss Hiawatha's
Sheath Gown.

With apologies
to the
"Corn Show
Mermaid."

King
Photo.

King obviously enjoyed playing with his photographic flexibility. This paste-up, borrowed from Laura Turnbull, was never published as a postcard. The leaping figure is King himself.

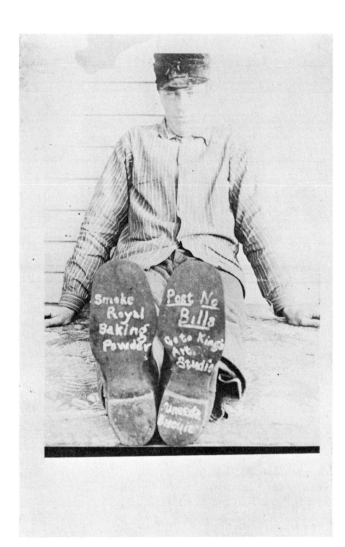

Again King uses himself as a model. This is not a photographic juxtaposition but is another example of King's sense of humor and interest in using photography as a device for creating comic effects.

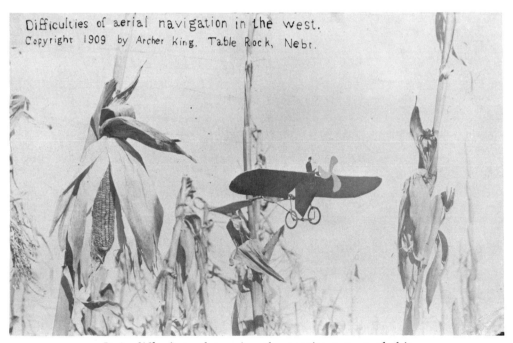

It is difficult to determine the precise nature of this photographic trick, but rather than being a darkroom juxtaposition, it appears to be a photograph of a *model* airplane in a cornfield, a cut-out photograph of Archer King at the controls! The photo was never published before.

In his files King left us both the "before" and the "after" photographs of this horse to show us what he could do with some artfully applied pencil lines on a negative.

King showed a clear preference for photos with corn. While they often lack the dramatic action that we will later see in the work of Johnson or Martin, these King photographs do display imagination and great skill in cutting and splicing the photos.

King produced a large number of different postcards. The popularity of his work can be determined from the fact that even though he was working out of a modest studio in remote Table Rock, Nebraska, his cards can be found in antique stores and private collections throughout the country today.

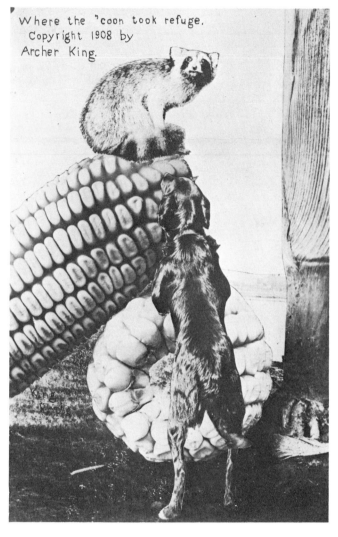

Where the 'coon took refuge.
Copyright 1908 by
Archer King.

Of King's tall-tale cards, this is the one found most often today, probably because its fine perspective and reproduction made it especially popular when it was first marketed in 1908.

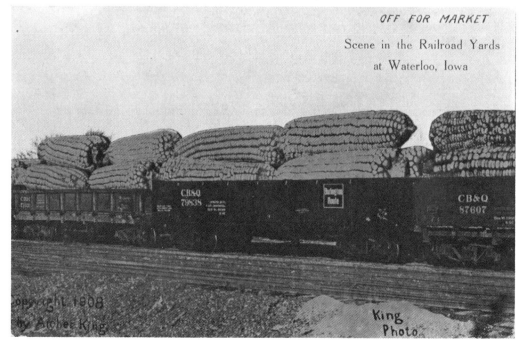

OFF FOR MARKET

Scene in the Railroad Yards
at Waterloo, Iowa

William Martin

Little is known of William Martin except that he operated out of Ottowa, Kansas, and his cards were distributed and published by the North American Post Card Company and the Canadian Post Card Company.

Martin's cards are by far the best and most varied of all tall-tale postcards, without question. His topics are most diversified; indeed, it would be difficult to say that he seemed to prefer any one subject more than another, treating vegetables, animals of all sorts, and so forth. His cards inevitably show graphic action and imagination. Furthermore, his inventory was the largest of all the freak postcard photographers. Variations, as in the two cards entitled "Salted" as pictured—(not only is the lettering different but the position of the rabbit has changed in relation to the background [note the position of the bunny's nose in comparison to the saplings]) suggest that the cards must have gone through several printings, a reflection of their popularity. This card type is also the one most frequently encountered on the antique card market today.

"Salted" was one of William Martin's most popular productions and went through several printings, as can be seen by the very slight differences between these two examples: the positions of the captions, the location of the rabbit's nose in relationship to the nearby sapling, and the differing lettering.

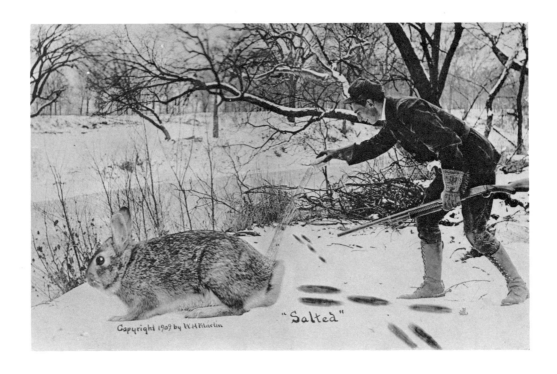

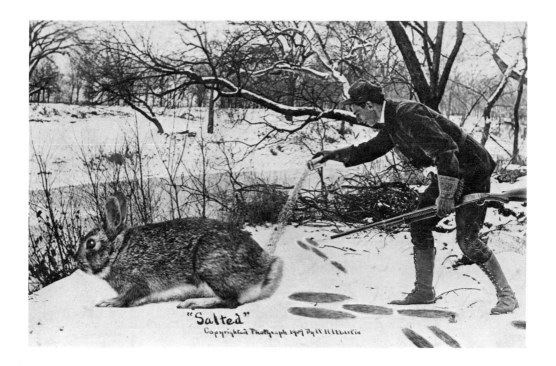

"Salted"
Copyrighted Photograph 1909 By N H Martin

Some of Martin's cards might have been so impressive, in fact, that they were plagarized by other card distributors, printed, and dumped on the market. It is possible, of course, that the seconds are actually second printings by Martin, but the sloppy work is not at all characteristic of Martin's careful and precise work, and it does seem unlikely for Martin to have covered over his original copyright notice. The copies, incidentally, while displaying the copyright symbol do not carry the complete information required for a legitimate and valid copyright notice.

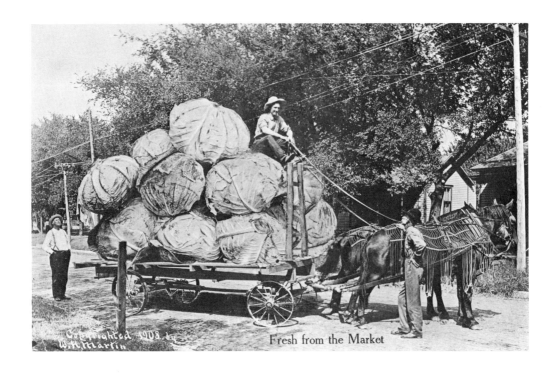

Fresh from the Market

The contrasts between these two cards, the lack of
clarity in the second example, the removal of Martin's
name, and the addition of the copyright signature sug-
gest that the second postcard might not have been
produced by Martin's studio, but instead by a para-
sitic studio.

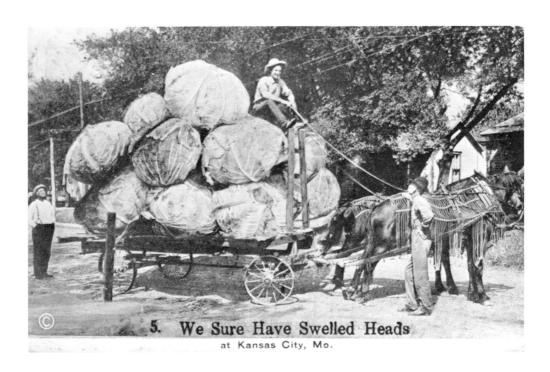

5. We Sure Have Swelled Heads
at Kansas City, Mo.

A series of cards that are clearly William H. Martin's work have had the original copyright information obscured with notices tying them to Bob Burns's famous Ozark radio family of the 1930's, again a possible case of plagarism in the postcard market. The style is unmistakably Martin's and in two cases in my collection, the Bob Burns cards have Martin parallels.

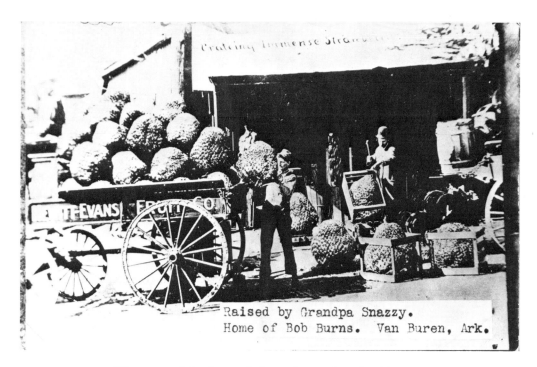

Raised by Grandpa Snazzy.
Home of Bob Burns. Van Buren, Ark.

These two Martin cards have been altered with new captions linking them to Bob Burns popular radio program. The resultant obliteration of Martin's identification suggests that the cards were plagarized by another publisher.

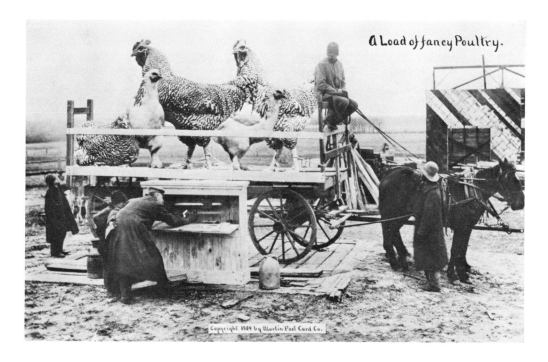

A Load of fancy Poultry.

The Martin postcard, as mentioned, showed action and excitement, a true sign of the master photographer. The bald-headed man pouring water on his head in the card bearing the legend "The Bass I Caught" (see photo), presumably nearly overcome by the excitement of the catch, appears in a number of Martin cards.

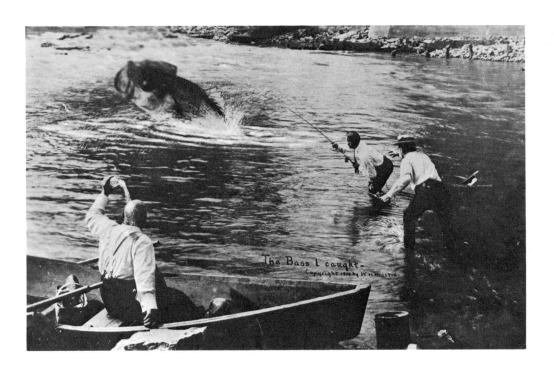

The bald-headed man in these two Martin cards is shown in central, active roles. Could he be Martin himself? The two cards were copyrighted in 1909.

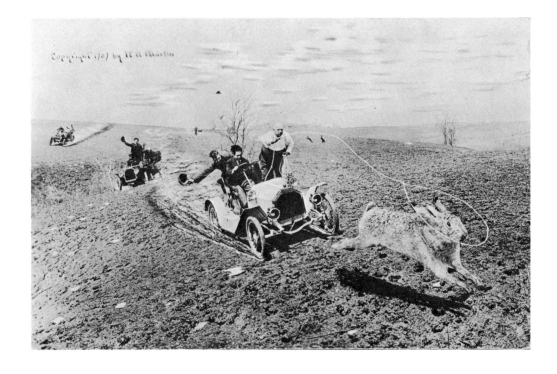

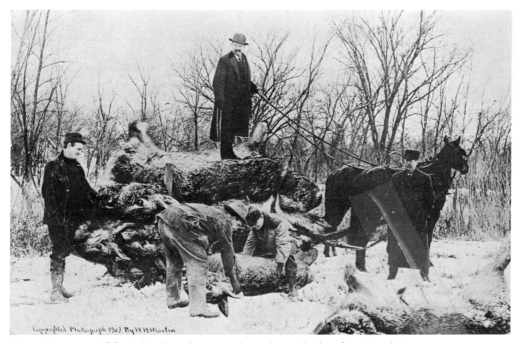

No tall-tale photographer showed the degree of ingenuity that Martin did in depicting unlikely actions. Here he does not simply show huge rabbits—but has his models loading them onto a sleigh. Published in 1909.

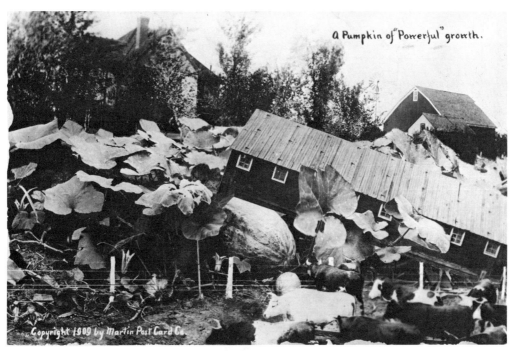

Martin's pumpkins do not simply grow big. In growing, they disrupt farms and lift houses from their foundations. This card too was published in 1909.

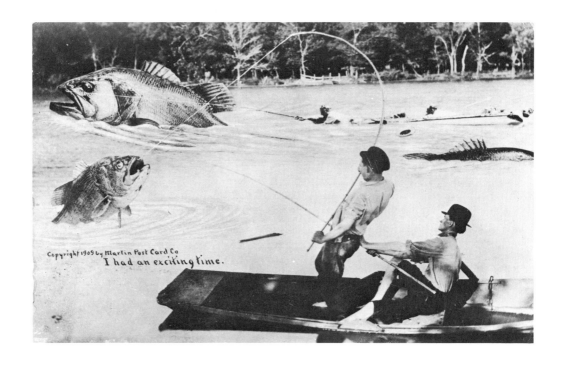

On the other hand, Martin also treated more conventional and popular themes in effective manner. These two postcards, both from 1909, also show Martin's mastery of the understatement in his caption writing.

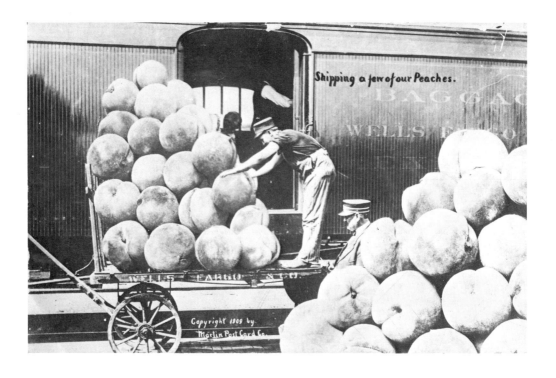

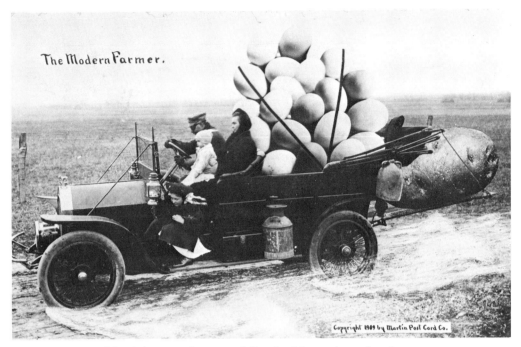

The Modern Farmer.

Copyright 1909 by Martin Post Card Co.

Martin's use of automobiles in his cards make them especially attractive and expensive on the antique market today. The autos must have made the postcards more interesting and marketable in a world where the auto was even newer than photography and the postcard.

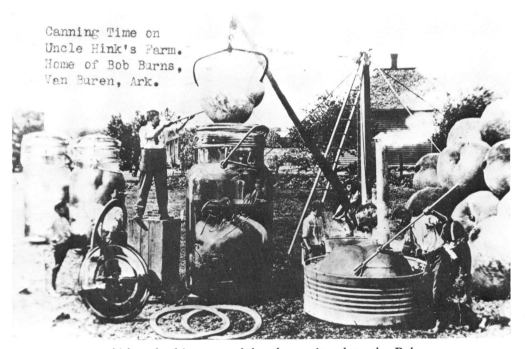

Canning Time on
Uncle Hink's Farm.
Home of Bob Burns,
Van Buren, Ark.

Although this postcard has been altered to the Bob Burns model, it is a Martin photograph and shows the fine detail of his work. The relative sizes are well matched, the perspective is perfect, and the various elements have been integrated into a convincing unit. Courtesy of Mrs. Cecil Schmitt.

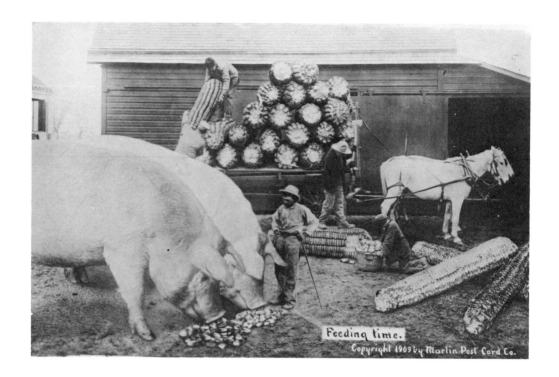

Feeding time.
Copyright 1909 by Martin Post Card Co.

Another feature of Martin's cards that make them classical examples of the genre is their intricacy. Note in these two examples the number of figures that have been blended together to create the numerous motifs of action and form. The figure standing at the head of the hog can be also seen in a number of Martin's other cards.

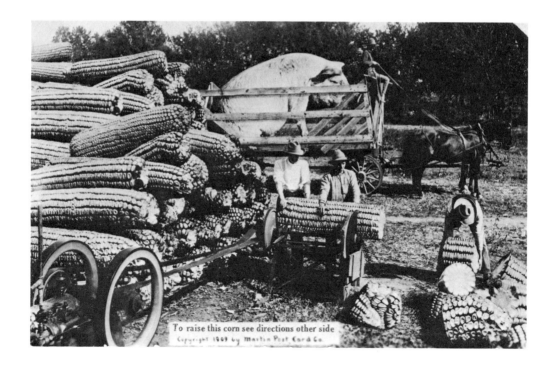

To raise this corn see directions other side
Copyright 1909 by Martin Post Card Co.

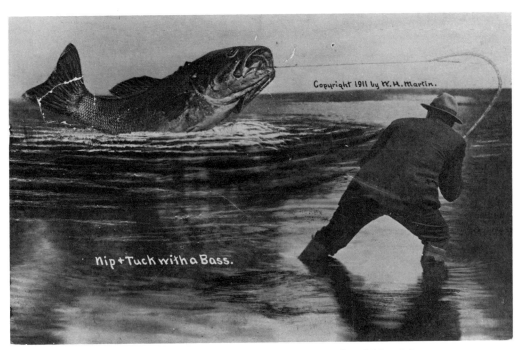

This fishing scene is an excellent example of Martin's ability to inject action into his postcard photographs. While Mitchell has two oranges sitting stolidly on a railcar, Martin has a scene of near riot.

Martin also produced photographic postcards that featured reenactments of historical events or popular scenes, like the one entitled, "Perils of the Plains, 1852."

This Martin shows an early interest in photographic manipulation for dramatic effect. Clearly, Martin was not on hand with his photographic equipment to capture a scene of frontier confrontation. This scene is a reenactment for the benefit of the lens—and the popular postcard market.

Although the card with the title, "Am Having Hard Luck" (see picture as shown), is not labelled as a Martin photograph, it carries all of his techniques and is like many of his that were adapted to other publishers' formats. It is without question the goriest of all tall-tale postcards.

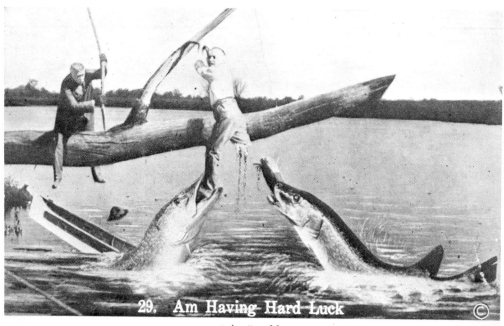

29. Am Having Hard Luck
at Joplin, Mo.

It is impossible to know if this card is indeed a Martin product, but it does display a good many of the characteristics common to Martin cards—extreme action, careful techniques, and accurate joining of the two pictures.

Alfred Stanley Johnson, Jr.

Alfred S. Johnson was second in the production of tall-tale postcards only to Martin, and then only in number. He was truly one of the masters of the short-lived art. Again, very little is known about him. He worked in his photographic studio in Waupun, Wisconsin, and then, according to my correspondence with Ervin F. Fletcher, current owner of the Johnson studio, under its new name, Fletcher Studio, he went to California around 1935, "where he was very instrumental in developing one of the first direct color processes."

Johnson's photographs, like Martin's, showed rich action and precision in cutting and pasting. The effect is always striking.

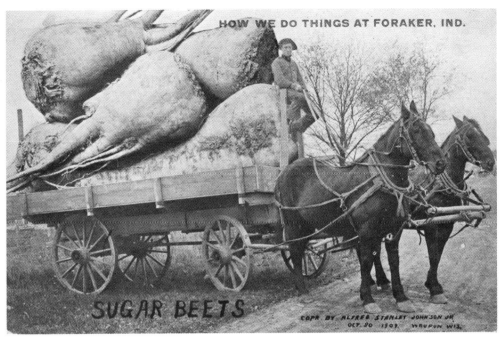

SUGAR BEETS

COPR. BY ALFRED STANLEY JOHNSON JR.
OCT. 30 1909. WAUPUN WIS.

Alfred Stanley Johnson, Jr., like William Martin, dealt with a wide range of topics in his exaggerations. He was, for example, the only photographer to deal with the unlikely topic of sugar beets!

Perhaps because of his location in Waupun, Wisconsin, A. S. Johnson produced a large proportion of cards dealing with fishing themes. Like Martin, Johnson developed action in his postcards that sometimes approached uncontrolled violence. Johnson's productive period comes a few years later than Martin's or King's. These cards were copyrighted between 1910 and 1913.

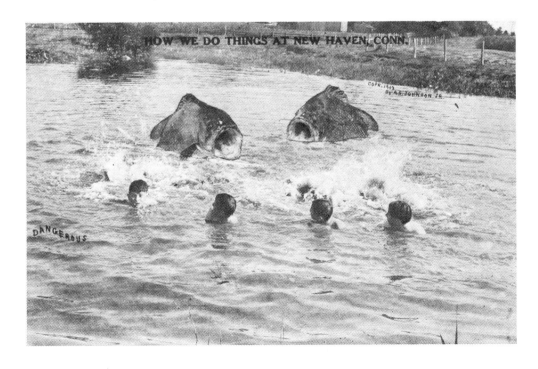

HOW WE DO THINGS AT NEW HAVEN, CONN.

COPR. 1913
BY A.S. JOHNSON JR.

DANGEROUS

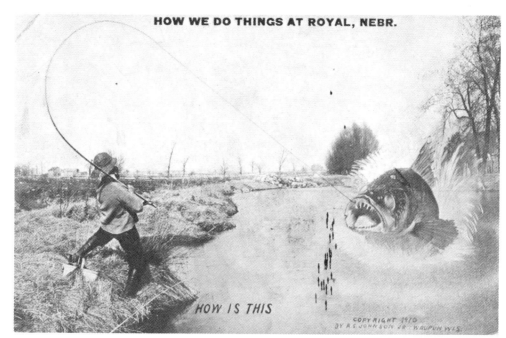

HOW WE DO THINGS AT ROYAL, NEBR.

HOW IS THIS

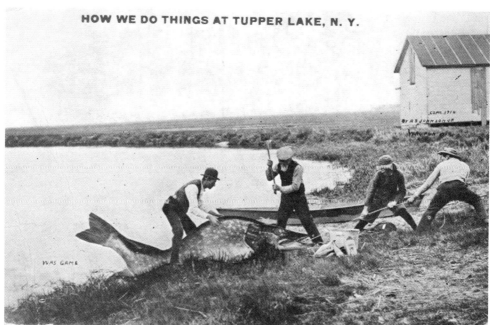

HOW WE DO THINGS AT TUPPER LAKE, N. Y.

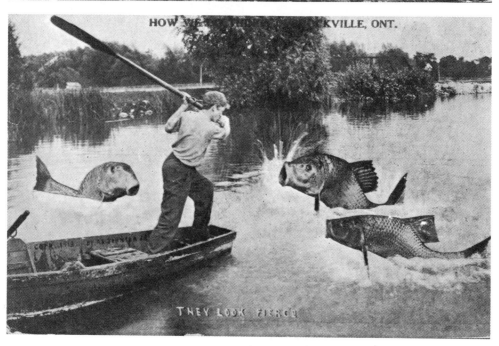

HOW WE DO THINGS AT BROCKVILLE, ONT.

THEY LOOK FIERCE

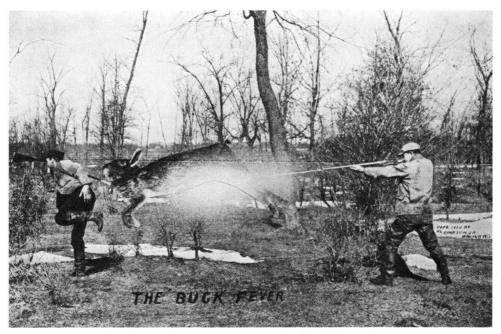

THE BUCK FEVER

Hunting cards are less common in the Johnson inventory, but show the same kind of dramatic action. This card was copyrighted in 1910.

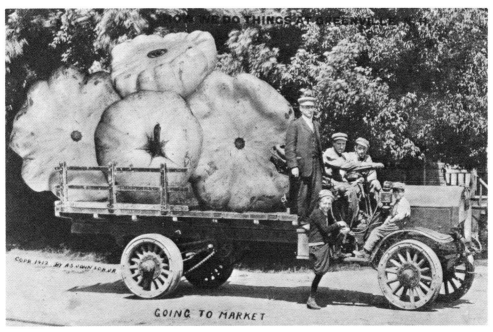

GOING TO MARKET

Johnson doted on the unusual. He preferred unlikely scenes, improbable captions, or rare fruits or vegetables—as in this case of squash. Even though the picture is a conventional tall-tale scene, the kind of produce is not.

In other scenes with more common produce, Johnson imposed on the scene unlikely harvesting or preserving activities to dramatize the enormous size of the crop.

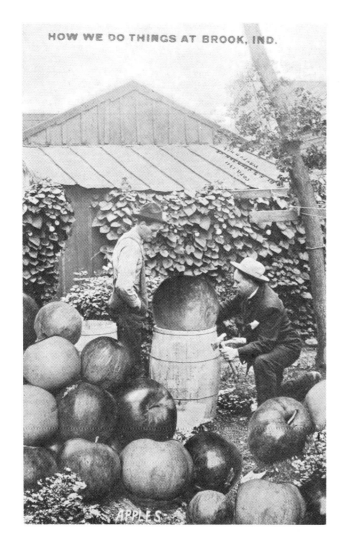

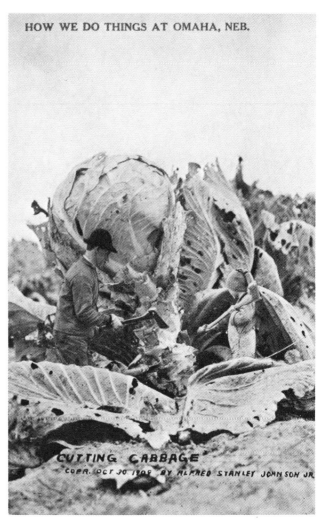

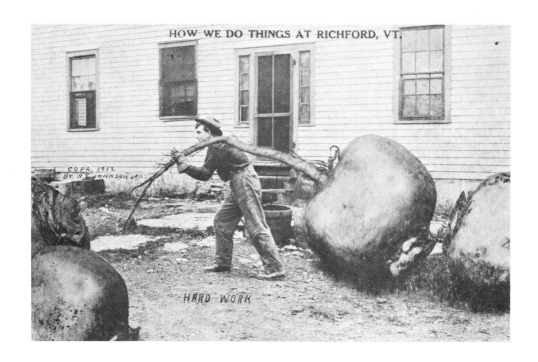

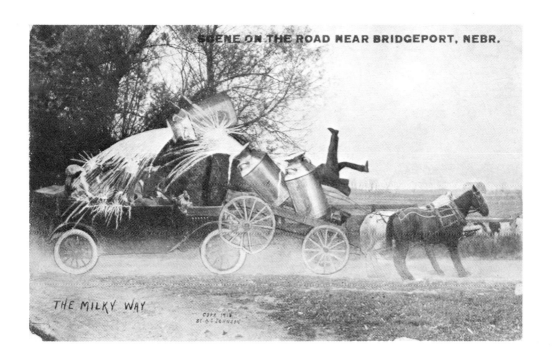

SCENE ON THE ROAD NEAR BRIDGEPORT, NEBR.

THE MILKY WAY

Of all tall-tale postcard producers, only Johnson attempted to develop the action of a scene to the point of cataclysmic collision. He has obviously had trouble with the effect of the horses (which, along with the vehicles, are the same in both pictures), but he had unusual success with drawing in the spilled milk.

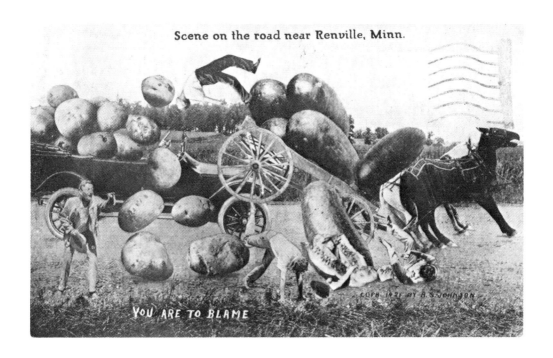

Scene on the road near Renville, Minn.

YOU ARE TO BLAME

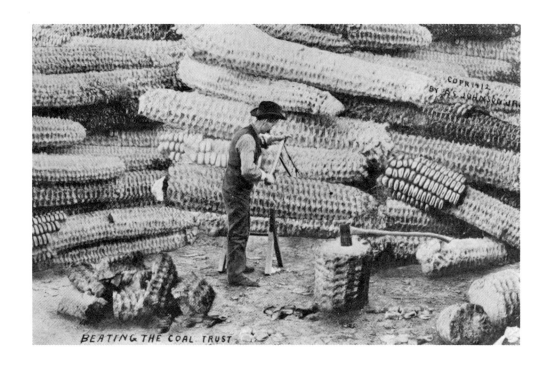

BEATING THE COAL TRUST

Johnson's picture composition, like Martin's fills the postcard format, the colossal clutter enhancing the effect of the gigantic cobs and corn in these two cards, copyrighted in 1912.

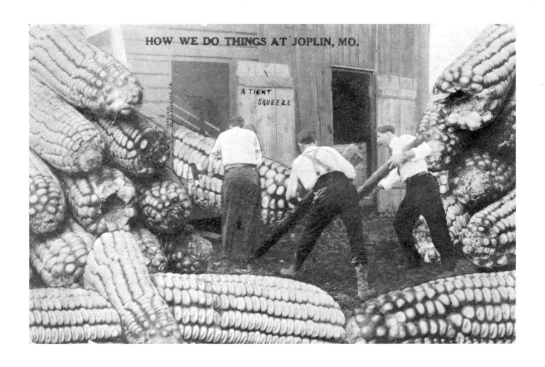

HOW WE DO THINGS AT JOPLIN, MO.

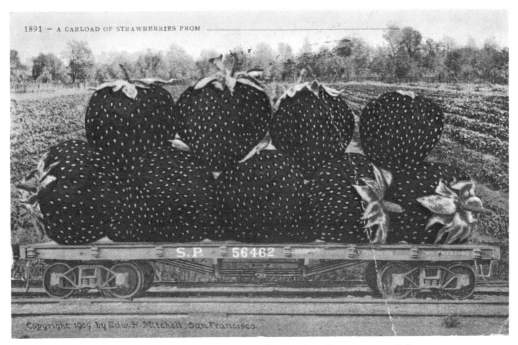

S.P. 56462

Copyright 1909 by Edw. H. Mitchell, San Francisco.

Compare for a moment the kind of action presented in Johnson's cards with the standard style of one of the other popular producers of tall-tale postcards, Edward Mitchell. There really is no comparison!

Johnson, more than any other tall-tale postcard photographer, used children as his subjects—not to exaggerate even further the size of the produce, but to make the scenes more appealing on the market. Even at the turn of the century, children and animals were photographic favorites.

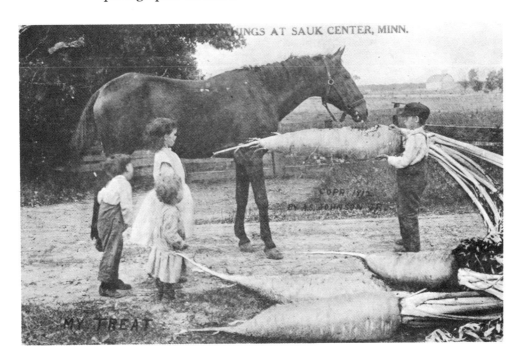

...THINGS AT SAUK CENTER, MINN.

MY TREAT

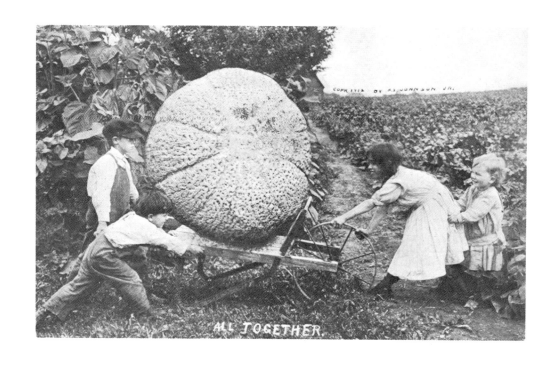

ALL TOGETHER.

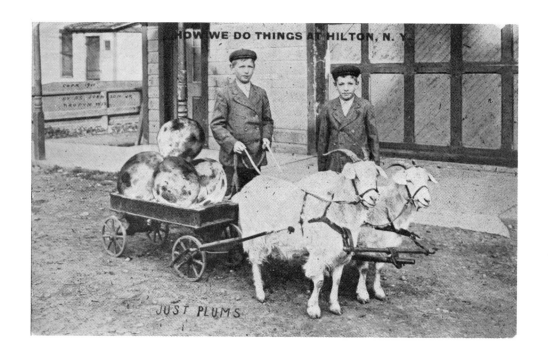

HOW WE DO THINGS AT HILTON, N. Y.

JUST PLUMS

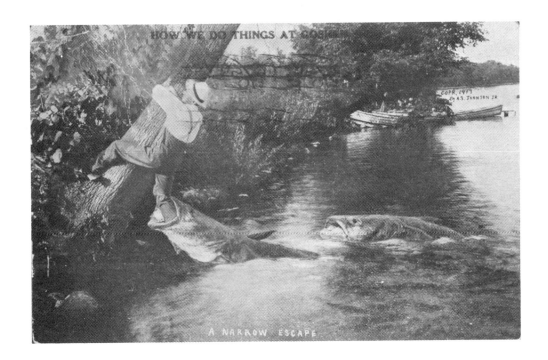

From common topics like fish to uncommon ones like blackberries, Alfred Stanley Johnson, Jr., was a master of exaggeration. In his works things are happening and the amazement of the viewer is focused not only on enormous size, but also on the difficulties such bounty brings along with it.

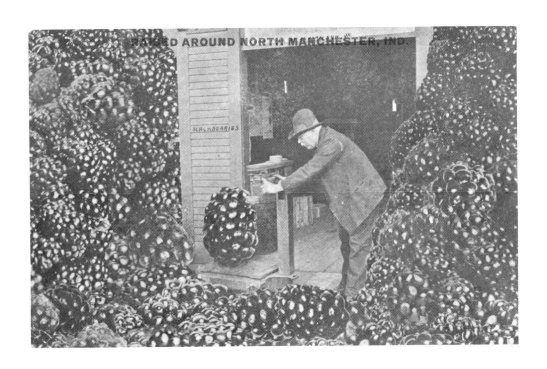

Many of Johnson's cards show great style with words. Whenever I come upon a Johnson card, the first thing I do is read his text. He is the absolute master of the understatement, the laconic smile, the wry pun. With two words, he can destroy me. Never again will the phrases "Father Works," "Boy Scouts," "Apple Butter," or "Some Ducks" (see photos of same) mean quite the same to me as they did before I became acquainted with Alfred Stanley Johnson, Jr.

If Johnson excelled in photographic and dramatic technique, his skill in writing captions for his photos was transcendent. In these two—his best—the caption completely ignores the incredible wonder of boulder-size potatoes or watermelon-size eggs and notes, in the first case, that the boys are scouts! The second is even more misdirected, answering only the viewer's question, "Why are *children* driving the wagon?"

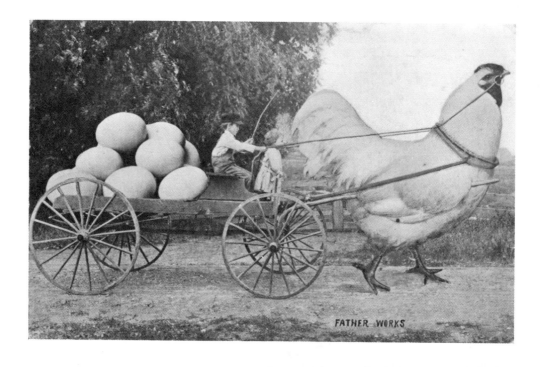

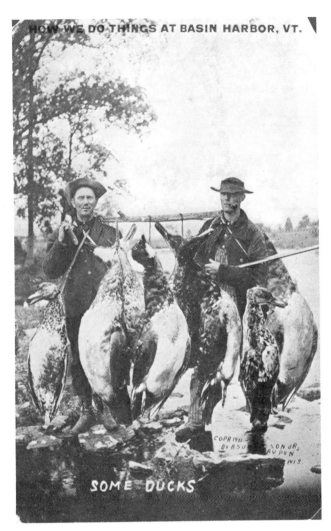

HOW WE DO THINGS AT BASIN HARBOR, VT.

SOME DUCKS

Johnson was also fond of the pun—witness "The Milky Way" above:—and he pursued that inclination in these two postcards. In the first, the reader cannot be sure whether "some ducks" means simply "a *few* ducks" or "*what* ducks!" The second is a little less subtle and is designed to evoke groans from the reader.

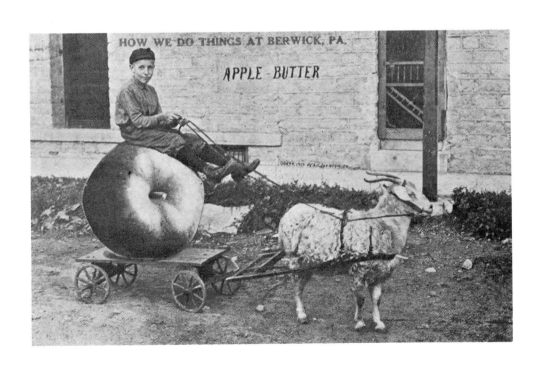

HOW WE DO THINGS AT BERWICK, PA.

APPLE-BUTTER

H. W. Brown

Nothing is known about Brown except that he operated out of Tifton, Georgia, and concentrated primarily on southern—and Georgia and Alabama—subjects.

H. W. Brown worked from Tifton, Georgia, and it is not surprising, therefore, that he used some themes not found among Plains inventors—for example, cotton.

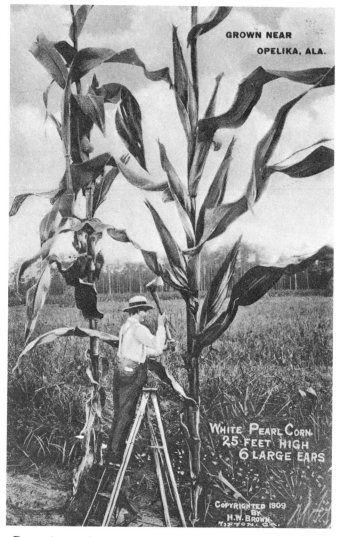

Brown's work is especially attractive because of the precise, extensive work that went into it. Most publishers were, for example, content to enlarge only an ear of corn, but Brown has gone through the tedious process of cutting and pasting the entire plant, as in this card, dated 1909.

122]

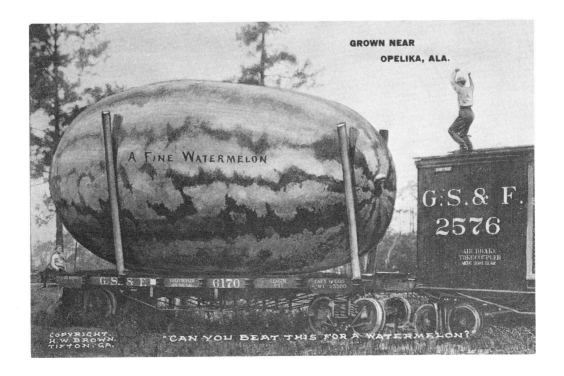

Brown has also employed ideas common to the tall-tale postcard tradition—here, for instance, the wagon-load or railroad carload of a single item of produce.

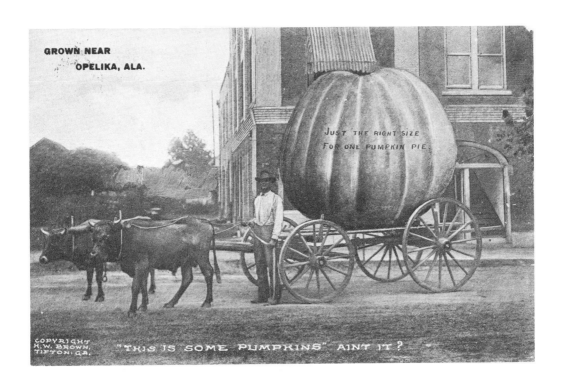

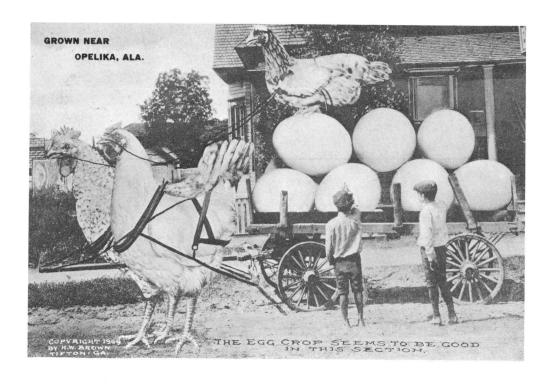

Brown could also take conventional exaggeration ideas and give them special intensity by, for example, using in these cards chickens to pull and drive a wagonload of huge eggs or by adding straight-faced labels of incredible weights to the watermelons.

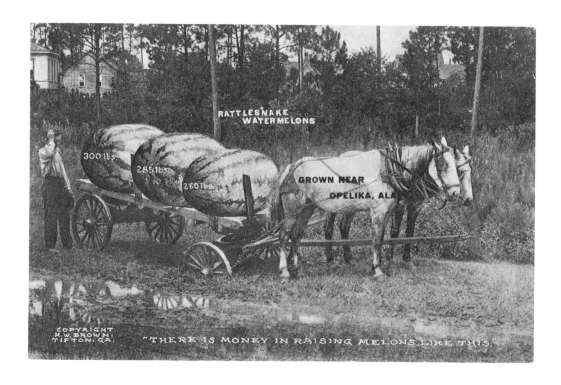

Oscar Erickson

Virtually nothing is known about Erickson, including the location of his studio, the Photo Art Shop, the name under which so many of his photographs were copyrighted.

Most of Erickson's pictures centered around exaggerated game, hunting, or fishing situations, but he also had other less effective produce photos too. The Erickson Photo Art series contains at least fifty pictures in all and is prized by collectors because the cards are numbered and clearly labeled.

Oscar Erickson's work, also appearing under the label "Photo Art Shop," was done primarily during the years 1909 and 1910. One can gauge the popularity of Erickson's postcards by the fact that they are still found in large numbers today in shoeboxes throughout the antique shopper's world. A substantial point in Erickson's favor was that he did not specify *where* the exaggerated produce or fish were supposed to occur. Note in these four fishing cards, for example, that the events could be happening anywhere—and therefore could be sold and purchased anywhere.

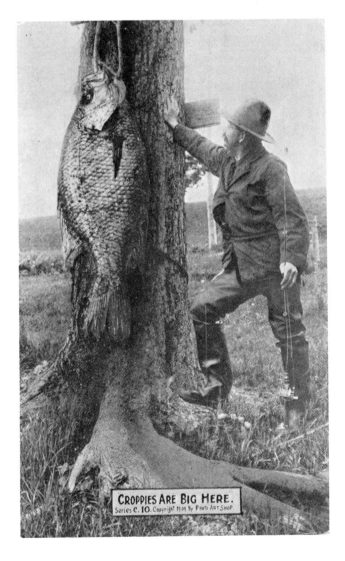

CROPPIES ARE BIG HERE.
Series C. 10. Copyright 1909 by Photo Art Shop.

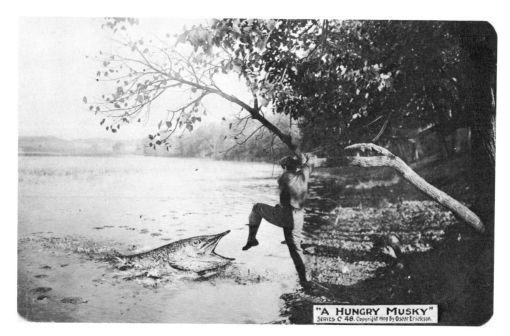

"A HUNGRY MUSKY"
SERIES C 48. Copyright 1909 By Oscar Erickson.

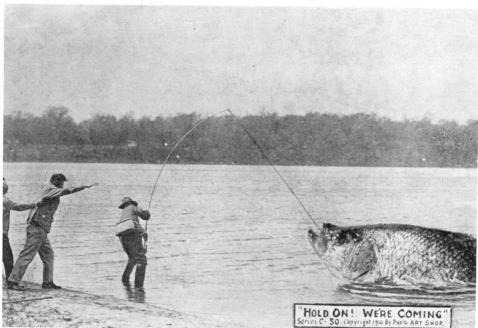

"HOLD ON! WE'RE COMING"
Series C· 50. Copyright 1910 By Photo Art Shop.

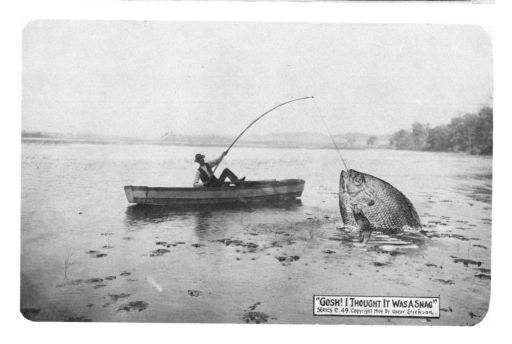

"GOSH! I THOUGHT IT WAS A SNAG"
SERIES C· 49. Copyright 1909 By Oscar Erickson.

Erickson also marketed a full range of hunting exaggerations, from cows to quail, from squirrels to rabbits. They too avoided restricted markets by bearing only the most general kind of labeling.

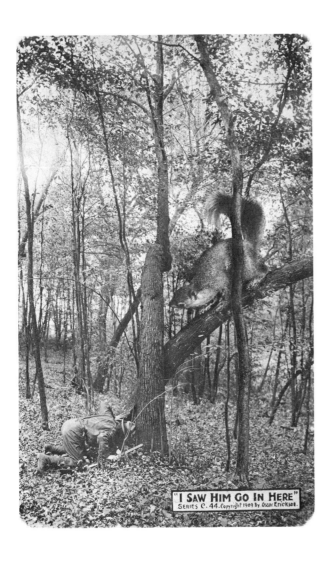

"I SAW HIM GO IN HERE"
SERIES C. 44. Copyright 1909 By Oscar Erickson.

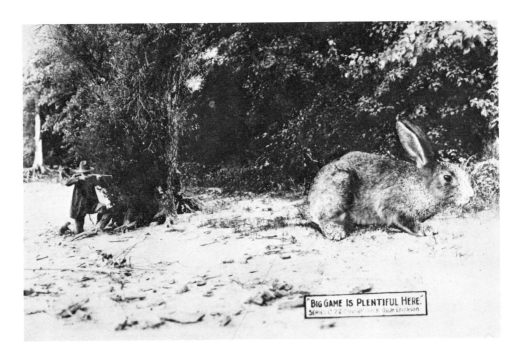

"BIG GAME IS PLENTIFUL HERE."
SERIES C 22 Copyright 1909 By Oscar Erickson.

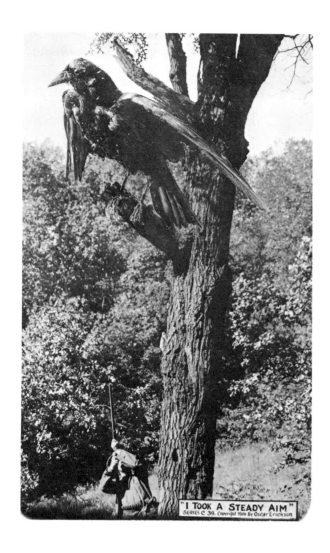

"I TOOK A STEADY AIM"
SERIES C 39. Copyright 1909 By Oscar Erickson.

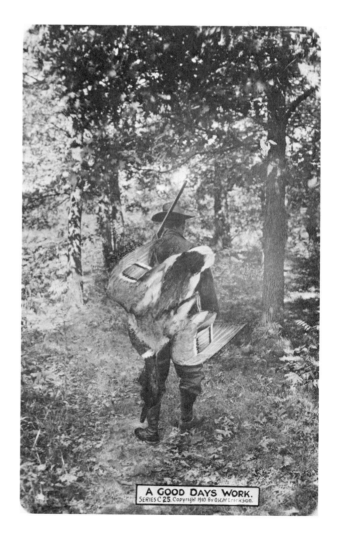

A GOOD DAYS WORK.
SERIES C 25. Copyright 1910 By Oscar Erickson.

128]

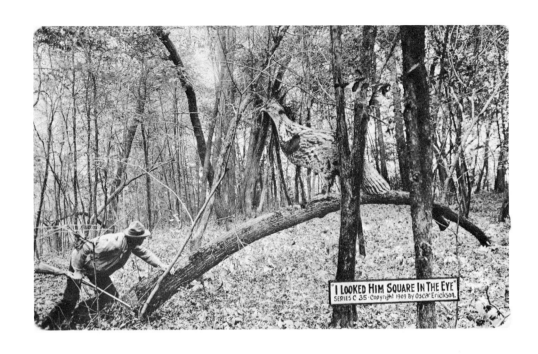

"I LOOKED HIM SQUARE IN THE EYE"
SERIES C 35 · Copyright 1909 By Oscar Erickson.

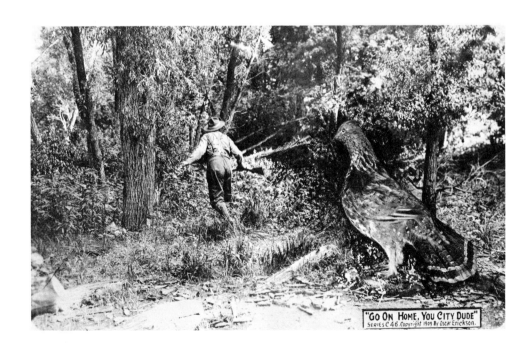

"GO ON HOME, YOU CITY DUDE"
SERIES C 46 Copyright 1909 By Oscar Erickson.

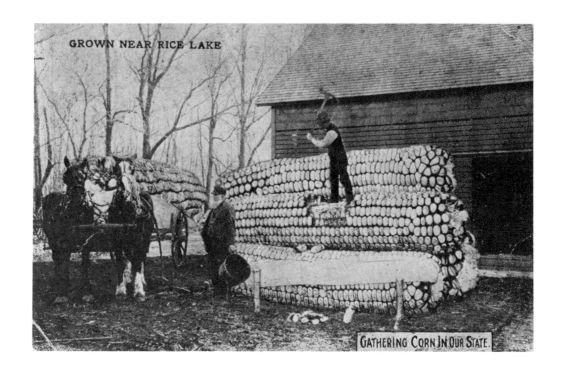

Erickson also used common exaggeration themes—here
the most common to be found, huge produce filling a
wagon or railcar.

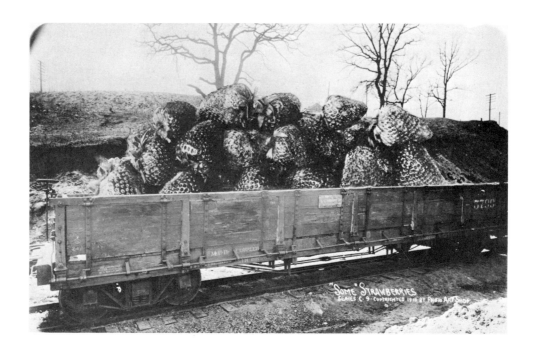

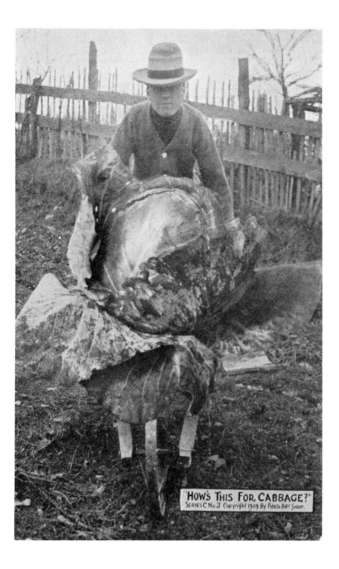

"HOW'S THIS FOR CABBAGE?"
Series C No. 3 Copyright 1909 By Photo Art Shop.

Even though this card, like so many of Erickson's, is dated 1909, it bears a low series number, C-3, and therefore is one of his earliest efforts.

Edward H. Mitchell

Mitchell published his cards through San Francisco. Collectors prize his work because they are carefully labeled and numbered and the color is always striking and well done. But, in all honesty, I have always been bewildered by the prices set on these cards—up to one dollar each—because they are without question among the dullest of the tall-tale cards that one can find. They almost inevitably show several pieces of huge fruits and vegetables resting on a railroad car seen flat on, lacking even the perspective of the bed of the car. In one example, the form of a human being can be seen standing rigid at the side of the car, but other than that there is no life, no excitement, no imagination whatsoever shown in Mitchell cards except for two. The cards in the Mitchell examples (see photos) labeled, "Old Maid's Honeymoon" and "A California Honeymoon" do show a life and interest very uncharacteristic of Mitchell's work, and for those he deserves full credit as a master tall-tale card publisher.

Mitchell cards were also sold in sets and folders, the only such marketing device I have encountered in tall-tale postcards.

The single most common producer of postcard series that are found in postcard albums from the first quarter of the century, and the single most common publisher encountered in antique shop postcard files today is Edward Mitchell of San Francisco. But the attraction of the postcards lay primarily in the importance of sending a postcard from a California vacation or the well-done tinting, for no cards show less imaginative work or action than Mitchell's. There is never any suggestion of movement and several dozens of his pictures show only the most modest variation from example to example.

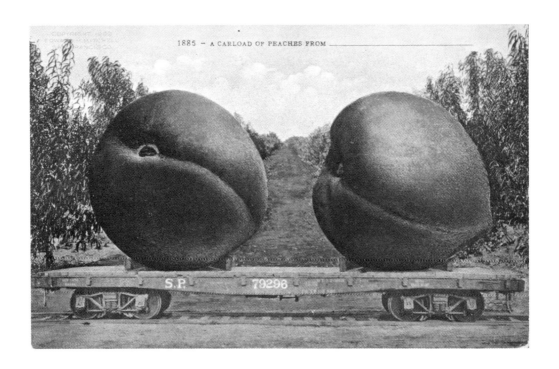

1885 — A CARLOAD OF PEACHES FROM _____

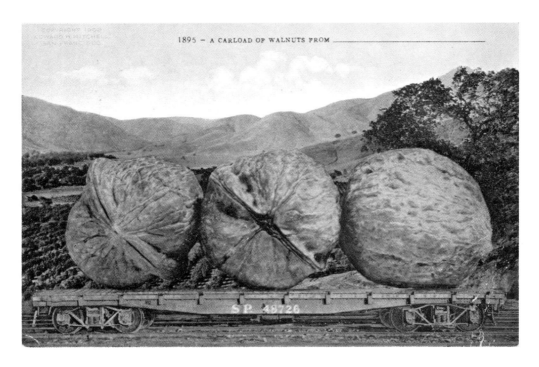

1895 — A CARLOAD OF WALNUTS FROM _____

132]

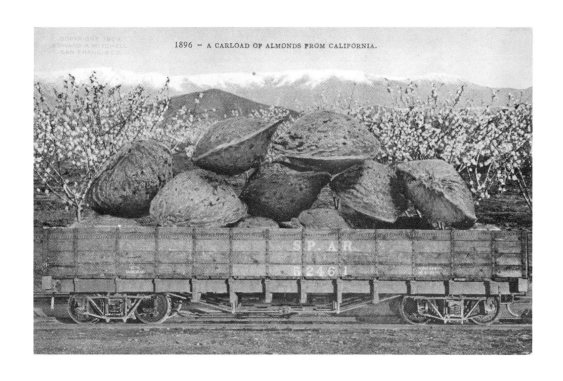

1896 – A CARLOAD OF ALMONDS FROM CALIFORNIA.

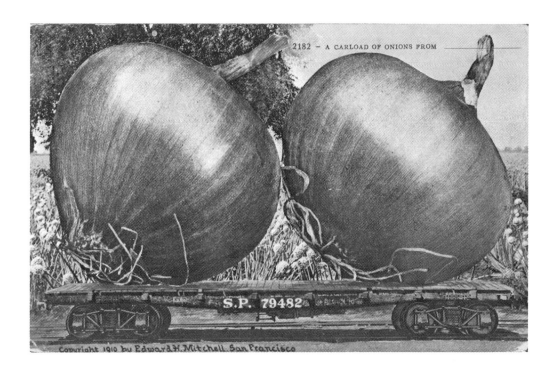

2182 – A CARLOAD OF ONIONS FROM _____

Copyright 1910 by Edward H. Mitchell, San Francisco

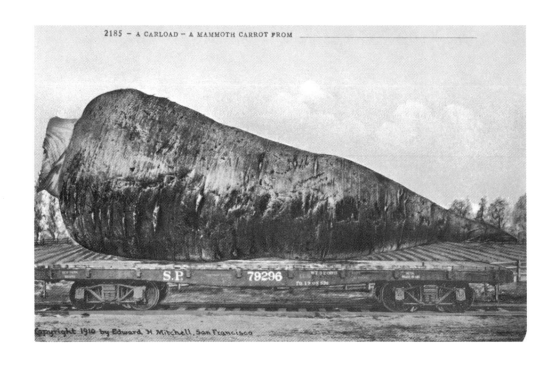

2185 — A CARLOAD — A MAMMOTH CARROT FROM _____

S.P. 79296

Copyright 1910 by Edward H. Mitchell, San Francisco

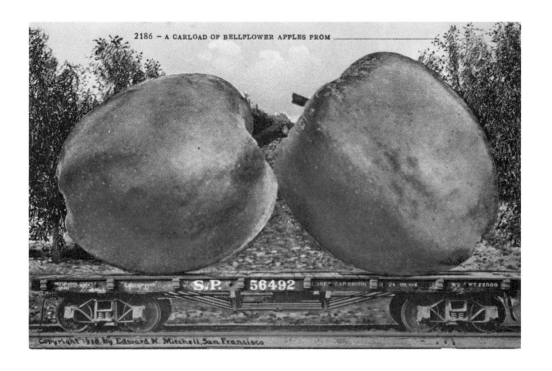

2186 — A CARLOAD OF BELLFLOWER APPLES FROM _____

S.P. 56492

Copyright 1910 by Edward H. Mitchell, San Francisco

The one marketing device that was apparently unique to Mitchell, however, was the sale of folders of ten or twelve exaggeration cards that could be bought and sent as a package or as individual mailings. Mitchell also made his cards suitable for a wide market by permitting the seller or sender to fill in the appropriate geographic name on each postcard.

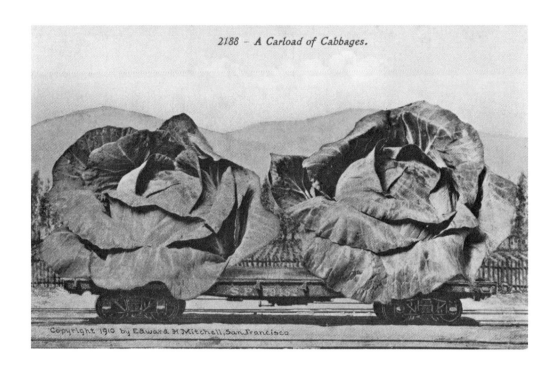

2188 – A Carload of Cabbages.

Copyright 1910 by Edward H. Mitchell, San Francisco

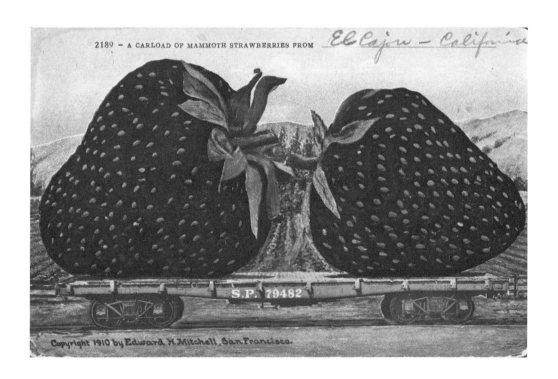

2189 – A CARLOAD OF MAMMOTH STRAWBERRIES FROM El Cajon – California

S.P. 29482

Copyright 1910 by Edward H. Mitchell, San Francisco

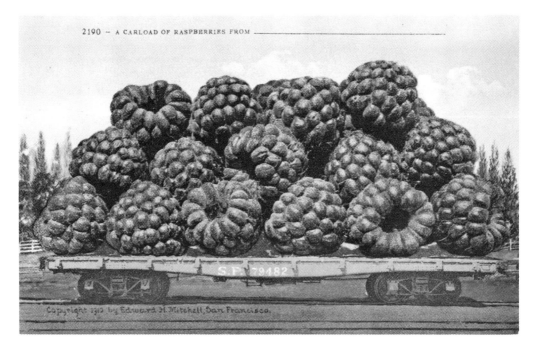

2190 - A CARLOAD OF RASPBERRIES FROM _____

Copyright 1910 by Edward H. Mitchell, San Francisco.

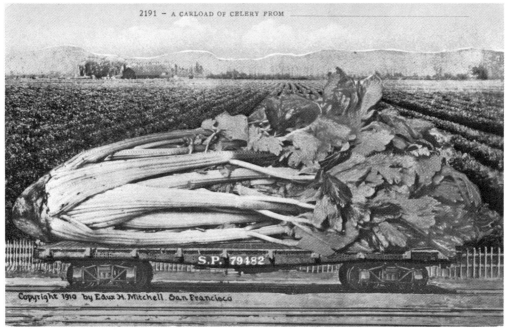

2191 - A CARLOAD OF CELERY FROM _____

S.P. 79482

Copyright 1910 by Edw. H. Mitchell, San Francisco

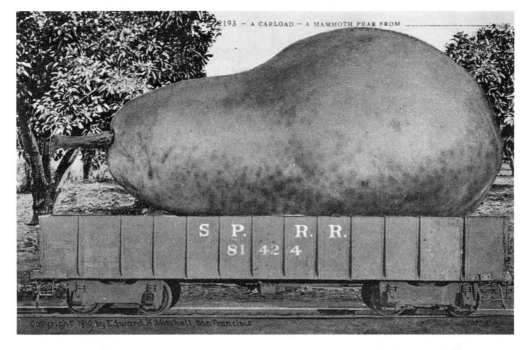

2193 - A CARLOAD - A MAMMOTH PEAR FROM _____

S. P. R. R.
81 42 4

Copyright 1910 by Edward H. Mitchell, San Francisco

2606
OLD MAID'S HONEYMOON.
COPYRIGHT BY
EDWARD H. MITCHELL
SAN FRANCISCO

The single most significant variation in Mitchell's large-fruit-on-the-railroad-car theme was this set of two cards using huge fruit as balloons—appropriately an apple for the joyous California honeymoon, a lemon for the old maid's honeymoon. Both of these cards are dated 1910, but all of Mitchell's efforts stem from 1909 to 1910.

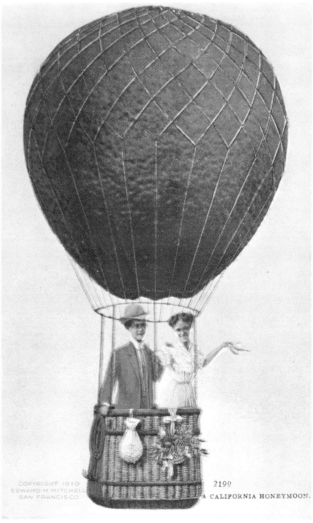

COPYRIGHT 1910
EDWARD H. MITCHELL
SAN FRANCISCO
2199
A CALIFORNIA HONEYMOON.

[137

In his haste to produce and market ever more cards for the burgeoning market, Mitchell sometimes failed to attain an appropriate adjustment of perspective between the two photographic items that were to be spliced together. The result is enough to cross the viewer's eyes!

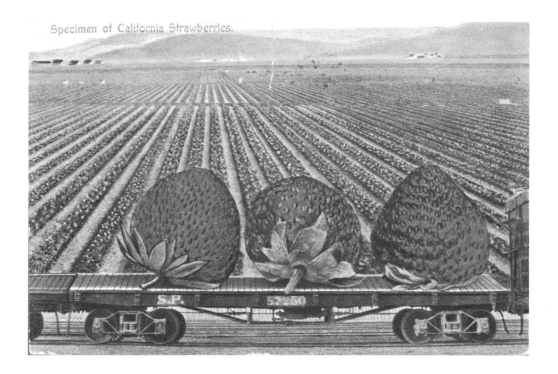

Specimen of California Strawberries.

Not only are Mitchell's cards, despite their continuing popularity, generally uninteresting and unimaginative, but some examples display eye-wrenching distortions in perspective. These two unfortunate samples are not dated, and the first has a slightly different coloration than the rest of Mitchell's photographs, so they may represent early efforts rather than mere sacrifices to economic expedience.

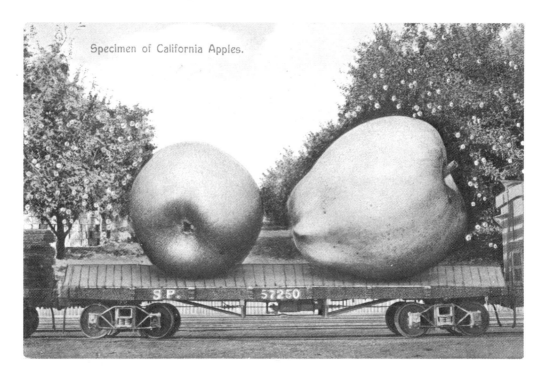

Specimen of California Apples.

M. L. Oakes

M. L. Oakes from North Yakima, Washington, is another favorite with collectors, but again the reasons for this are hard to understand. In contrast with Martin, Johnson, King, and Erickson, and like Mitchell, his cards are in color, but, also like Mitchell, Oakes's cards lack life and imagination. The color is at best blurry. In some Oakes cards the photographic reproduction is so bad that it is difficult to tell if the characters in the pictures have human faces. The cards entitled "Cabbage as grown in Washington" and "Expressing Washington Apples" (see photos) are essentially the same, only the fruit has been changed and the photograph reversed. Also like Mitchell, Oakes had his share of perspective problems.

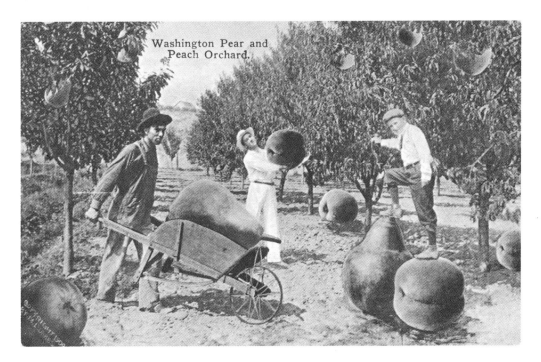

Washington Pear and Peach Orchard.

M. L. Oakes was another tall-tale postcard producer who, like Mitchell, produced his work only in color. Unfortunately, Oakes's postcards suffer in comparison with Mitchell's because his postcards, while more lively than Mitchell's, had some problems in the printing process.

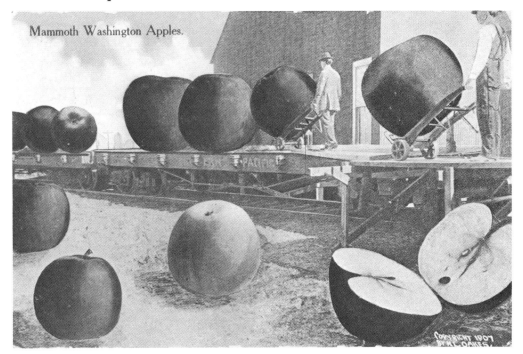

Mammoth Washington Apples.

[139

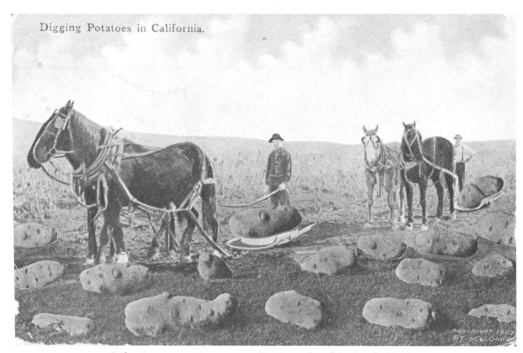

Digging Potatoes in California.

Oakes's postcards never display the kind of lively action we have witnessed with those of Martin or Johnson, but the mere inclusion of people and animals in the scenes, and the variety of contexts speaks well for Oakes as a tall-tale artist.

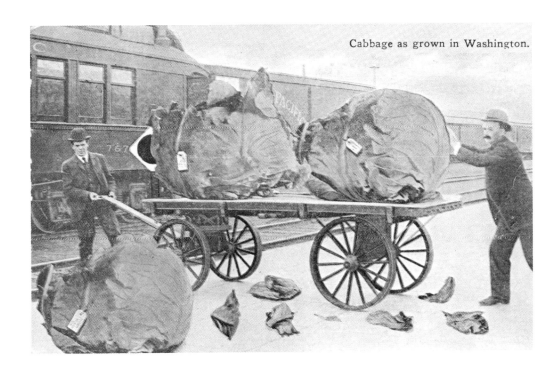

Cabbage as grown in Washington.

Oakes, like many master tall-tale photographers, used the same photographs for several postcard juxtapositions, sometimes reversing the negative to add the kind of variation lacking in Mitchell's cards. Oakes's postcards are also enhanced by small touches like the addition here of a few huge fallen cabbage leaves on the loading platform. These cards, like all of Oakes's are dated 1907.

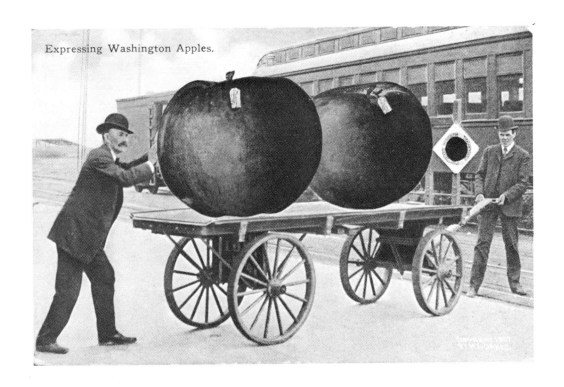

Expressing Washington Apples.

Olson Photograph

Olson Photograph of Plattsmouth, Nebraska, also produced a limited number of cards, mainly of the mammoth fruits and vegetables type. At best, they were of mediocre quality. However, they often command premium prices because of the fine old trucks that are pictured hauling the mighty crops to market.

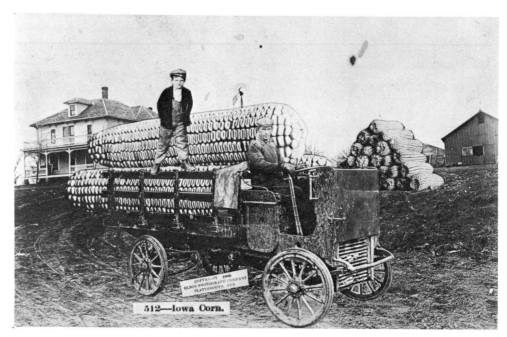

512—Iowa Corn.

The Olson Photography Company of Plattsmouth, Nebraska, produced tall-tale postcards between 1908 and 1909. The exaggeration here of Iowa corn is not necessarily an indication of a wide distribution of Olson cards for Plattsmouth lies directly across the Missouri River from Iowa.

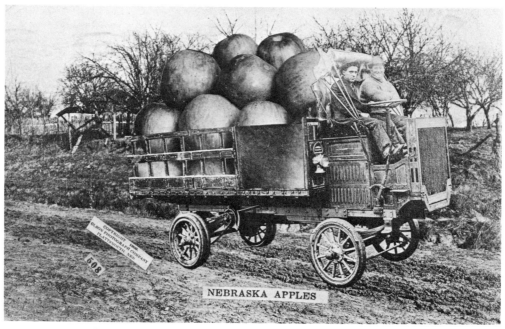

NEBRASKA APPLES

Not many of the Olson Photography Company cards were published and they are therefore rare in collections today, but there is some suggestion in the range of index numbers (here #504, #508, and #512) that there might have been examples not yet encountered. This card is a gift from Neal Chism.

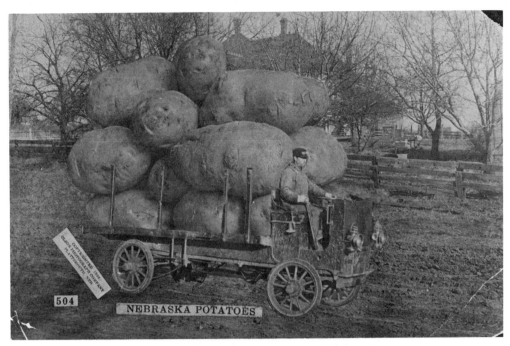

Even postcard collectors who are not interested in exaggeration motifs are attracted to Olson's cards because of the frequent appearance of fine old trucks on them. This card was provided by Mrs. Cecil Schmitt.

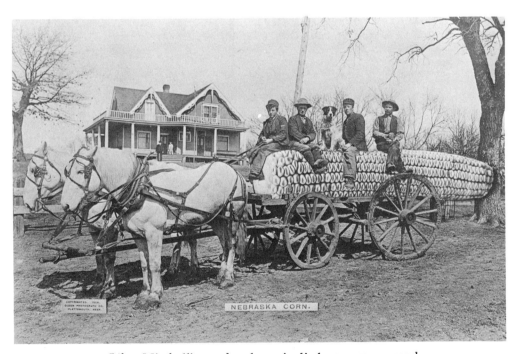

Like Mitchell's cards, there is little to recommend Olson Photography Company postcards, aside from the unadorned huge dimensions of the corn, potatoes, or apples. This card was produced by Olson Photography Company and was published by L. W. Snow.

"Greetings from . . ."

"Greetings from" cards present a strange combination of photograph and drawing. They are usually tinted, which was probably supposed to add to the reality of the portrayal, but the "sketched-in" quality that accompanies such tinting considerably detracts from the desired effect.

This set of cards bears no publisher identification, but it can be seen easily from the similarity of type faces at the top and bottom of the cards and from the identification numbers on the flatbed railcars that they have indeed come from the same source. On the reverse side, the first three cards bears the legend "No. 926 Freak Vegetables, 10 des." The fourth, sixth, and seventh read "No. 925 Freak Fish Locals 12 des."

JUST A SAMPLE OF WHAT WE RAISE HERE

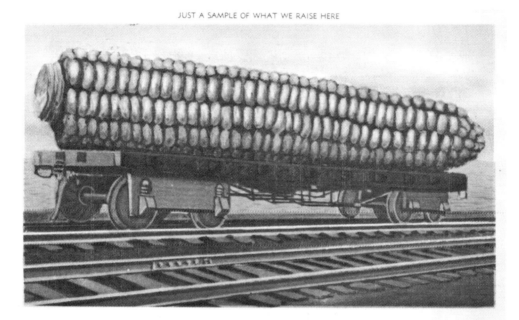

Greetings from SOUTH ROYALTON, VERMONT

IT IS THE ATMOSPHERE THAT DOES IT HERE

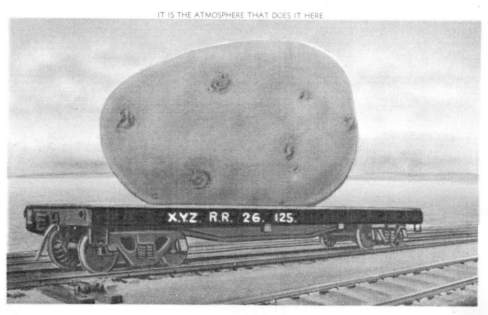

Greetings from PEMBERVILLE, OHIO

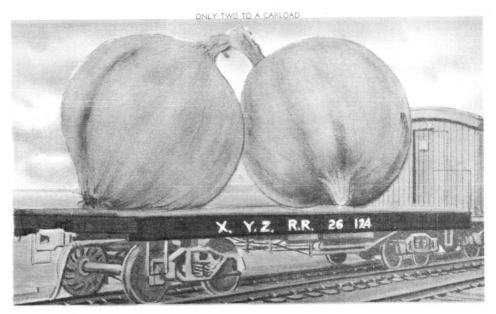

ONLY TWO TO A CARLOAD

Greetings from PEMBERVILLE, OHIO

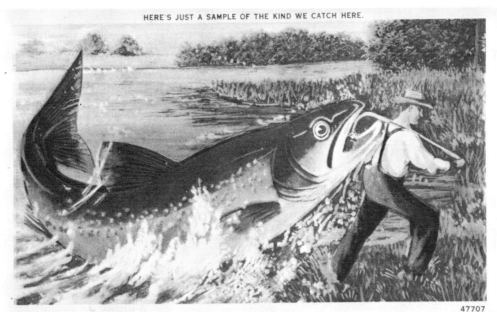

HERE'S JUST A SAMPLE OF THE KIND WE CATCH HERE.

47707

Greetings from PEMBERVILLE, OHIO

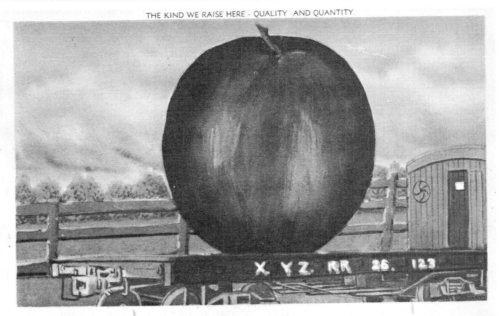

THE KIND WE RAISE HERE - QUALITY AND QUANTITY.

Greetings from PEMBERVILLE, OHIO

[145

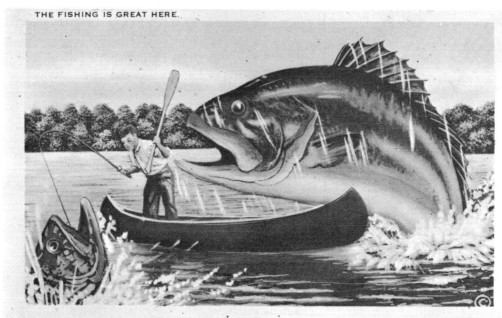

Greetings from KOKADJO, MAINE

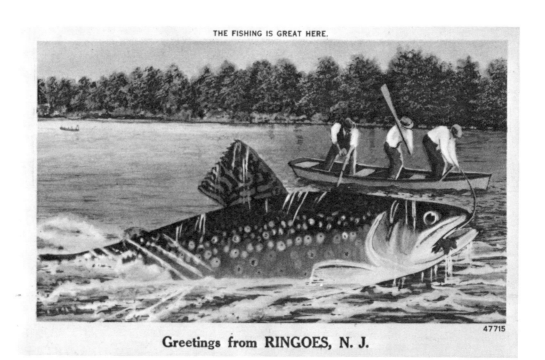

Greetings from RINGOES, N. J.

J. Herman

Herman's work appears both under his name and under the label, "Series 85," both usually published by the Midland (New York) Publishing Company. The cards issued under his own name are generally of better quality than the Midland Company cards, showing considerably more action. The railroad car sequence is, in my opinion, better than Mitchell's because it does show better composition and depth of perspective. Unfortunately for collectors, Herman issued only a very few postcards, probably not more than twenty examples all told.

The cards entitled, "The Kind We Raise in Our State," "The Kind We Raise Here—Quality and Quantity," and "A Carload of Fish," were published under Herman's name. The Midland postcards are as follows: "The Kind We Raise In———," "The Kind We Raise in Our State," (there are two cards in this genre, one of an oversized celery stalk and another of a giant cucumber), "The Kind We Catch," and finally "Sweet Dreams." (See photos for examples.)

J. Herman's name does not appear on these cards but they are clearly his work: the numbers on the flat car, the perspective, the paper and texture, and the color are precisely the same as those that do bear his name.

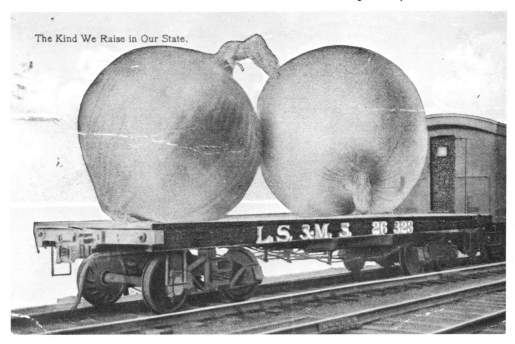

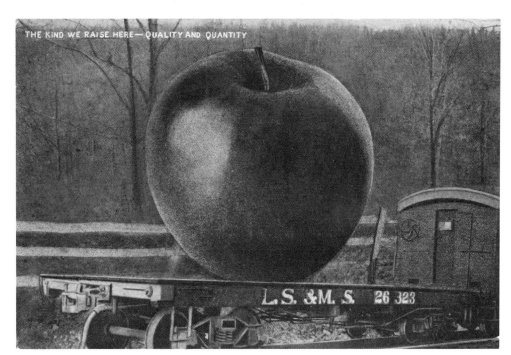

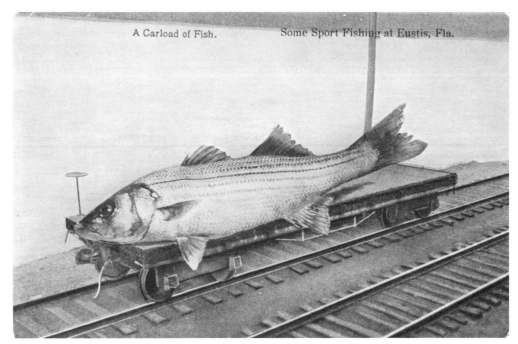

This Herman card displays the most complete documentation. On the reverse is printed, "J. Herman, 1912. Midland Publishing Company, Series No. 86, #86-19."

J. Herman's name does not appear on these cards, but there is little mistaking his style, his subject, or his choice of railroad flatcars.

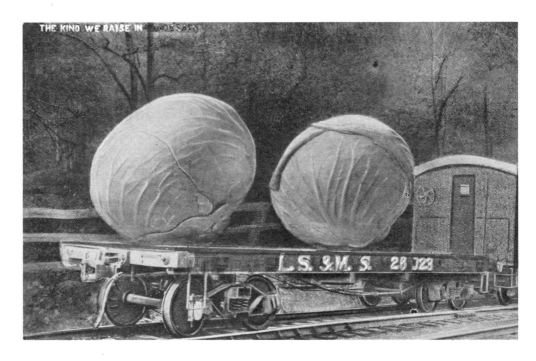

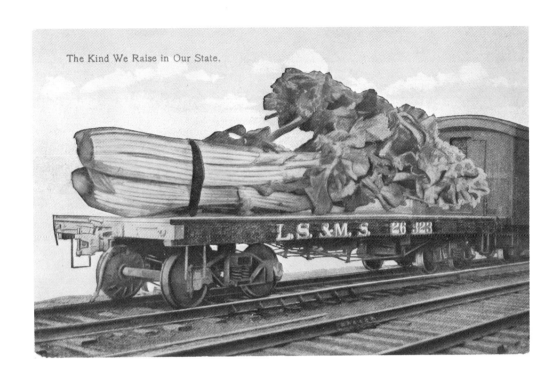

The Kind We Raise in Our State.

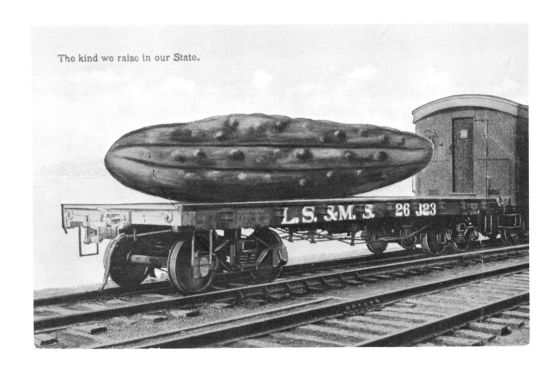

The kind we raise in our State.

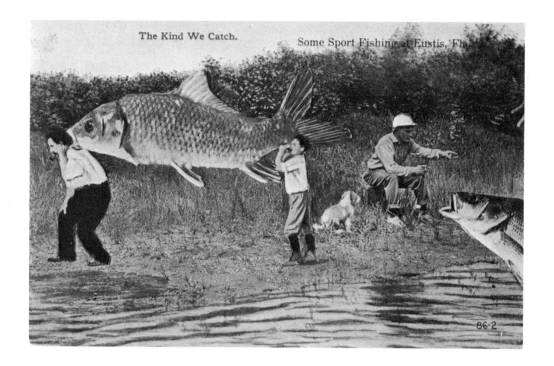

The Kind We Catch. Some Sport Fishing at Eustis, Fla.

Herman, however, did try ideas other than a Mitchell-like piece of fruit on a railcar. Indeed, the second item of this set is a unique depiction of a hunter apparently dreaming the exaggeration portrayed on the postcard. The first is one of the few Herman cards bearing a date, but those that are dated are limited to 1912 and 1913, suggesting that J. Herman was a late entry in the tall-tale postcard fad.

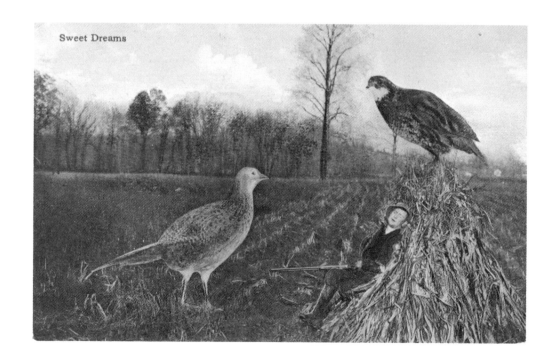

Sweet Dreams

Leigh

Leigh cards were published through the Asheville, North Carolina, Post Card Company and were exclusively Florida cards. They inevitably showed a horse or mule drawn wagon with a load of very large fruit.

The color and technique of Leigh's cards is good, but the variety and imagination used is minimal. At any rate, Leigh must be considered a minor producer of tall-tale postcards. The numbers of his cards are few, distribution limited, and interest closely regional.

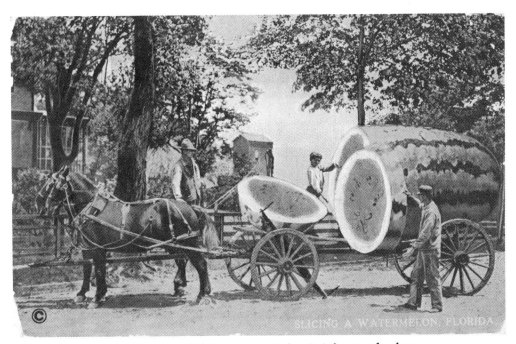

All of the tall-tale postcards by Leigh—no further identification is available for him—show Florida scenes. Indeed, they all deal with produce on a small, horse-dawn wagon, often with children in attendance. This is perhaps his best effort because of the smooth depiction of action in the scene.

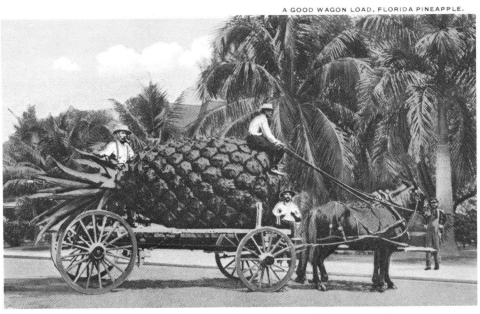

All of Leigh's cards are dated 1909. The geographic limitation of his distribution was probably an economic handicap, but it permitted unusual subject matter such as this pineapple—not possible as a theme on the Plains or prairies of Martin, King, and Johnson.

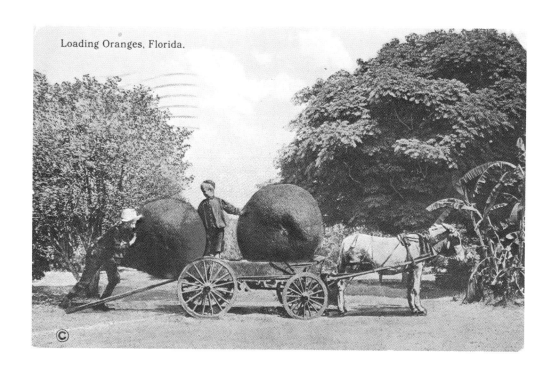

Loading Oranges, Florida.

Here Leigh has obviously used precisely the same basic scene, changing only the produce in question. The Leigh cards were published by H. and W. B. Drew of Jacksonville, Florida.

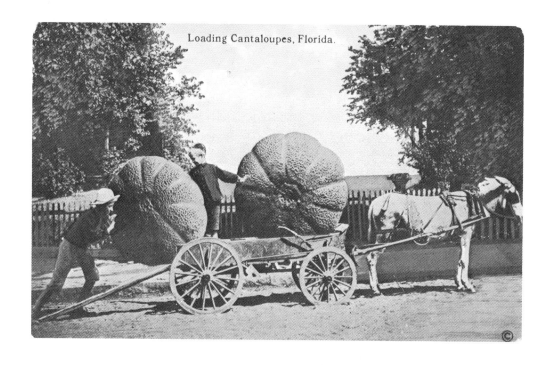

Loading Cantaloupes, Florida.

George B. Cornish

George B. Cornish worked out of Arkansas City, Kansas, and worked only with watermelons and corn.

Two of his watermelon cards were used in a previous illustration, and I include two of his corn pictures (see photos)—relatively undistinguished in theme and technique.

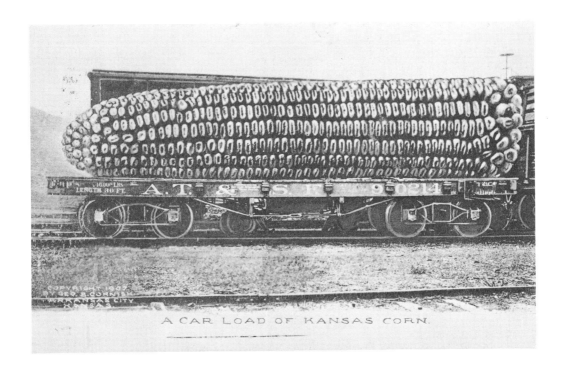

A CAR LOAD OF KANSAS CORN.

The only examples I have found of the work of George B. Cornish show corn and watermelon. His cards all are dated 1907 and 1909.

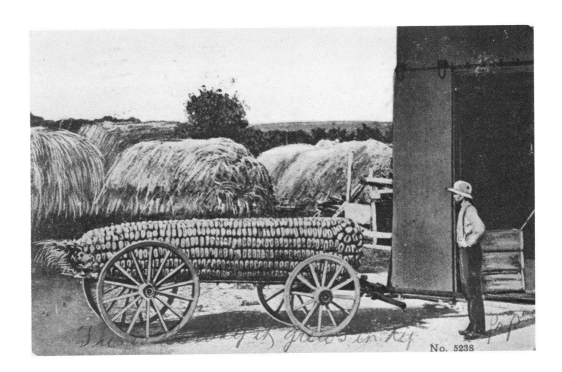

No. 5238

Several dozen other publishers and photographers are represented in the tall-tale postcard field by one or two cards and therefore do not have a section devoted entirely to their work, but this is not to diminish the importance of their contribution. Sometimes their few attempts are actually better than most of Martin's or Mitchell's and are lesser lights only in terms of numbers.

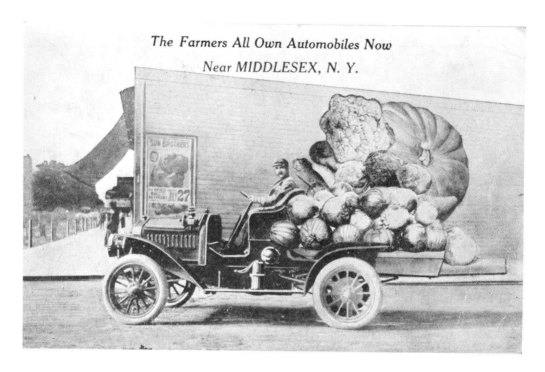

The Farmers All Own Automobiles Now
Near MIDDLESEX, N. Y.

Many tall-tale photographers are not identified on the cards, but the style is distinctive enough that a group of postcards can easily be recognized as the work of the same hand. Note in this pair, for example, the identical type face. The second is especially well done, *actually* incorporating four separate photographic exaggerations into one. What a pity credit cannot be given to the artist!

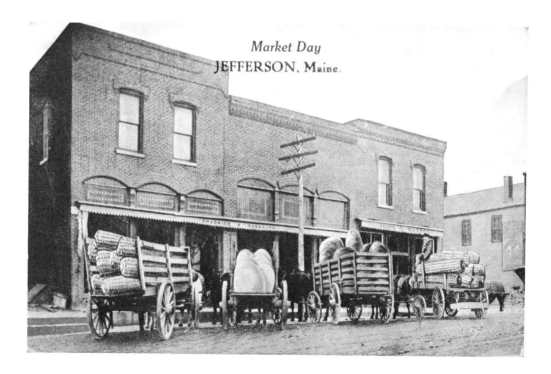

Market Day
JEFFERSON, Maine.

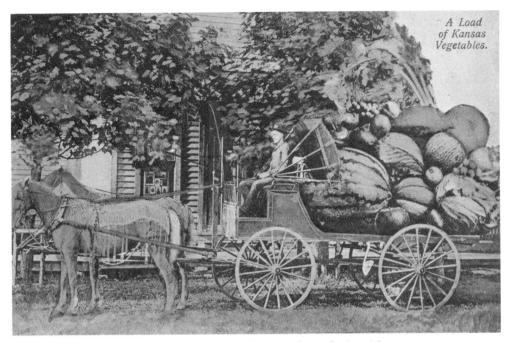

A Load
of Kansas
Vegetables.

Many of the unknown photographers dealt with conventional tall-tale themes and would scarcely be of note even if we knew their names, as in the case of this card, so reminiscent of Leigh. This card does bear a distributor's label—"Ekstrand Drug & Book Company, Post Card Importers, Salina, Kansas. Made in Germany."

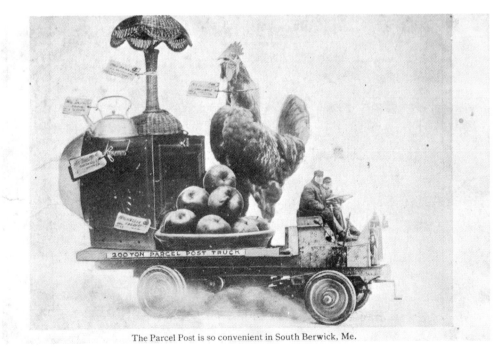

The Parcel Post is so convenient in South Berwick, Me.

Other cards are interesting and complex, even unique, like this one, totally barren of any identification.

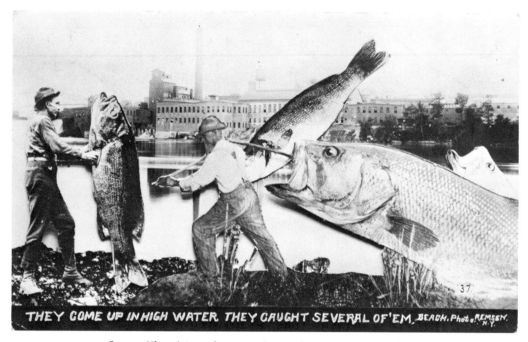

THEY COME UP IN HIGH WATER. THEY CAUGHT SEVERAL OF 'EM. BEACH. Photo. REMSEN. N.Y.

Some, like this unfortunately crude attempt, were apparently made to order. This card has on the reverse the identification line, "Beach Photo, Remsen, New York. Made from any photo at Remsen, New York." It is not dated.

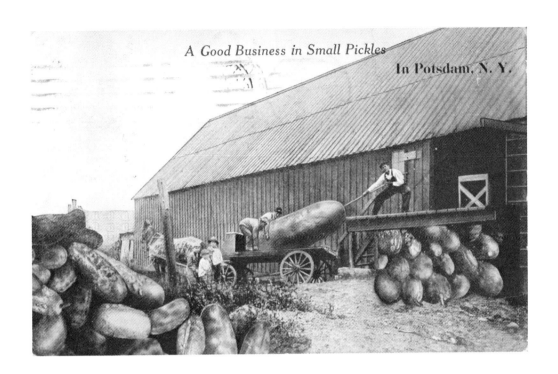

A Good Business in Small Pickles

In Potsdam, N. Y.

These postcards, better than average examples of the tall-tale craft, are completely without label and the photographer's work must be appreciated without even knowing his name.

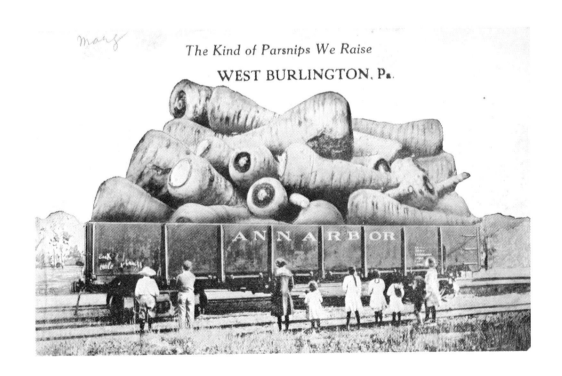

The Kind of Parsnips We Raise

WEST BURLINGTON, Pa.

Series by Unidentified Publishers and Photographers

In any body of postcards it is possible to identify cards belonging to the same artist even though there are no labels because the type of lettering used in the text, the kind of paper used for the card, and the techniques used in producing the photographic effect are so similar. In other cases, a series number is the same or the wording of the text is nearly identical, but there are no indications of a publisher or photographer. It is unfortunate not to know the names of the artists and to give them appropriate credit, but it is all the worse when the work is truly superior. For example there are four cards (see photos) that are clearly from the same series by virtue of the paper, the printing, and the style, but there is no identification whatever on them or any of the other several cards in the series. The cards display the following legends: "You Should Look Before You Leap," "The Fish Grow Big Here," "One Fish Makes a Meal Here," and "We Caught A Few Small Ones Today."

These four cards are all from the same photographer's shop as can be seen from the style and the type face, but the photographer and publisher are not identified. That is particularly unfortunate because the cards are especially well done and the captions are worthy of a master like A. S. Johnson, Jr.—with emphasis on the subtle ambiguity of "One Fish Makes a Meal Here"!

You Should Look Before You Leap

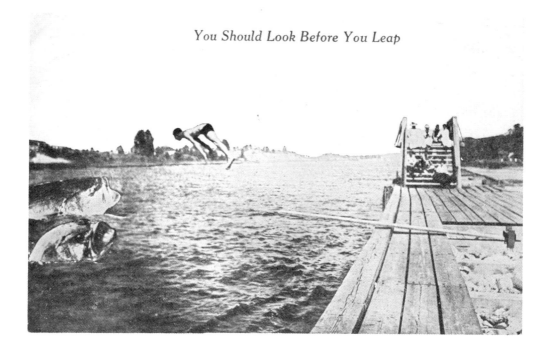

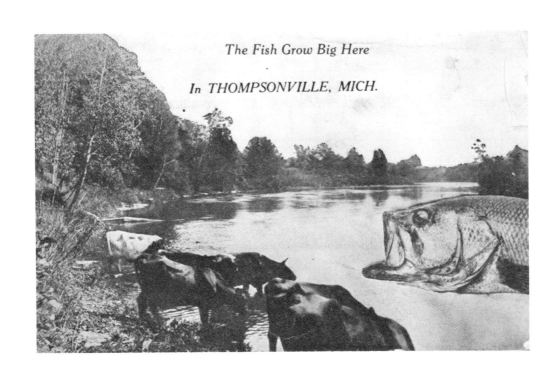

The Fish Grow Big Here

In THOMPSONVILLE, MICH.

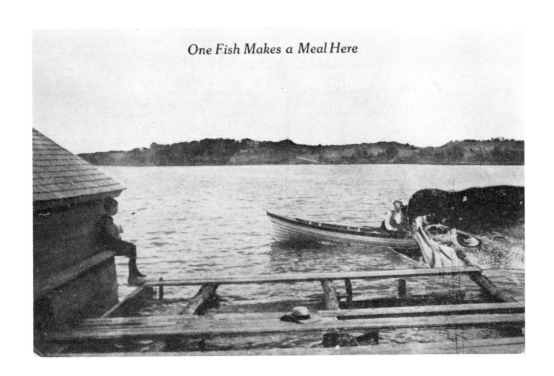

One Fish Makes a Meal Here

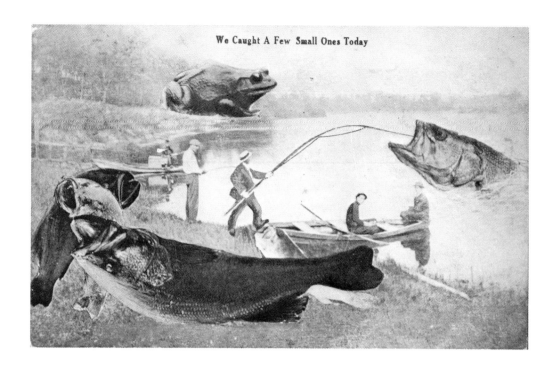

We Caught A Few Small Ones Today

Other examples, such as those in the giant fish category (see photos), also lack identification, but are similar in the aspects mentioned before. In this case the style—always three men with hats and caps and the same boat—adds another distinguishing characteristic. All are labeled on the back "Freak Fish—12 des." and are characteristic in photographic technique, paper quality, and theme to the other cards in the same series.

These four cards, clearly of the same series, bear on the reverse side the label "Series 881. Freak Fish. 12 des." The three men appear to be the same on each card.

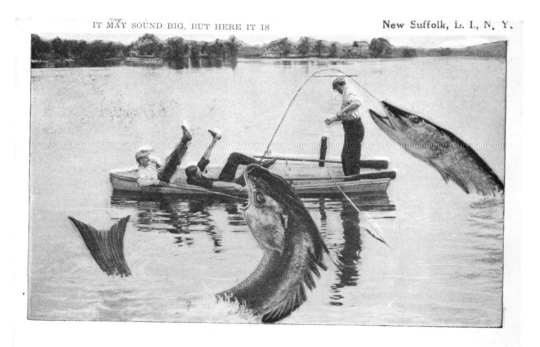

IT MAY SOUND BIG, BUT HERE IT IS New Suffolk, L. I., N. Y.

160]

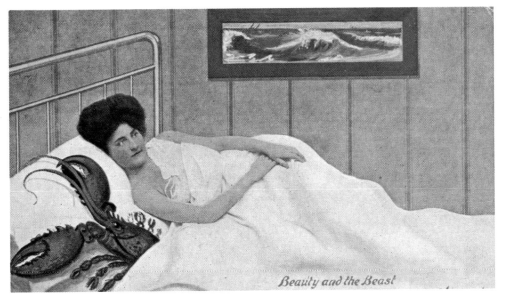

Beauty and the Beast

The theme of this card is so bizarre that it remains obscure for the modern viewer. It may be quasi-sexual. This card is identified only with the printer's number 621.

The publisher of this card is unknown. The photograph was provided by the Wyoming Travel Commission.

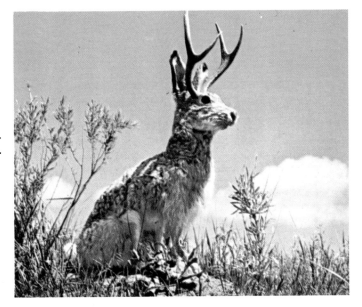

Superimposition produces a literal interpretation of a romantic metaphor.

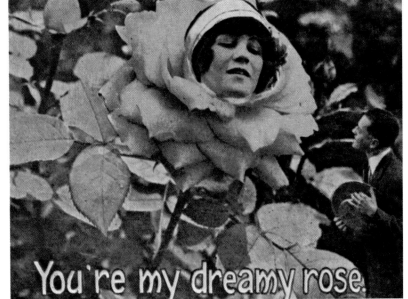

You're my dreamy rose.

This card bears no identifying marks. The exaggeration is a matter of whimsy rather than tall-tale surprise.

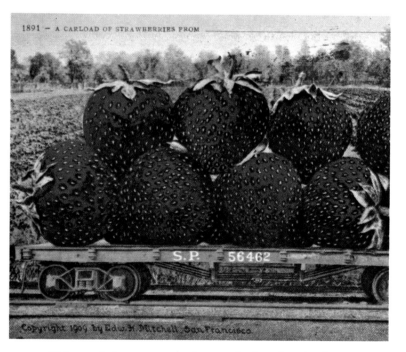

This card demonstrates the standard style of Edward Mitchell.

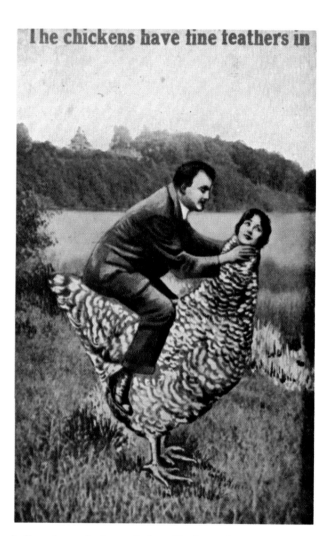

A literal rendering of the allusion of a woman as a "bird" or "chick." This was a popular though not especially flattering theme.

The Fishing Is Great Here.

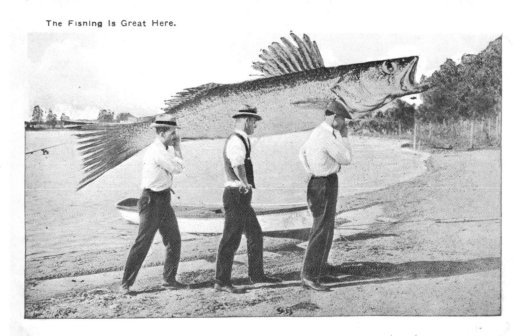

GREETINGS FROM HOMESTEAD, FLA.

THE FISHING IS GREAT HERE.

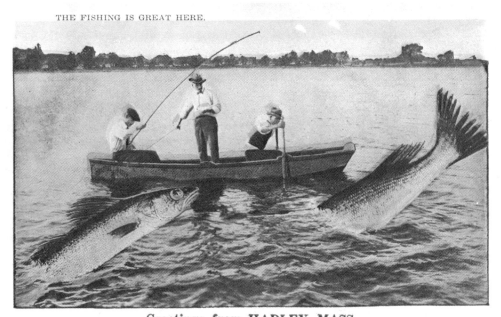

Greetings from HADLEY, MASS.

IT TAKES REAL FISHERMEN TO LAND THESE

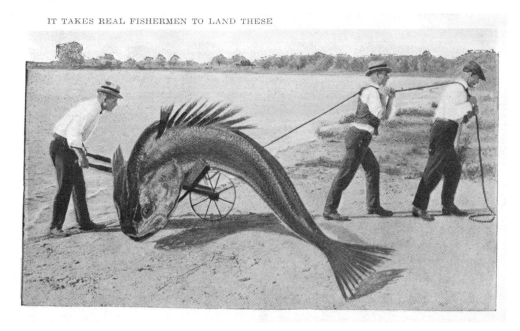

Auburn Post Card Manufacturing Co.,
Freak Fish Series

The photographer is not signified on this series, even though it is one of the best in the genre. The cards were published in Auburn, Indiana, and show a special imaginative flair. In fact, it is my opinion that the last card of this series entitled, "The Only Small One Caught This Season" (see photo), constitutes one of the cleverest of the entire genre, twisting the tall-tale spirit completely around so that the viewer is supposed to focus on the miracle of normality!

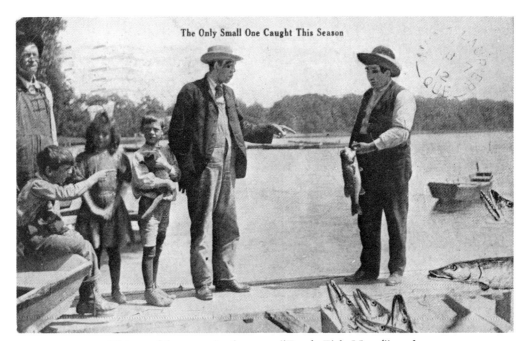

The Only Small One Caught This Season

This card bears only the note "Freak Fish No. 4" and is from the Auburn Post Card Manufacturing Company. The card is so poorly printed that the facial features are hard to make out on the subjects, but the extension of the laconic delivery so that the amazement of the participants on the card is focused not on the huge fish in the water, but on the small bass only fourteen or fifteen inches long makes the card a masterpiece.

The 2010-2011 Series

A series which opens interesting speculation is what I have labeled the "2010-2011" series. As can be seen clearly from the pictures as shown, the cards are almost identical, except that in the case of the corn photograph entitled, "Farm Products from Haynes, North Dakota," several rows of kernels have been tacked on to make the ear fatter and a number "1" has been pasted over the original "0," as can clearly be seen in the brightness of the "1" in comparison with the "O." Some of both the 2010 and 2011 series are labeled "The Art Manufacturing Co., Zanesville, Ohio," so a case of plagarism does not seem likely, but one must wonder why the numbers would have been juggled between printings.

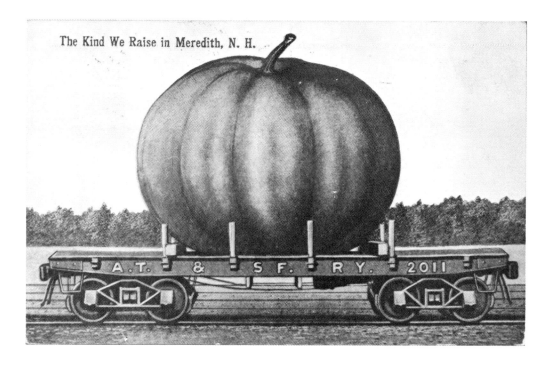

Here, too, it is clear that this series of postcards comes from the same publisher. One need only note the legend on the railcar and examine the grainy texture of the picture to establish that fact.

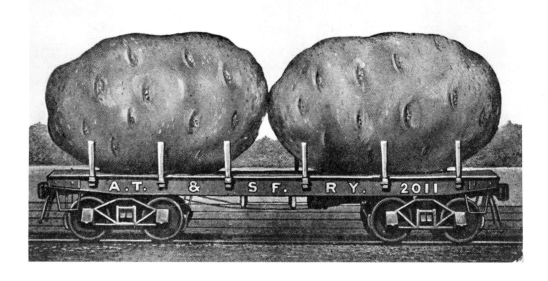

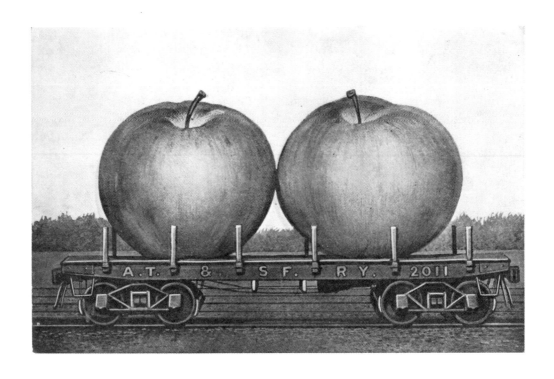

A strange problem appears, however, in some pairs of this type of card. Note that the number of the railcar has been changed from 2010 to 2011.

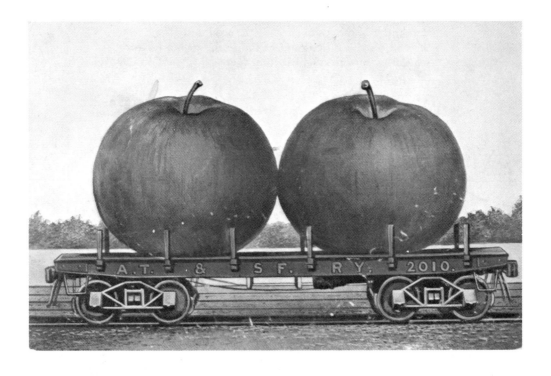

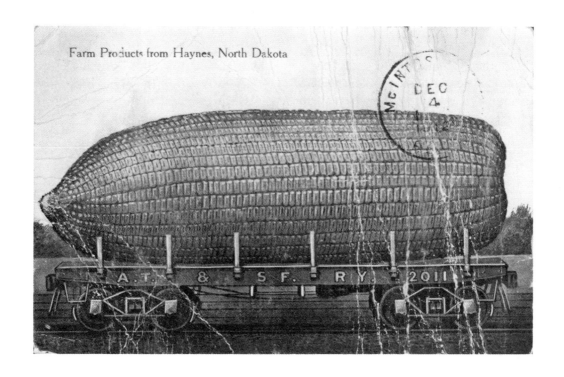

Farm Products from Haynes, North Dakota

The car number has been changed in this set of cards too, but in addition several rows of kernels have been added to the top of the ear of corn!

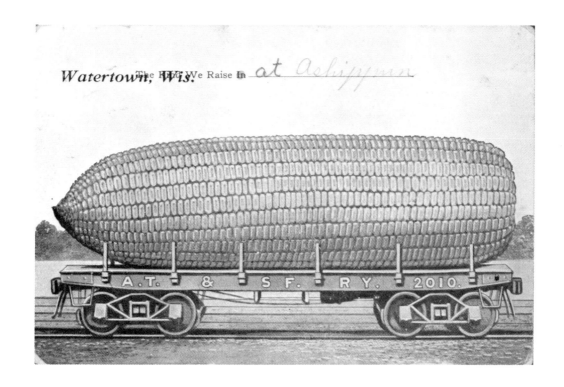

Watertown, Wis. The Big We Raise In *at Ashippun*

Some Class

I have included the final unidentified series because it is also one of the best sequences of exaggerated fishing photography. These cards often display the additional photographic manipulation of hand-drawn lines—for example, the splash lines added to the cards labeled "Some Class to the Fishing Here" and "This Is Where We Are Spending Our Vacation." A light blue wash over sky and water areas of these cards brings color to a genre which was primarily black and white.

These cards, all by the same manufacturer, bear the identification number 2249 for "freak fish" designs, 2250 for "freak vegetables."

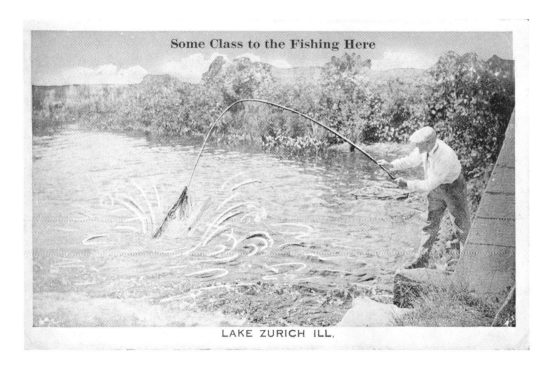

LAKE ZURICH ILL,

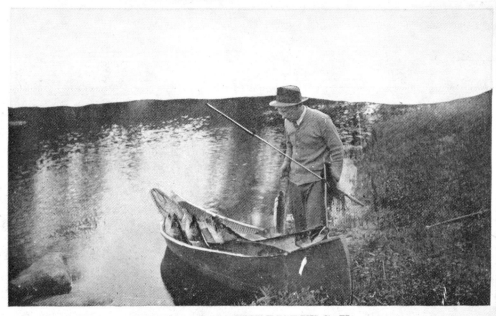

Greetings from FERRISBURG, Vt.

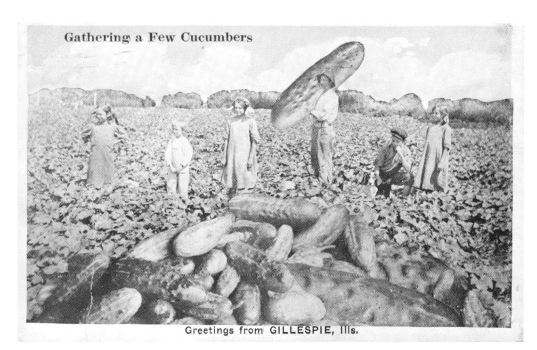

Gathering a Few Cucumbers

Greetings from GILLESPIE, Ills.

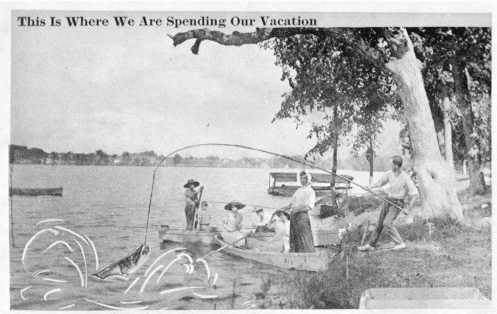

This Is Where We Are Spending Our Vacation

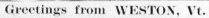

Greetings from WESTON, Vt.

Bringing Home a Good Catch

AUGUSTA, ME.

Pennants

A common format for tall-tale postcards was the "pennant" card, carrying a banner proclaiming with splendid pageantry the point of origin and, with the use of the exaggerated photograph, some of its virtues. A printer or publisher could adapt the card to new locales simply by replacing the name with new print.

These "pennant" cards were probably published by the same manufacturer since they have very much the same style of identification number on the face. In most cases, the pennant was used as a device to localize the appeal of the cards; a town name could be printed on a number of ready-made cards to be marketed in that particular town.

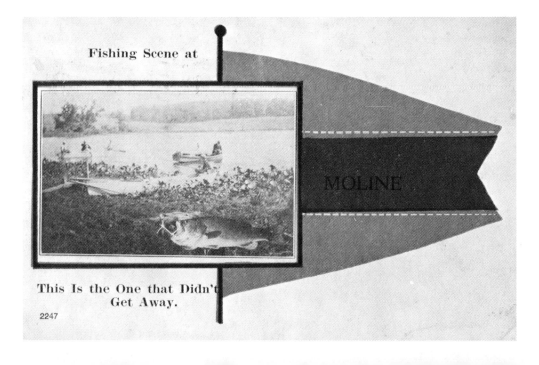

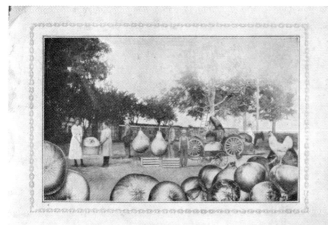

Farm Life Around

Jamestown

Is a Bit Strenuous

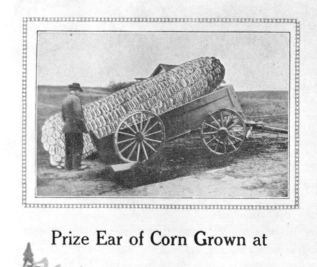

Prize Ear of Corn Grown at

Sudbury

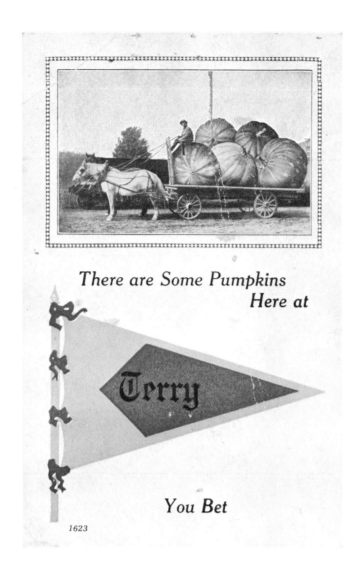

There are Some Pumpkins Here at

Terry

You Bet

1623

Mike Roberts

Sporadic efforts have been made to revitalize the tall-tale postcard market but only rarely does a photographer produce more than one or two examples, and then they are usually weak copies of the ideas rendered by photographers during the earlier part of the century.

An exception is Mike Roberts of Berkeley, California, who has in recent years produced a series of tall-tale photographs that are exceptionally well done and contain many ideas not touched on by his antecedents.

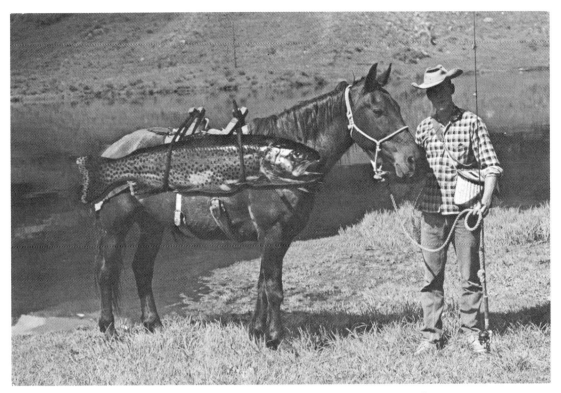

Mike Roberts of Berkeley, California, is clearly the most successful tall-tale artist producing cards today. This example, distributed by Triangle Distributing of Colorado Springs, Colorado is representative of his clean, clear photography and excellent color reproduction.

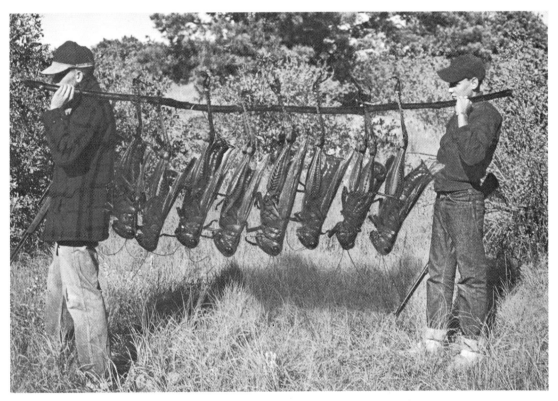

Roberts's photos are surprisingly convincing and are not simply copies of his predecessors' work. A mark of his successful execution of tall-tale themes is that his cards remain popular even though the popularity of the postcard as a genre has declined by and large, the photographic exaggeration postcard virtually disappearing except for Roberts' cards.

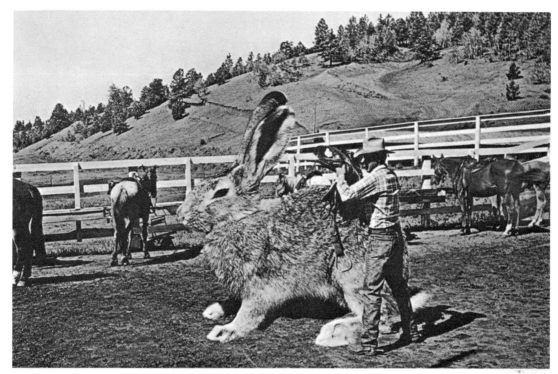

SADDLING UP BIG JACK

Most of Roberts's themes are western or focus on hunting and fishing subjects. These cards are distributed by Kontinental Kards of Colorado Springs, Colorado.

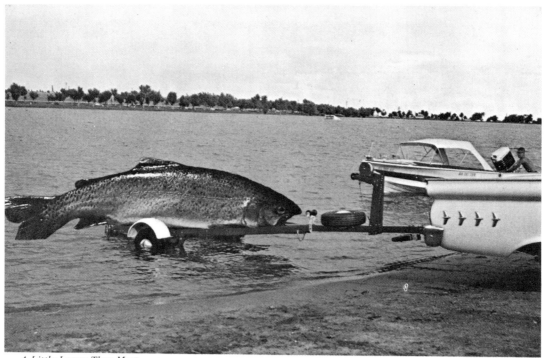

A Little Larger Than Most

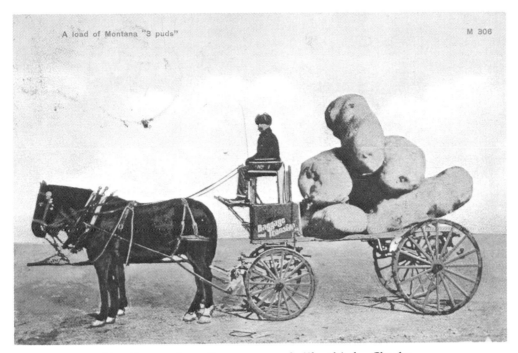

Puzzling to the collector are cards like this by Charles
E. Morris of Chinook, Montana. The card is at least as
good as those by Mitchell. Why then is it a unique
example? Why did Morris not pursue the theme fur-
ther with Mitchell's success? Perhaps because Montana's
market is not as rich as California's?

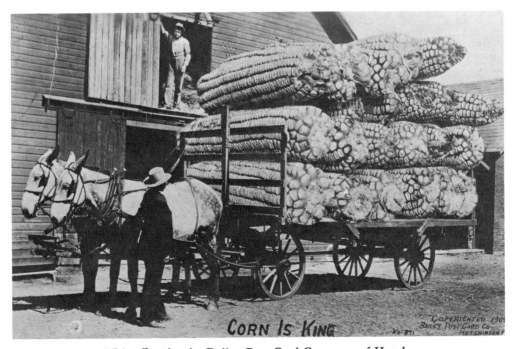

This effort by the Bailey Post Card Company of Hutch-
inson, Kansas, dated 1909, denies the possibility of suc-
cess stemming from geography alone. This is a unique
card, the only card I have seen from the Bailey Com-
pany, and yet is as well done as many of King's or
Martin's very successful postcard exaggerations.

[173

Perhaps, in some cases, for publishers like Nadeau or Day Photo, of which these are solitary examples, the single item they produced exhausted their imaginations. These two items are clearly within the inventory of the most common of tall-tale postcard themes.

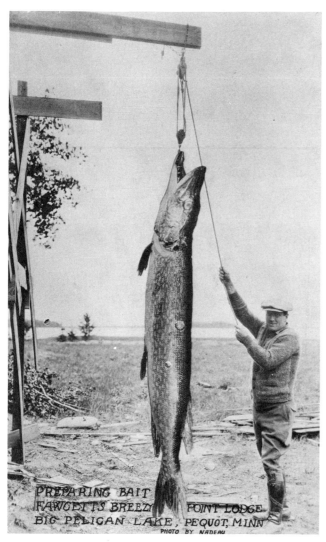

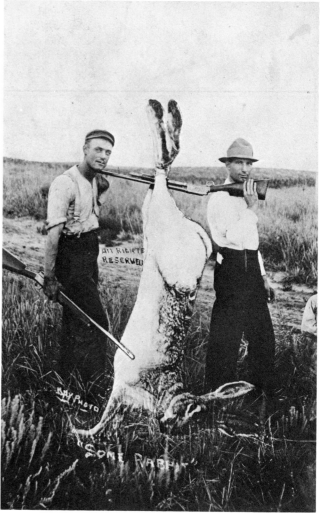

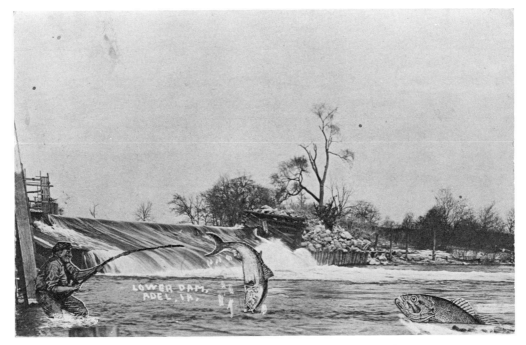

In other cases, like this one (which bears no identification marks whatever), the crude execution put it at a considerable disadvantage when compared to the ubiquitous postcards of Alfred Stanley Johnson, Jr., and other such masters.

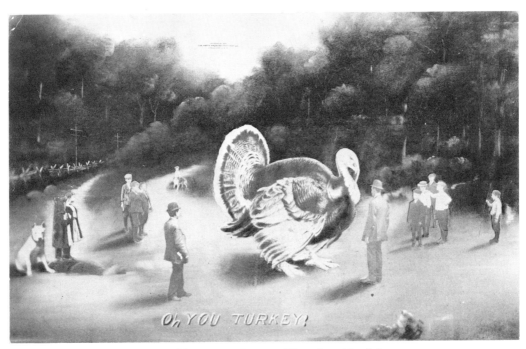

Curiously, this postcard, so stiff and void of humor, was published by the same publisher who issued some of the exciting cards of William Martin, the North American Post Card Company of Kansas City, Missouri, in 1909.

Published by Photographer W. E. Bowman, Ottowa, Ill.

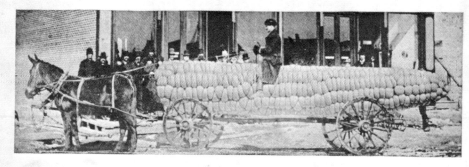

Product of the Illinois Valley "looking for a sheller."

In many of the unidentified items, some care has obviously gone into the formulation of the captions to enhance the humor, as is the case with these two cards, the first by W. E. Bowman of Ottowa, Illinois, and the second by Frashers, Inc., of Pomona, California. Neither bears a date.

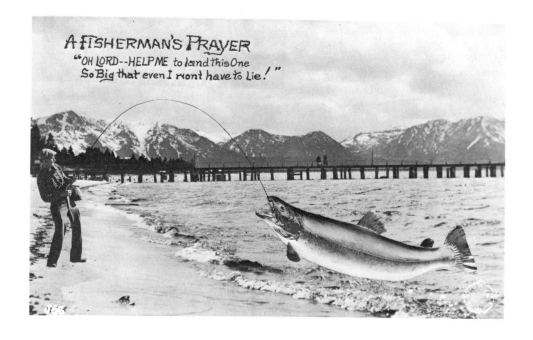

4

The Message: Texts

I have already commented briefly on the photographers' skills as writers: some were at best ordinary while others, like Johnson and Martin, showed themselves to be as skilled with their pens as with their cameras. A few cards bear specific labels—"This is the way we do it in Freeble, Kansas—or leave the specifics to the buyer—"This is the way we grow them in ————." My favorites in this line are the masters of ambivalence that labeled their cards "This is the way we do it here." That certainly minimized the marketing problems for the distributors.

More revealing, more curious are the messages that the buyers and senders scrawled on the backs, the message sides of the tall tale postcards.

It may seem impolite—almost like eavesdropping—to read what people, unknown to us, have written on the backs of these cards and perhaps, at least at first, it is not easy to see the relevance of these texts. But I have included in this study the messages scrawled on the backs of the cards for two reasons:

1. I remarked earlier that these cards are sociological indicators and, since they were obviously used by *some* or *several* levels of society in the early part of the century, perhaps these texts can tell us something about that level (or levels), and the content might reveal information about the appeal and sociological function of the tall-tale postcard.

2. They are interesting! It *is*, of course, a form of eavesdropping to read them, but almost everyone enjoys a little impersonal eavesdropping now and then, be it in an elevator, on a subway—or on the back of a fifty-year-old postcard.

And there are some real surprises to be found on the side opposite the picture. James Laver's assertion in the Foreword of Frank Staff's *The Picture Postcard & its Origins* that the development of the picture postcard exerted a shortening effect on America's writing style is borne out. Sentences tend to be truncated, brief, and blunt:

Got your card today. Will write tomorrow. Louis.

Love to all and Happy New Year. F. G. Carter.

Hello how are you fine and dandy I hope. I suppose you think I have forgotten you but have not. Was sorry I could not come and see you this summer. Was to dance last night had a good time Alice.

This may well be the chief advantage of the postcard. It avoids the necessity of filling both sides of a long sheet of paper when there really is not very much to be said, and yet one does not have to say, "I don't have much more to say," or "That's about it for now." It is obvious to the reader that there is not room for more than a few lines, and if the sender writes with a full and generous hand, and with a blunt pencil, there is not room for much more than a few words. Yet the sender of the card *has* written; he has said what he had to say, which is usually implied by the postcard alone: "I am still alive, I remember you, and I want you to remember me."

This is precisely why the postcard, when it is still used today, is primarily the medium of the tourist in a hurry, with little to say and a lot of people to say it to. A typical example:

Had a lot of bad luck but still going. Came from Winchester to Charlottesville today. Saw Jefferson's home at Monticello. It's so old and so very beautiful. Hope the cat and the refrigerator are doing OK.

The pervasive illiteracy, misspelling, and poor or totally absent punctuation of the messages in general suggest broad use of the freak postcards by the lower, less educated classes. Again, this is quite logical because it would be precisely those people (for whom writing is most painful) who would select the picture postcard as a way of avoiding demands for lengthy manuscripts. Moreover, since the tall-tale card was most prevalent in the rural midwestern areas, where education was also sketchy at best, it is to be expected that there would be a correlation between the relatively uneducated and the tall-tale postcard. The following messages are illustrative of this:

Dear Cousin: We are planning a Surprise pardy on John Anderson. Wed. Eve April 1st then he wil be 21. years old. and we would like for you to come too if you can. you can meet to Johnnies aboute 7 are 7-30. be sure and come. With love to all. Christena W.

Hello Ben how are you I am fine and dandy how is the girls we took buggy riding that night right me and tell all the new right me Mt. Hope, Kans, from Willie

Dear Mother Father all I heard you was sick now rite and let me now how you ar at once I think you outh to rite once in a while rite soon From Daughter and family

Favorable postage rates on postcards also must have made the postcard especially attractive to poorer, less educated mailers.

Sometimes the messages on back of tall-tale postcards carry a poignancy that still lingers today, some sixty years later:

[In a childish scrawl] How are you. yes this is my writing From geneva [A note added above this notifies Granny that Geneva did indeed write this postcard herself, with her very own pencil.]

Well Miss G. I suppose you have a sailor by this time that you don't care for the cow puncher any more bet there are lots of them. I do thank you for the cards. They all came at once. I only read 25 that mail. It was nice of you to think of me.

My dear May, I shure was surprised to learn about that jump but I thought it would come some day You have my congratulations and hope you will both be happy and can be if you both pull on the same string. From your Aunt Mary.

Dear Marion, I thought I would write and tell you that I have got a little sister. She was born at 2 o'clock Monday. She weighed 11 lbs and I named her Marion Elsie, and the first name is after you. . . .

Tall-tale postcards did yeoman service as social notices, witnessed by the fact that twenty cards from my corpus carry invitations and announcements of one sort or another:

Dear Nell and family You are invited to John Stenerts to A reseption for [?] to night Friday the 27 in [?] They furnish refreshment. . . .

Dear Brother when are you comeing home? Horses are doing well the cow is better now we are going to have a dance the 20. wish you was hear the baby is getting along fine now write to me soon your brother Dett

And sometimes the cards carry a story that can still bring a smile these many years later:

Dear Zora Did you miss anything I found I had a new apron on when I took my coat off. Will send it back. . . .

[In a child's hand] Dear sister I am well. Are you well. Today I hit Bill W. Belle. . . .

And sometimes the message content can only be described as folk poetry:

Hellow Bill am out here and it is wild and Dogs Barks at straingers have Bin working Every day since have bin here till this A.M.

This is unsettlingly reminiscent of Goethe's words (as translated by Colonel Robert Ingersoll), "I always know that I am traveling when I hear the dogs bark," or the dateless nursery rhyme quatraine,
"Hark! Hark! the dogs do bark,
The beggars are coming to town.
Some in rags, some in tags,
And some in velvet gowns."
Another example of folk poetry that has always been one of my personal favorites reads:

hello Katie We got home safe and sound all but our pocket books and they was empty and so was the bottle.

Many of the card texts clearly demonstrate that the principal message is simply the sending of the card and that the message is in reality only a filler, since it is only a casual reference to the tall-tale photo on the opposite:

So I am a "fisher" and he made me *pull hard*.

This is the kind we kill out west—weight 200 lbs. Gouchen.

Dearest. The soil down here is very productive "Lookit" the size of the cabbages they grow. Aren't they some whoppers? Lovingly, Him.

A few cards contain messages of a home-industrial nature, a notification. One, showing two huge strawberries on a plate may or may not be an actual splicing of photographs; it is possible that children's dishes were used for a single photograph or perhaps the strawberries actually are enormous! At any rate, the message notifies the recipient that his strawberry plants are ready to be picked up.

Other examples of the commerical use of tall-tale postcards follow:

Your carpet is done. You can have it any time. Yours truly, . . .

[Addressed to AAA Spooling and Winding Company, Auburn, Rhode Island] Dear Sir Please send me a Embroidery Catalogue free. I am thankful to you. . . .

And finally, a jackalope card that carries a double ad. It was published as a promotion, carrying the printed text on the reverse side:

This critter excaped from my yeard yesterday. Was last seen south of town. If he comes your way, please pen him up. His favorite food is Cargill Corn. See you soon, Your Cargill Representative.

Immediately below this in handscript, is this message addressed to Trading Post, [Radio] WPRE Prairie du Chien, Wisconsin:

For Sale a purebred Hereford Bull, without papers. He's 3½ yers old. Well build bull. Call. . . .

Several purely commercial messages can be found on freak postcards. I imagine that they were indeed successful advertising devices because the pictures themselves were so eye-catching. Several of William Martin's postcards, for example, are on file at the Kansas State Historical Society showing on the reverse side an advertisement reading:

BIG BARGAIN SAMPLE RAINCOAT SALE
ARTS BUILDING, FAIRGROUNDS
Surely visit Palace Clothing Co.
For extra value
Suits and Overcoats
at $17

Other postcard publishers used their cards to call attention to their own business, emphasizing their own confidence in their product.

King not only sold his photographic wares, but also profited from their presentation and exhibition, as can be seen from this postcard on which he used one of his own exaggeration photographs to advertise his program.

[179

The most common item advertised through the tall-tale postcard was the tall-tale postcard! They were, obviously, their own best recommendation, for any explanation of them without an example is impossible.

The new Woodruff Hotel of Watertown, New York, used tall-tale postcards to advertise and the results yielded some of the most interesting examples of that genre. Exaggerations on such postcards were only rarely human beings, but all of the New York Woodruff cards feature huge humans.

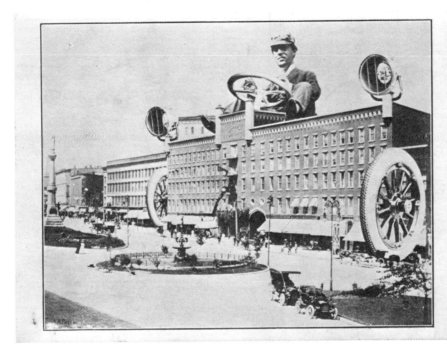

Loren R. Johnston Running the New Woodruff

Watertown N. Y.

The only examples I have found in which the tall-tale postcards deal with the merchandise itself and which were made specifically for the client are these two for New Woodruff Hotel of Watertown, New York. The cards are not dated, but the automobiles suggest a date compatible with the general flowering of the tall-tale postcard, 1905 to 1915.

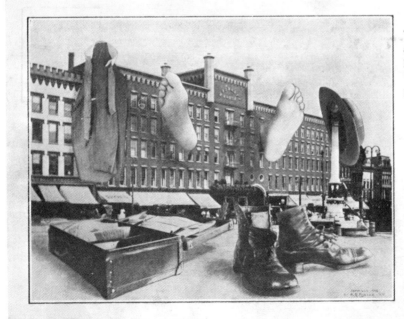

THE BIG GUEST at the New Woodruff Watertown N. Y.

William Martin altered cards from his regular tourist-sales inventory and transformed them into ingenious advertising cards.

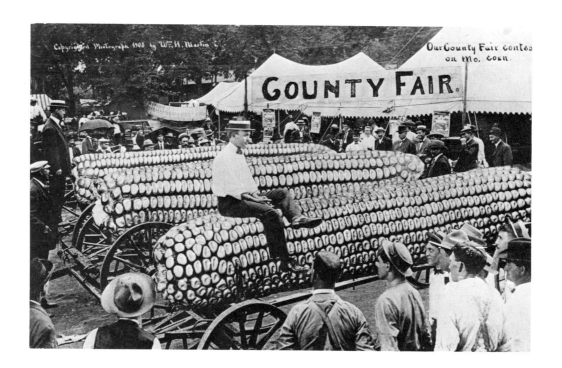

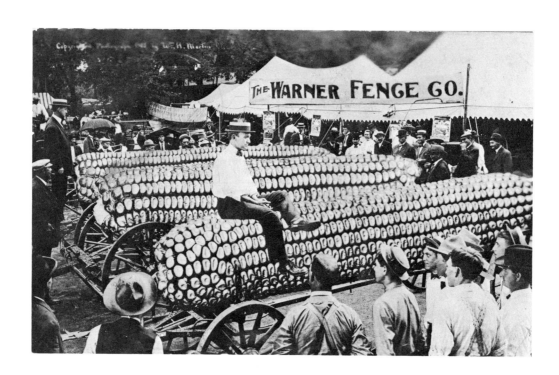

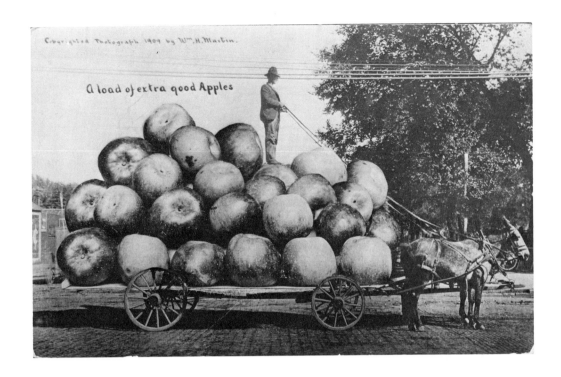

Here Martin skillfully added a billboard to the background of a regular tall-tale postcard, taking care to lap the mule's ear convincingly over the sign bottom. This pair is dated 1909.

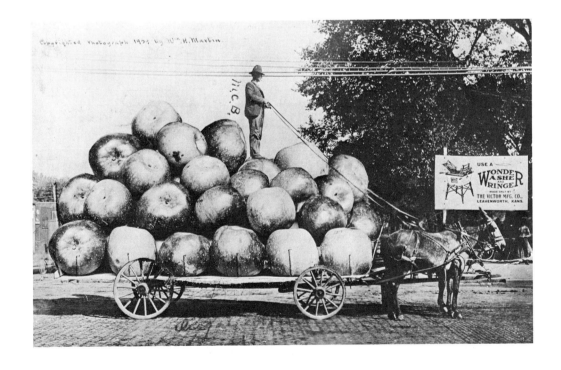

Martin also produced one special card that was used to tout Presidential candidate Taft in Kansas, Iowa, and Nebraska, boldly associating him with rich, inflated abundance on every hand.

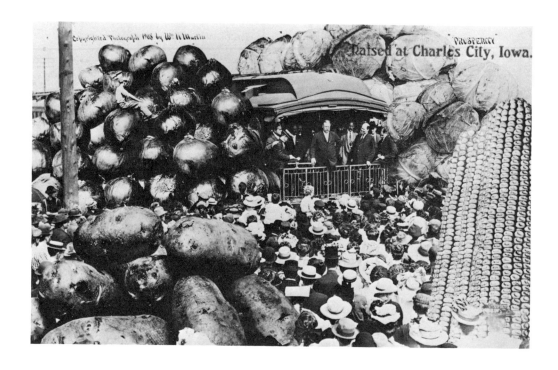

Martin also marketed cards with political messages—"Prosperity" and "His Trip Bore Fruit"—for Taft in his 1908 campaign for the presidency.

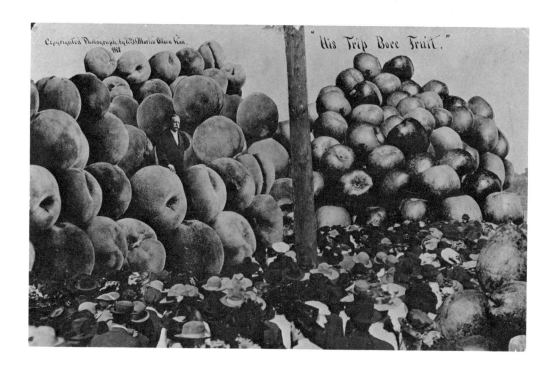

The colorful, pictorial, advertising handout was a very popular device at the turn of the century. Such advertising cards are considered valuable antiques today and are collected as avidly as antique postcards.

Some of the advertising cards also used the technique of exaggeration, but all examples I have seen were drawn rather than photographed.

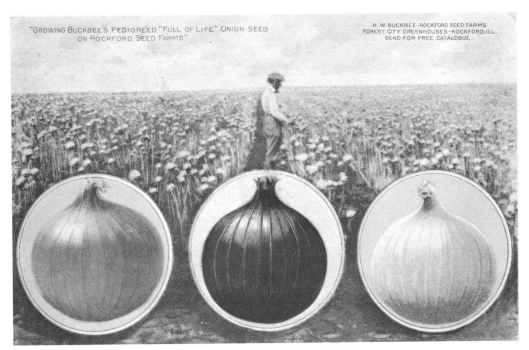

Seed catalogs are perhaps the closest rival to fishermen for stretching the truth. It is significant to the development and climax of the tall-tale postcard that at the same period the so-called "trade" cards were common marketing devices. This one, from Buckbee's Full-of-Life Seeds is not strictly speaking a tall-tale juxtaposition, but the exaggeration is nonetheless implicit.

This trade card from Bartelde's Seed Company, published by the M & M Novelty Company, is closer to the tall-tale postcard. It is not dated, but, as can be seen here, a date was written on the face of the card, March 4, 1912.

The Richmond Lithograph Company of Buffalo, New York, produced this set of cards for the Sioux City Nursery. Once more the exaggeration is not so dramatic that it produces the humor present in the best of the tall-tale postcards, but the idea of special bounty, which we have also found in the tall-tale postcard, can be seen in these trade cards too.

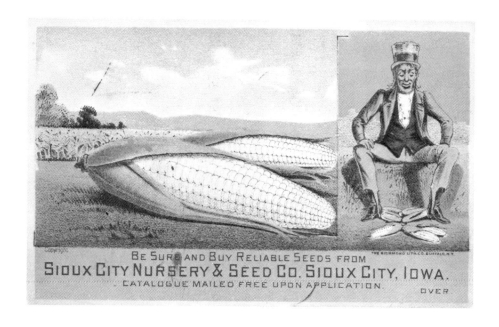

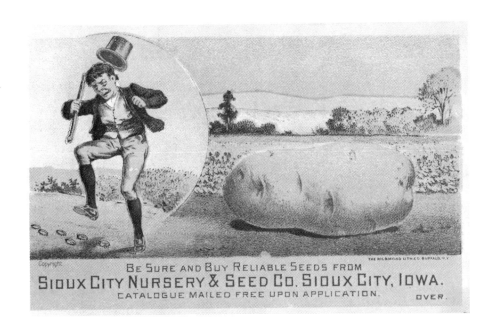

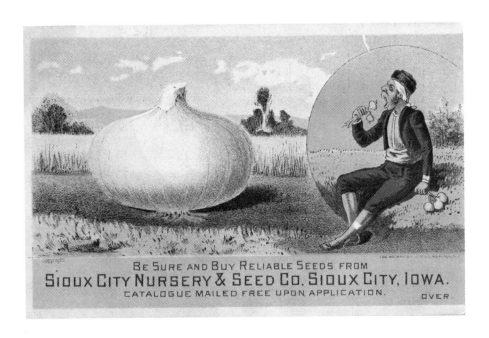

As can be seen from this illustration of the backside of the trade cards for the Sioux City Nursery, they were not produced to be sent as postcards, but were meant primarily to be collected, like today's baseball or football cards.

There is obviously no intent of humor in this postcard's exaggeration juxtaposition. The photographic manipulation is used, perhaps, to draw attention to the message and to dramatize the stature of the evangalist in the community.

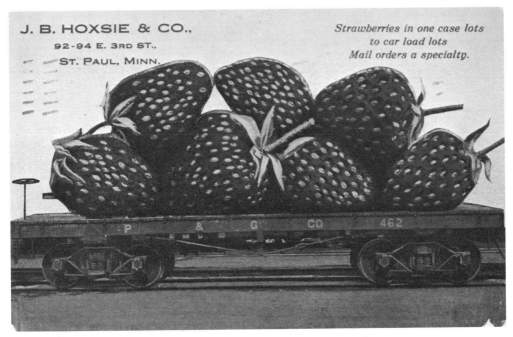

J. B. HOXSIE & CO.,
92-94 E. 3RD ST.,
ST. PAUL, MINN.

*Strawberries in one case lots
to car load lots
Mail orders a specialty.*

P & G CO 462

This postcard, published by R. Steinman & Company of St. Paul, Minnesota, is perhaps the most appropriate promotional use of a tall-tale postcard, for it is using a clear tall-tale exaggeration of strawberries to sell strawberries.

One carefully lettered message on the back of a card in my collection is doubly interesting because it is a homecraft advertisement, and, at the same time, tells us something about the importance of postcard collecting—and, specifically, tall-tale postcard collecting:

Hattie—these are some that was sent to me do you & Effie want to sign for Farm & Home for 6 months for 25 cents & ten cards like these wish you would and see if you could get some more to I want to get 12 & then I can get three free curtains. let me know.

One of the most frequent motifs in the written texts of tall-tale postcards—and without question the most unsettling and surprising—is news of disaster, illness, accident, sad news, and unhappy messages. A possible explanation for the use of such light-hearted, comic cards for ill tidings is that the poor too have to send sad words at times and it follows that they selected the least expensive way of sending those words—the postcard.

That does not at all explain, however, why the *comic* tall-tale card was so used, unless, perhaps, it was a way of reducing the jolt of the message, by incorporating a mild, innocent, impersonal note of good cheer along with the bad news. The following are illustrative:

Dear Ray—am not feeling quite so spry today. Dr. said I would get home next week. Say you might send me a $5 I still have $10 but must pay room rent and meals. I am going to May's and see if she can take me first of week. Stella.

. . . Is awful dry and hot here. Corn is burning up. I wrote to Mrs. Gaines quite a while ago she must of not got it. I sure was sorry for Aunt Nina hope she will get better. Clair has been sick, is better this morning.

. . . I will pen you a few lines this noon to let you know that grandma is better to day, terrible last night we have hope for her again.

I had a hard time yesterday. Had to take a hypo—and was sick all afternoon and night. I just left the office. no treatment needed to day. We pay $7.00 for room.

Dear Maude & Frank—Kirk was operated on this 9:00 A.M. the operation was a success as far as we can tell so far he is suffering intense pain now was on the table 2 hours. Bertha.

Dear Ante and Cousins—pa is still alive but getting weaker every day he is holding out pretty long so sick man we are looking for end not very far off rest are well. Martha still with us hope you all well love. . . .

[189

. . . Miss Sue is quite sick to day. seriously so. Hardening of the arteries & Hemorrhage of the lung. . . .

. . . Robbie got his arm broke. They are not going to tell Mrs S anything about it as it would spoil her visit. . . .

. . . Willie is sick. The Dr. thinks he is taking the fever though I hope not. I am only tolerable well. . . .

. . . Laura has not been a bit well. Was not when we started. . . .

Hello old sport. Well I am going about on one wheel these days. got a bad fall at the shop about a week ago and it put me out of business for some time. . . .

. . . I am on the sick list again. . . .

. . . Evelyn had her op last night we got our money back at the Hotel and had no trouble to get here we walked up the street aways then crossed went up one block got there just a few minutes before the Dr came and he went right to work. She was very nervous all night. She would talk and get up and do so many foolish things there are two others in the same room with us and they said she woke them up different times I don't think I would leave her here alone. I think I can bring her sooner than what he said yesterday. She began to bleed in the night so I called the home Dr as he told me in case it bled. Byby—Love Annie. . . .

. . . Myrtle is slowly improving. They are taking switchboard out today. Fired my girls Sat and now we are alone. . . .

. . . Ruth is getting better broke out with the german measles is not as thick as Wilbur was when he had them about 2 yrs ago don't know where she got them was not any place guess her teeth was what made her sick she is very cross. From Lizzie.

And here is my nomination for the international award for grossly insensitive letters, best of class, open competition:

Dear Sis—Ida Betts gave birth to a dead baby girl Dec 16-1- and she came near dying. She lay under chloroform 2 hours after the baby was born. Will cried like a baby when the baby was born and they thot Ida was dying. She is quite low but getting along as well as can be expected. They had to take the baby away from her. They buried it in the sweetest little coffin and nice clothes. It looked like Ida—weighed 10 lbs. Have you named your boy yet? Your Sis, Ellen.

Remember that Sweet Ellen wrote that tragic news,

with apparently chipper spirit, on a postcard! A joke postcard!! And then she had the incredible audacity to ask whether her sister had named her newborn yet!!! It was enough to make me furious sixty-three years after the event.

Nor were all of the tragedies recorded on tall-tale postcards human ones:

. . . All the horses got distemper . . .

Received your card all right from ——— [illegible on card]. We just have one dog. The other two got cross and papa killed them.

A good many cards carry accounts of heavy weather—

". . . We are having another snowstorm & the roads are a fright. . . ."—underlining both the rural use of such cards and the fact that only during times of inclemency could the farmers find time to write even the short note restricted by the 3 x 3 inch message section of a picture postcard.

The texts of two postcards carry inauspicious messages that, nonetheless, leave the eavesdropper's curiousity unsatisfied:

. . . Last night there was a hole up about a block away from us about half past nine. We heard the shooting. We have not heard any more about it. Well. . . .

. . . Ma had a feller yesterday God dam him. Shell tell you about it. . . .

The oldest card of my own collection is in Swedish and the handwriting is so minute and blurred that it is hard to imagine that the recipient—even if he could read Swedish, and his name, Larson, suggests that he could—deciphered this one. Two other cards carry messages written in Scandinavian languages, suggesting, I believe, not so much that Scandinavians were drawn to this type of humor, but that a preponderance of rural immigrants in the Midwest during this period were Scandinavians.

However, it must be noted that the tall tale does occur in Scandinavia too. During the summer of 1973 when I was in Norway, a friend, Inger Burns, told me about a story commonly told in which the mosquitoes are so large that they are killed and dried for later use as milking stools.

Collectors and casual observers of tall-tale postcards are sometimes puzzled by postcards that bear messages (sometimes spread over the entire reverse side of the card), but have no stamps, or postmarks.

Such cards were sent in envelopes, serving as a form of stationery. Thus they avoided the wear and tear of passing through the postal system, of being cancelled and handled. Thus they could be put into the recipient's postcard album in pristine condition.

Tall-tale postcards were often sent with no message—only an address—and others were covered on the reverse side with a message, but no address. These were cards destined for a collector's album or shoebox. Those with no address or stamp were sent in envelopes to prevent scarring by handling or cancellation in the postal system.

Jan 18 — 1900.

Dear Edna: —
Don't these look
good enough to
eat? I received your
dainty little calendar
and want to thank
you for sending it
to me. I will think
of you every time
I look at it.
The weather
is freezing cold in
San Francisco at
present.
Love & best
Alice

246

60

Fresno June 28

all well

Weather cool

waiting for a letter

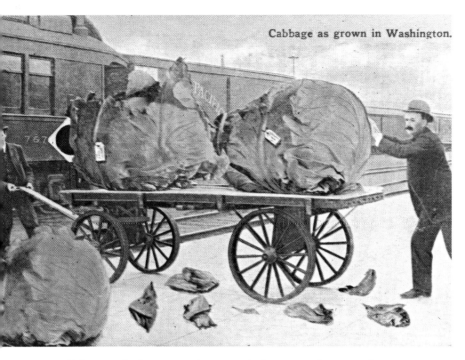

Cabbage as grown in Washington.

Oakes used the same photograph for several postcard juxtapositions, sometimes reversing the negatives to add variation. These cards, like all of Oakes's, are dated 1907.

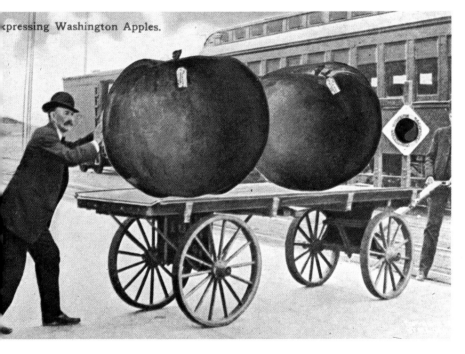

xpressing Washington Apples.

RIGHT 1910
D H MITCHELL
FRANCISCO. 2190
A CALIFORNIA HONE

Huge fruit used as a balloon is a significant variation on Mitchell's large-fruit-on-the-railroad-car theme.

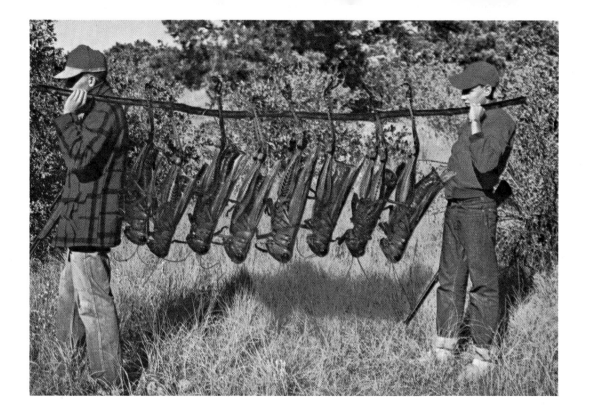

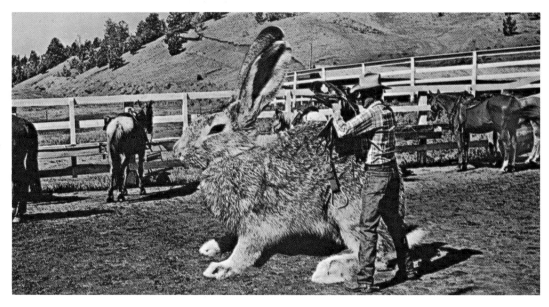

Two Roberts cards. These remain popular even though the popularity of the postcard as a genre has declined. The cards are distributed by Kontinental Kards of Colorado Springs, Colorado.

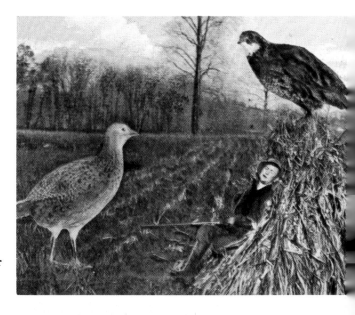

This Herman card is a unique depiction of a hunter apparently dreaming the exaggeration portrayed.

Almond N.Y.
Sep 27-1913
Went To Arthur
and Maxbell Fishers
Abbie and Hazel
Went With Me
Went On The Train
This card Was Givin
MaxBell Fisher To

His aunt
Anna C
Hammond

Mrs May Merchant

Fredonia

[193

Gimmicks and Gags:
Other Types of Photographic Exaggeration

Up to now we have been looking primarily at post-cards and photographs where, as I have explained, the photographer took two pictures—one, for example, of an ear of corn, and another of a railroad car. He then cut the ear of corn carefully out of its picture and pasted it on the other picture so that it appeared that the single ear of corn filled the entire railcar. He then took a picture of this composite and had the basis for his tall-tale postcard.

The collector, however, encounters other kinds of exaggerated postcard scenes that must, in some capacity, also be viewed as tall tales in graphic depiction. Some are simple photographs of large models of an item.

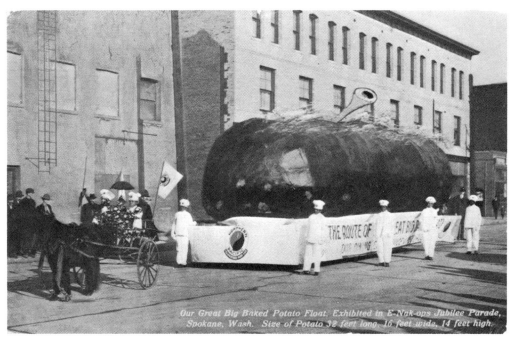

Our Great Big Baked Potato Float, Exhibited in E-Nok-ops Jubilee Parade, Spokane, Wash. Size of Potato 32 feet long, 16 feet wide, 14 feet high.

The true tall-tale postcard is a splicing of two or more separate pictures. Here there is exaggeration, but not by virtue of photographic manipulation of that type. This is clearly a float from a parade, presented by the Northern Railroad.

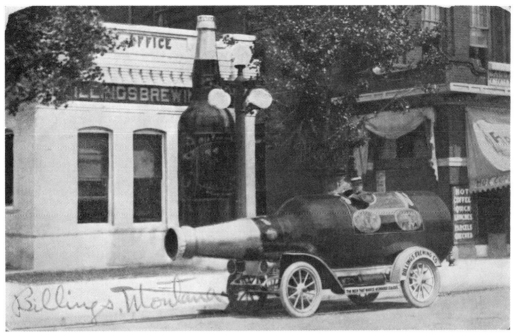

This card published by the Spokane Post Card Company of Spokane, Washington, depicts what was obviously an advertising vehicle—a clever one—for a brewery.

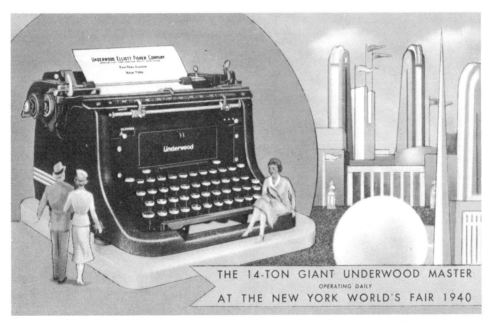

America has long prided itself on being a country of big—of biggest—things, and so it is to be expected that big things would find their way to the faces of postcards. This gigantic typewriter is not a photographic trick, but an industrial manufacturing trick.

There are also those postcards that show larger than normal examples of ordinary objects and are therefore not really photographic trickery at all.

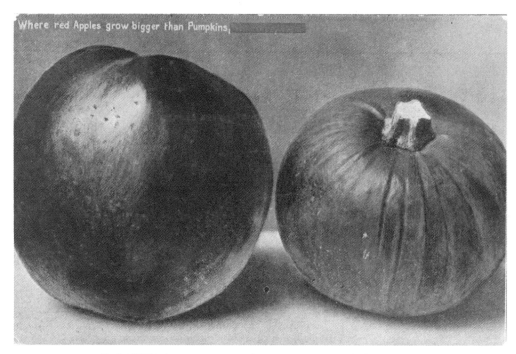

It is difficult to ascertain the exact nature of this postcard that was published by the Trattner Post Card Company of Seattle, Washington. Is it indeed an example of photographic trickery—or a small pumpkin?

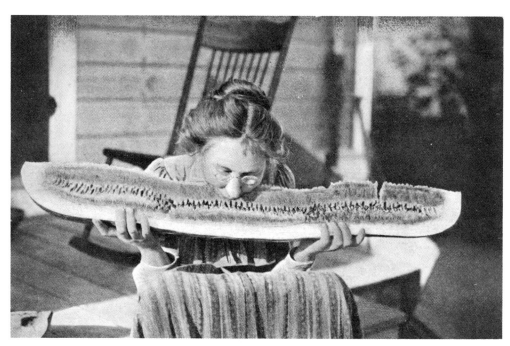

This particular card is a baffling problem for categorization. Is there any kind of exaggeration here at all? Or is this simply an ordinary, big watermelon and an ordinary, but particularly gluttonous lady? This card was published by M. Rieder of Los Angeles.

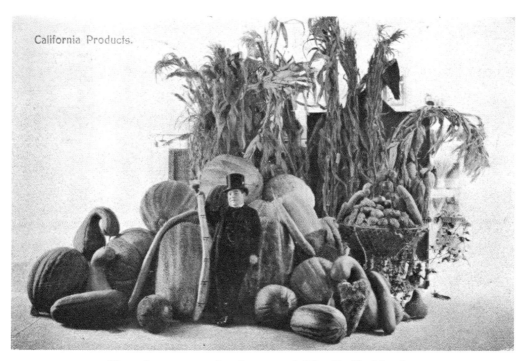

California Products.

Here the exaggeration is reversed. The Pacific Novelty Company issued this postcard of handsome produce and emphasized its size by photographing it in the presence of a midget.

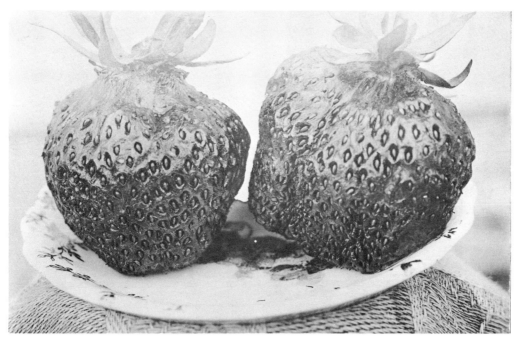

This card was sent by W. C. Hebdon of Blair, Nebraska, to a customer to notify him that his strawberry plants were ready for delivery. It is on loan from Mrs. Cecil Schmitt. The strawberries are clearly not actually cabbage-sized, but the photograph has probably not been tampered with. Two large berries were probably photographed on a toy dish.

The impact of this pair of fishermen's trophy postcards is the same as the true tall-tale card, but they are more than likely simple photographs of particularly large catches. The first is an undated product of the Detroit Publishing Company, the second of M. Rieder, Los Angeles.

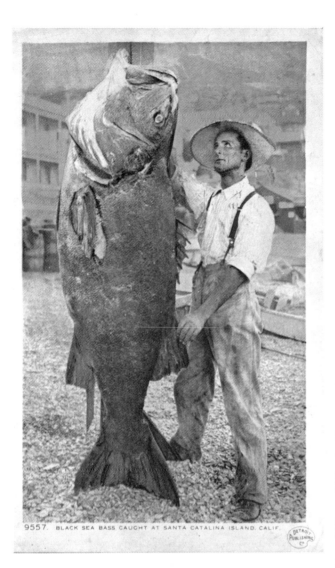

9557. BLACK SEA BASS CAUGHT AT SANTA CATALINA ISLAND, CALIF.

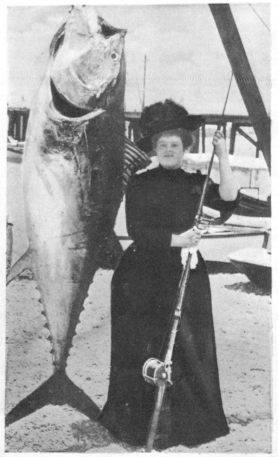

Tuna Caught at Catalina with Rod and Reel.

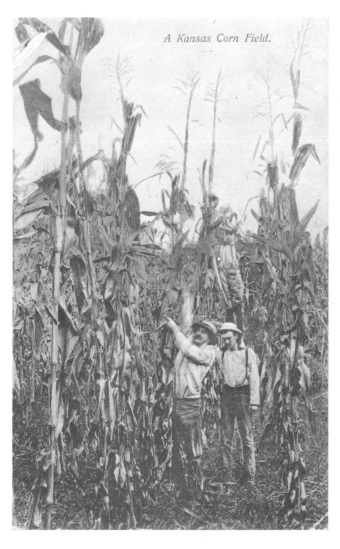

A Kansas Corn Field.

It will be hard to convince some people that these two postcards are not outright lies, but certain breeds of corn of this height do grow on the Plains prairie during good years. The first card was published by Ekstrand Drug and Book Company of Salina, Kansas; the second is not identified.

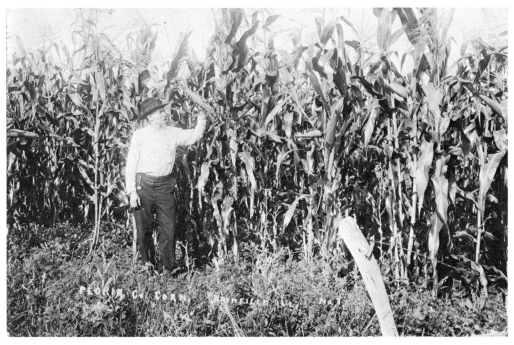

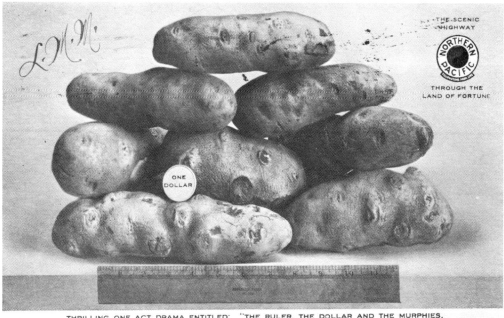

THRILLING ONE ACT DRAMA ENTITLED: "THE RULER, THE DOLLAR AND THE MURPHIES, OR WHY THE SMITHS LEFT HOME AND TRAVELED BY THE NORTHERN PACIFIC RAILWAY."

Here again the only exaggeration is the selection of particularly spectacular produce. The Northern Pacific Railroad published and distributed such postcards to promote travel to "the Land of Fortune."

Some pictorial postcards portray peculiar circumstances for humorous effect or simply show very ordinary scenes that are then transformed into a humorous exaggeration by virtue of the printed text. (See photos as shown.)

European postcards featuring photographic juxtapositions frequently derived their humor not from a false impression of size, but rather from a bizarre, inappropriate, unlikely logic.

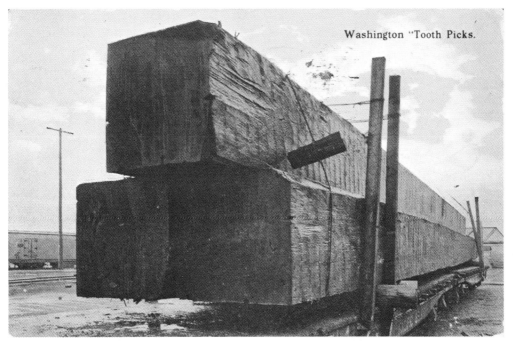

The ordinary scene of a railcar of Washington lumber timber is moved into the spectrum of the tall-tale by the publisher's caption, "Washington Tooth Picks," suggesting that these huge hunks of wood are really not all that spectacular in a wonderland of gigantic things. This card was published by Lowman and Huford Company of Seattle, Washington. It is probably a fairly late postcard, perhaps 1950, and appears with some frequency in collections today.

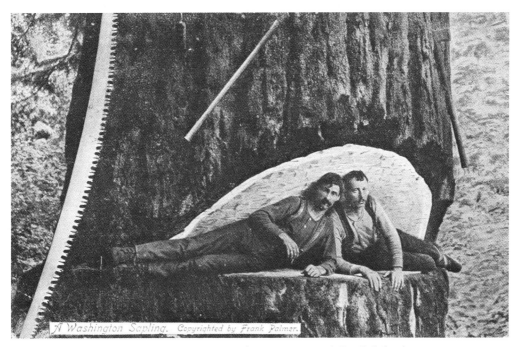

This postcard, on loan from Terry and Patti Schmitt, draws its humor from an unlikely caption suggesting that a tree huge enough to enclose the bodies of two lumberjacks is only a sapling in Washington. The card was published by Frank Palmer, Spokane Post Card Company, Spokane, Washington, in 1910.

In some photographic postcards it is obvious that one of the features—the exaggerated one usually—is simply an enlarged photograph that has been included as a normal element of the photo. For example, in one picture, the "girl" who is apparently sporting with the slicked-up country lads is actually only a large photograph or poster. The same is true of the fish in another photographic postcard. (See photos.)

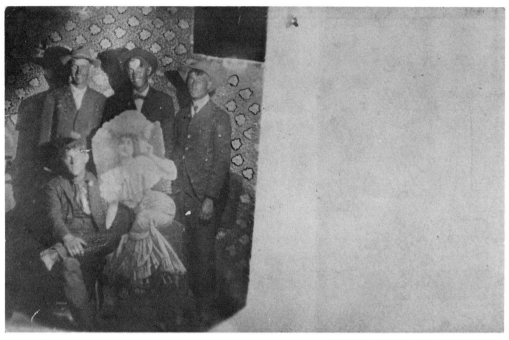

These two postcards represent very unusual efforts at photographic fakery in that a picture has been incorporated, with an effort at humorous deception, into a straightforward photograph. The first photograph of what might be a stag party with nothing more naughty than a life-size picture of a floozy is probably a home photograph and has no identifying mark whatever. The second was issued by the Auditorium Studio "On The Pier," Long Beach, California, and is not dated.

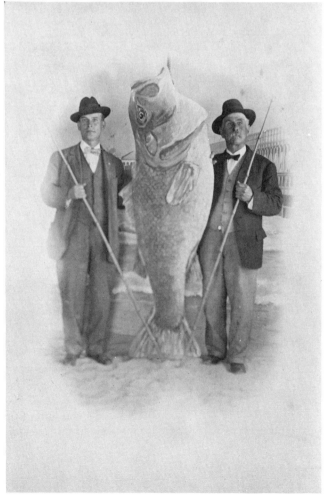

The photographic postcard with the fish may be a carnival picture—that is, a photographer set up a booth at a fair or carnival and then took pictures, for a fee, of a carnival goer with the cardboard fish, and then printed the postcard for him to send to his envious friends. Such attractions were very popular at fairs throughout the country during the early decades of the century and the frequency with which one finds such carnival photographs in antique dealers postcard files suggests that carnival photographers had a good business. The scenes, bodies, etc., were painted on a board and the customer simply put his head through a hole in the backdrop, and his face became a part of the entirety. From the expressions on these faces one must wonder if the photography of the period wasn't considerably more painful than that which we enjoy today!

Another concept of photographic trickery is unique to amusement parks. It takes two forms: photographic imposition of a person's face on a printed card with a comic situation or caption on it or a simple photograph of a person's head—usually wearing a hat—put through a hole in a backdrop with the comic scene or legend on it. Such cards, of course, were usually produced in lots of one or two, to be sent home by the lucky reveler, and so there were not many of any one example produced, but the popularity of the idea can be seen in the number of such cards that can still be encountered in collections. The first of this set was printed at 1517 Boardwalk, Atlantic City, New Jersey, and is not dated. The fourth was made by Myers-Cope Company on the Boardwalk in Atlantic City, as was also the sixth. The Boardwalk was obviously a popular site for such photos, for Carlin Studio on the Boardwalk "opposite the Steeplechase Pier" produced the eighth example shown here. Fletl Studio, with the same address as the first example and probably therefore the same manufacturer, produced the tenth. The rest have no identifying mark.

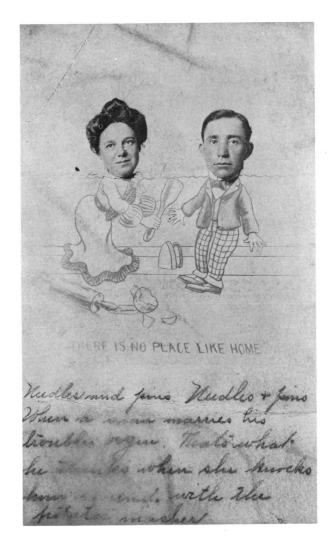

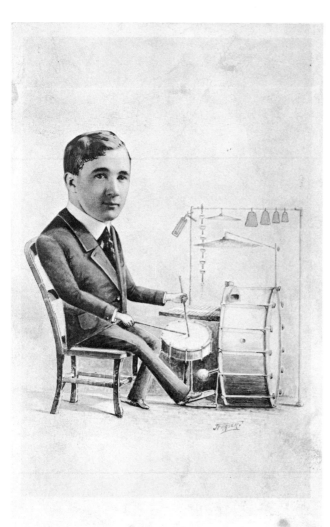

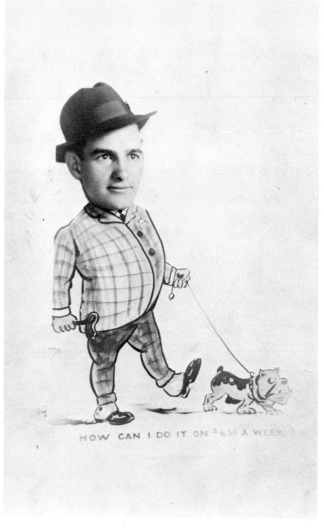

HOW CAN I DO IT ON $6.50 A WEEK?

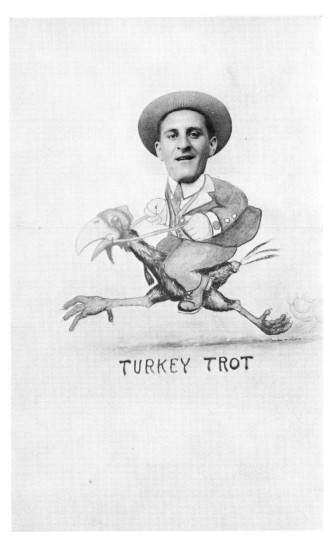

TURKEY TROT

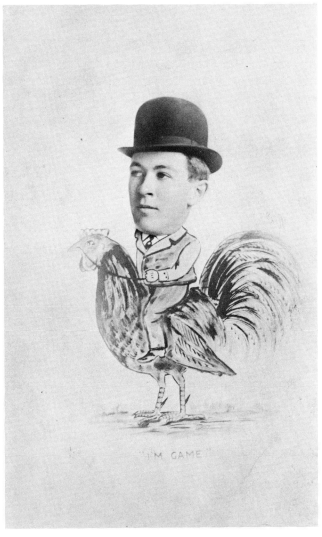

"I'M GAME"

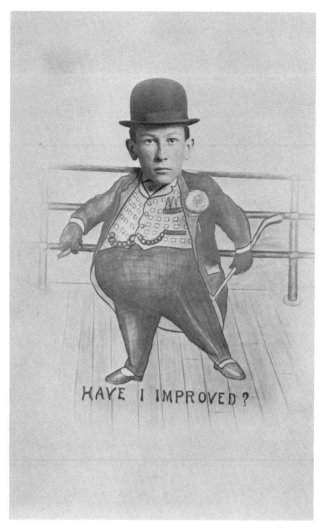

HAVE I IMPROVED?

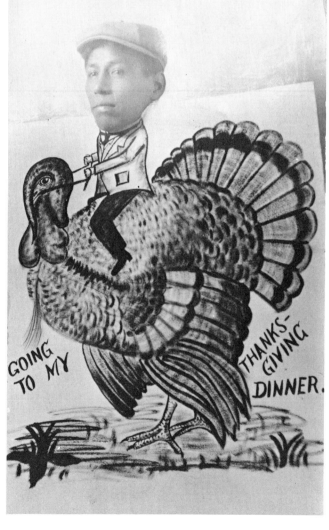

GOING TO MY THANKS-GIVING DINNER.

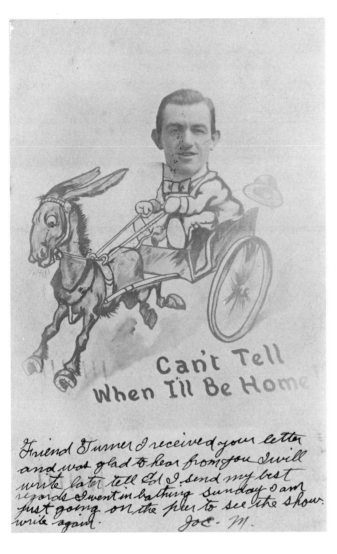

Can't Tell
When I'll Be Home

Friend Turner I received your letter and was glad to hear from you I will write later tell Ed I send my best regards I went in bathing Sunday I am just going on the pier to see the show. write again.
Joe. M.

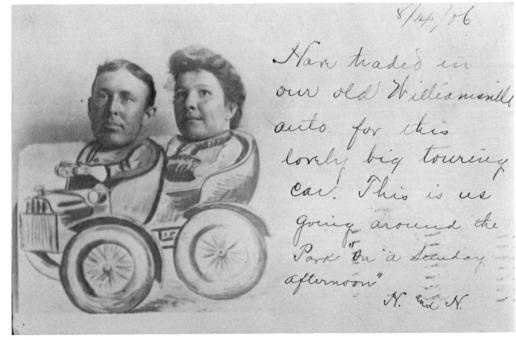

8/14, '06

Have traded in our old Williamsville auto. for this lovely big touring car. This is us going around the Park on "a Sunday afternoon"
N. and N.

A SURE LEAPYEAR BAIT

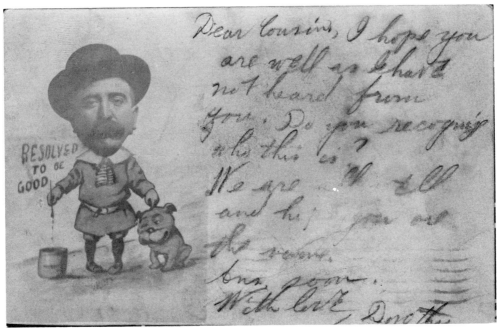

Dear Cousin, I hope you
are well as I have
not heard from
you. Do you recognize
who this is?
We are all well
and hope you are
the same.
Ans soon.
With love,
Dorothy

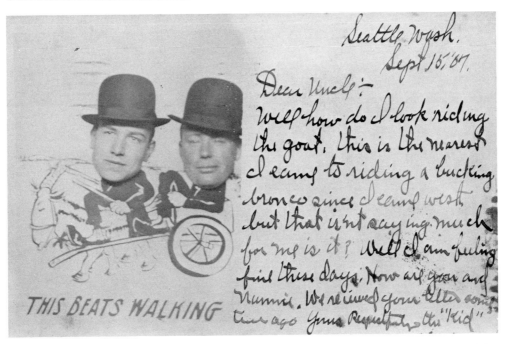

RESOLVED TO BE GOOD

THIS BEATS WALKING

Seattle, Wash.
Sept 15, '07.
Dear Uncle:—
Well how do I look riding
the goat. this is the nearest
I came to riding a bucking
bronco since I came west
but that isn't saying much
for me is it? Well I am feeling
fine these days, How are you and
Nannie. We received your letter some
time ago. Yours Respectfully, the "Kid"

An occasional effort was—and still sometimes is—made to produce a tall-tale card by photographing normal sized fruit in conjunction with realistic toys, thus arriving at roughly the same result as could be reached with a photographic juxtaposition. (See photos for examples.) The efforts, however, result in variable effectiveness, rarely achieving the impact of the true tall-tale postcard.

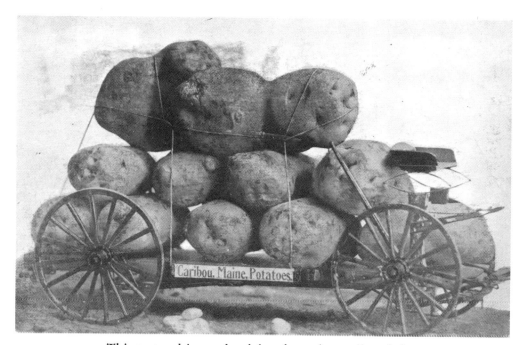

This postcard is not dated, but from the quality of the printing and the paper and the type of toy wagon used, it can be assumed with some safety that it is an early effort to produce a tall-tale effect by using normal produce on a toy vehicle. The card was produced by the Gibbon Drug Company, no location or date given.

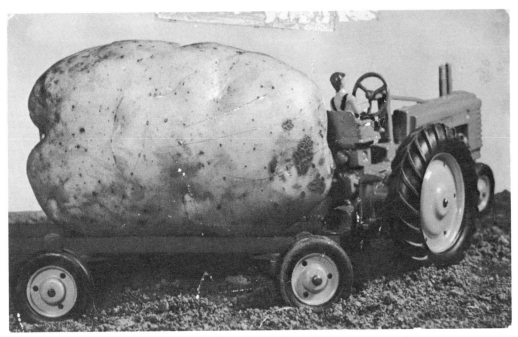

This card, on loan from Mrs. Cecil Schmitt, was published by Rhodes News Agency of Boise, Idaho. It is not dated. It is a very clumsy effort to suggest a tall-tale situation without the kind of effort and skill that produces the effective exaggeration.

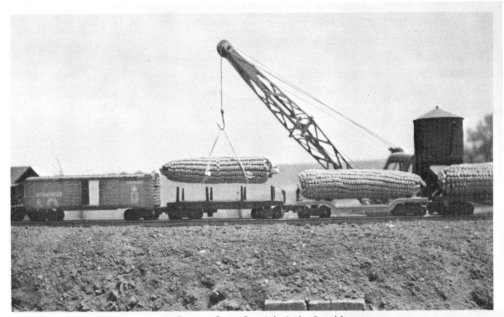

Iowa - Corn Capital of the World

Here toys have been used in an effort to produce an easy tall-tale postcard, and while it is better than the postcard immediately preceding, it falls far short of the effect achieved by masters like Martin, Johnson, or King, who did their work perhaps fifty years before this one. This postcard was produced by Stanley J. Mouser of Wellman, Iowa, and was provided by William Quade.

6

Booby Prizes

I would not like to leave the impression, however, that all photographers who worked at the tall-tale postcard were masters. That would make the art seem too easy. It was hard work to produce a really good freak postcard and any loafing would show through in the final product. Indeed, I feel that these failures make the smooth productions of people like Martin, King, and Johnson all the more impressive.

C. C. Slack of Soo [sic] Falls, South Dakota, did turn out some very good tall-tale cards in which the photographic juxtaposing was at least adequate if not polished. I hope that the two disasters entitled, "Hurrah for Bryant, S.D." and "We Are Feeling Pretty Foxy At Bryant, S.D.," were some of his first efforts.

C. C. Slack of Soo (*sic*) Falls, South Dakota, did publish some fairly respectable efforts at the tall-tale postcard, but he also has the distinction of having issued the two worst examples of the category. The work is sloppy, the concept appalling, and the quality painfully primitive.

Something went wrong with the perspective on the card entitled, "Spuds from California." The bed of the flatcar is on the wrong slant with the field in the background, the potato looks as if it should roll off the railcar, and the man in the carriage winds up looking bigger than the flatbed. Looking at the card more than a few minutes will give you a hopeless headache. The publisher wisely did not label the card with his name. (See photo.)

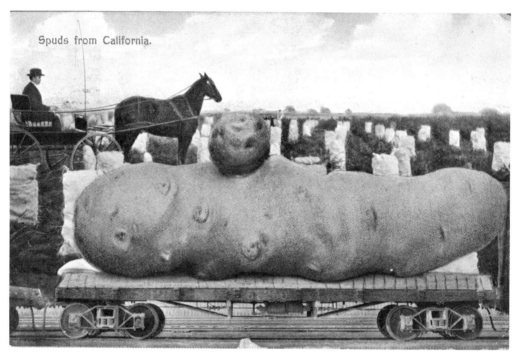

Spuds from California.

Difficulties with perspective seem to have been concentrated on the west coast. Mitchell especially had his troubles, as we have seen, and so did M. L. Oakes, but this postcard published by the Newman Postcard Company of Los Angeles for the Southern Pacific Railroad is particularly faulty. It is not dated.

7

Spin-Offs: Non-Photographic Exaggeration

Drawn and painted tall-tale postcards seem to contradict and conflict with the point of the humor of the photographic juxtaposition. In the case of photographic trickery, one sees a photograph of something that simply cannot be. It is a surprising, mind-boggling piece of magic. The viewer *knows* that fish, chickens, watermelon, or whatever simply cannot be that big, but there is a photograph, presumably a direct representation of fact. Of course no one is fooled by the photos, but the trick itself is interesting and eye-catching.

But a card that is drawn or painted by some artist with a huge watermelon or fish, to my mind, falls utterly short. Anyone can draw a man with a huge pumpkin—a pumpkin of any size, which brings one to ask, "So what?"

Curiously, the drawn and painted tall-tale postcards came much later than the photographic models, running from about 1909—but then with only sparse appearance—to the present day, apparently peaking about 1935, according to the distribution of the cards in my corpus. This is curious because by this time photography had come into maturity and would have provided even greater opportunities for experimenta-

tion and trickery than had been possible in 1909 or 1910. Why then were artists hired to paint and draw the pale imitations? The answer is perhaps economic; it cost less to print line drawings than photographs.

The drawn and painted cards show little of the imagination of the photographic examples, dealing almost exclusively with fish and obviously directed toward tourist and resort trade.

One of the earliest and clearly the best series of drawn cards dominates the entire field of drawn cards. Unfortunately, it is impossible to identify the cards from any markings on them and the sign of the publisher, an "S" and a "B" superimposed on each other is not listed in any American indices even though the cards are labeled "Made in the U.S.A." The cards in my collection bear postmarks from coast to coast with fairly even distribution so this is also not a hint of where the cards might have been manufactured. The postmarks are dated primarily before 1920, however, and this provides the clue that the craftsmanship in drawn cards, like that of the photographic cards, was at its best early in the history of the tall-tale postcard.

Obviously the impact of the tall-tale postcard lay in large part in the common belief that photography captures reality. "Here is a *photograph* of a grasshopper larger than a man," seemed to be the message. Just as obviously, the impact of that statement is diminished where the scene is drawn rather than photographed; anything, after all, can be drawn. However, the most effective of the drawn postcards are those by the B & S (or S & B—it is impossible to determine which from the publisher's logo) Publishing Company. The colors are handsome, the drawings are clear and imaginative, and the laconic delivery of the caption line is in keeping with the style of the tradition. None of these cards contains any further information than the publisher's logo.

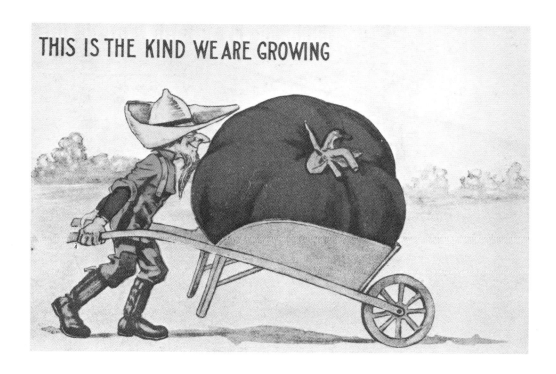

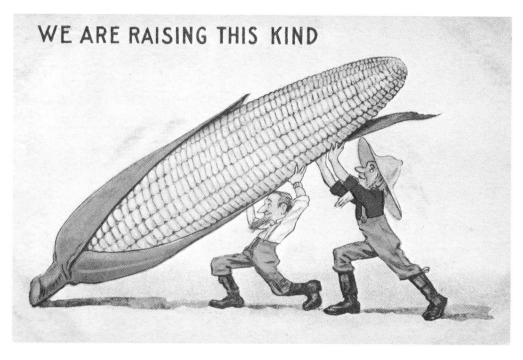

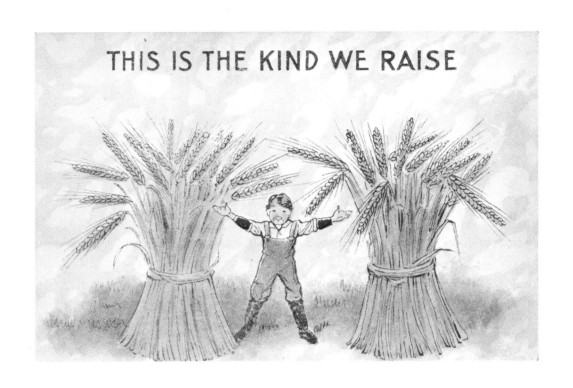

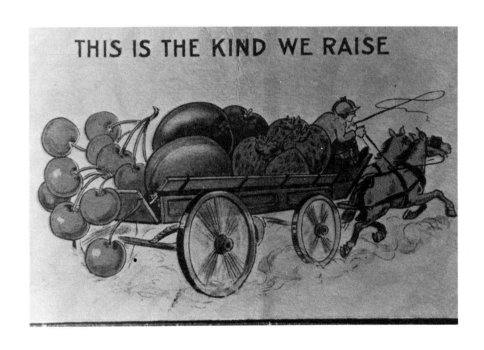

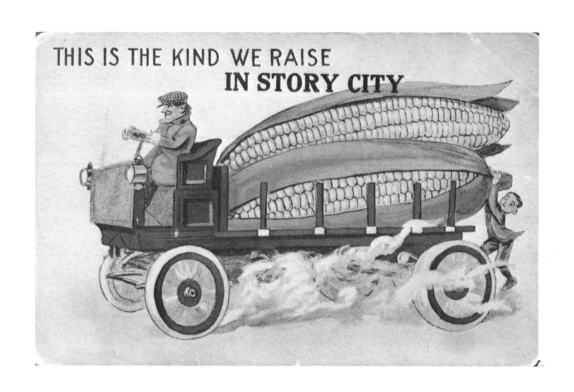

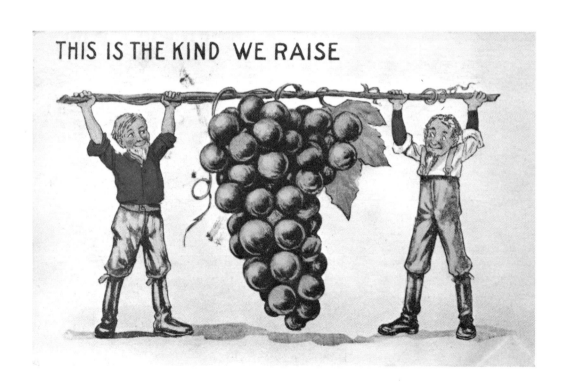

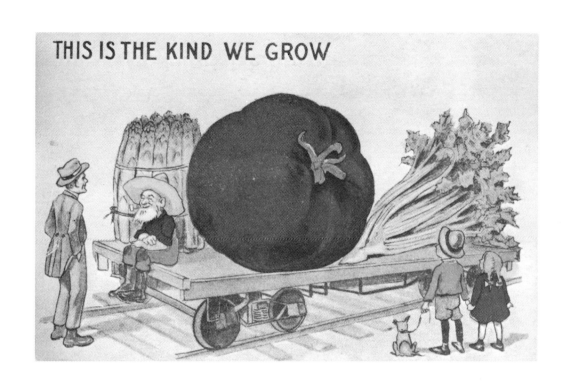

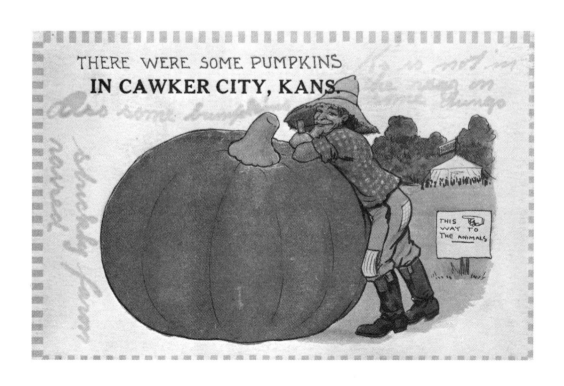

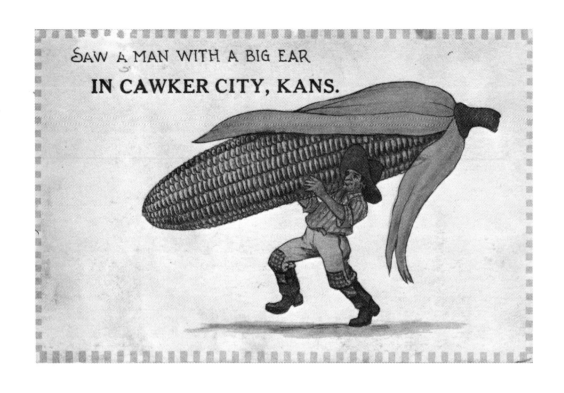

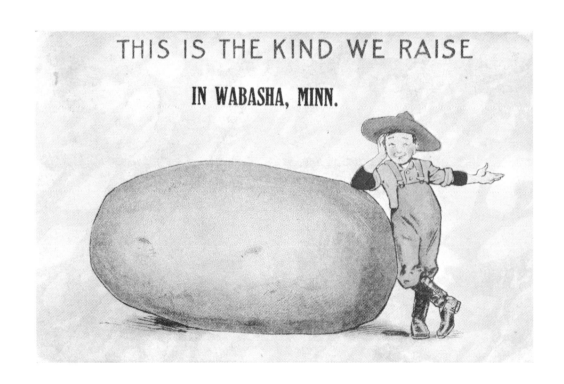

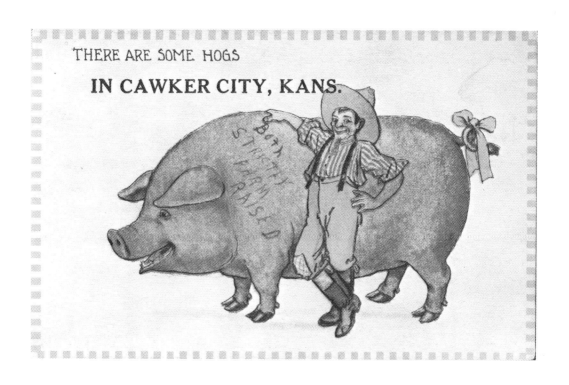

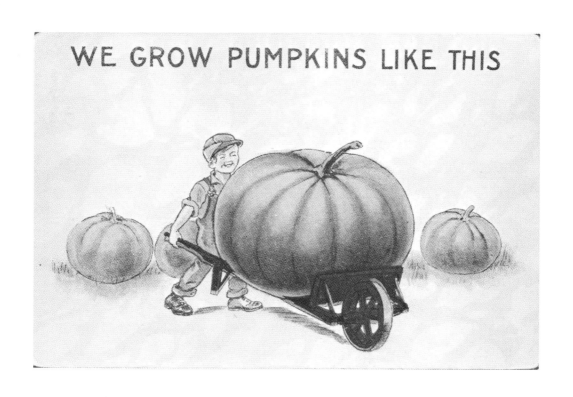

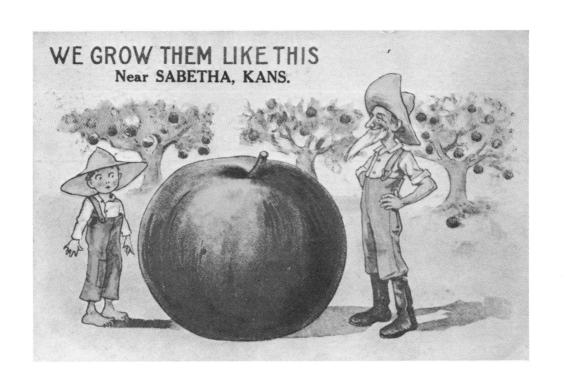

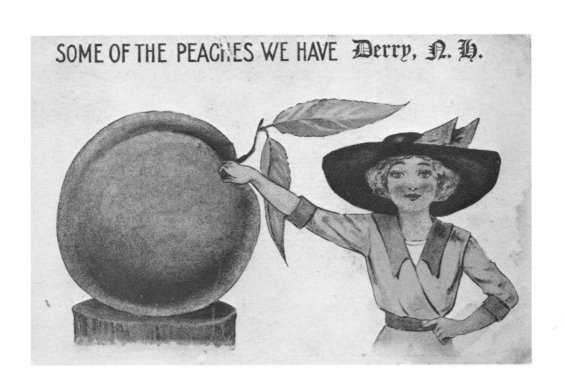

Other, later, drawn (rather than photographed) postcards were executed with various degrees of success. The card labeled "Just Wait till I tell You About landing 'this' One!" is poorly drawn while "Souvenir From" lacks humor in its exaggeration.

Here is a striking contrast between the well developed tall-tale and the failure. Both are drawings, and neither approaches the effectiveness of a William Martin postcard, but the first of this pair has a certain humor to it, especially in conjunction with the caption, in the comparison of the hum of a mosquito to the music of a fiddle. The humor intended in the second example is far less striking.

A Native June From Bloomfield, N. J.

Way down in my Heart
I've a feeling for You

Copyrighted 1904 by E. B. & E.

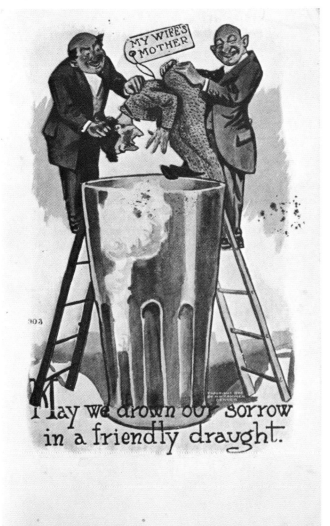

This card, published by H. M. Tanner of Denver in 1904, has considerable humor in its intent, but little in the actual exaggeration of the glass of beer.

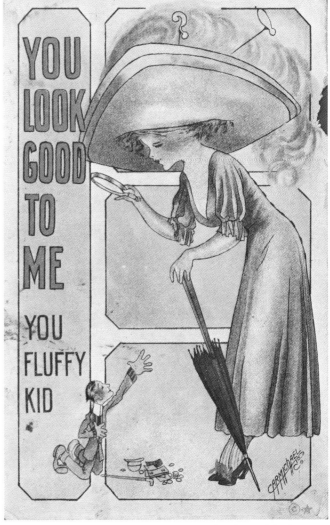

Carmichael Post Card Company published this drawn card that parallels photographic cards depicting the small helpless man at the mercy of the beautiful, "super-chapeaued" woman.

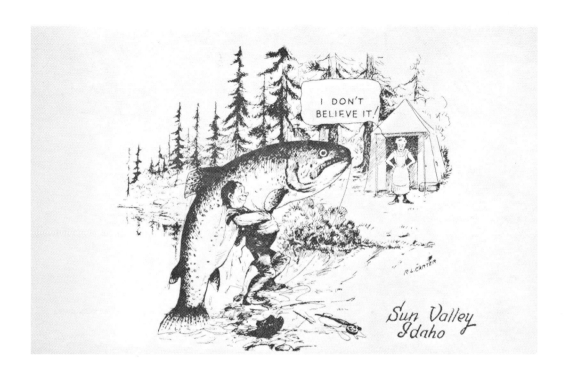

Drawn postcards used much the same exaggeration as did the photographic forms, though less effectively. These two postcards (the first by the Reeve Art Company, undated, and the second by Julius Bien and Company of New York in 1907, Keystone Post Cards "Wild Animals" series number 80) treat the familiar fisherman's theme.

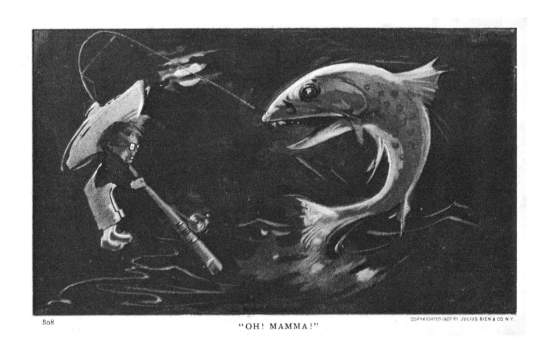

808

"OH! MAMMA!"

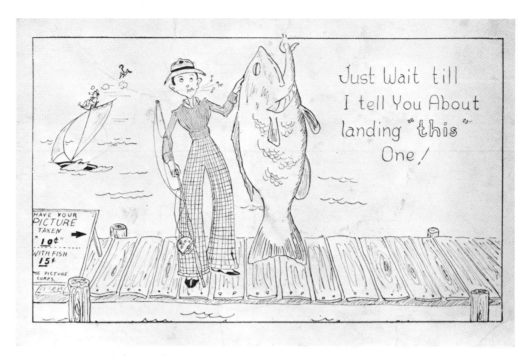

This card, poorly drawn and with weak humor, clearly misses the wonder of the photographic tall-tale post-card.

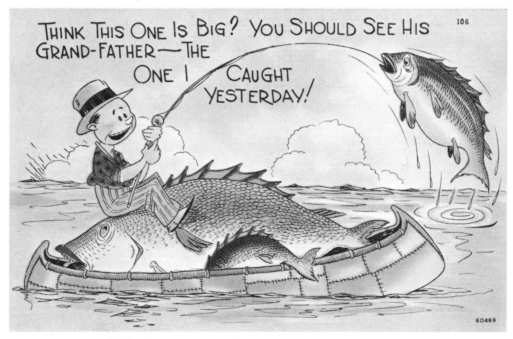

Cards of this type come closer to the model of the photographic prototype, in large part because the greater skill in the execution of the drawings brings the scene closer to life.

If pointless photographic exaggerations were humorless, the drawn analogues are even less inspiring. Even photographed, a huge seashell behind children playing on the beach would not have much purpose or point; drawn like this it is not even interesting as a curiosity.

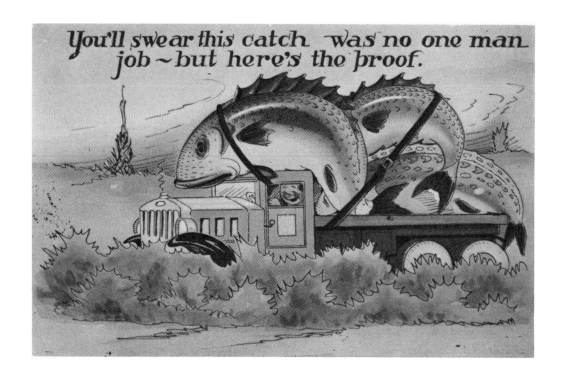

In drawn postcards like this pair, there is some interest
in the well executed art work even if the exaggeration
is unconvincing.

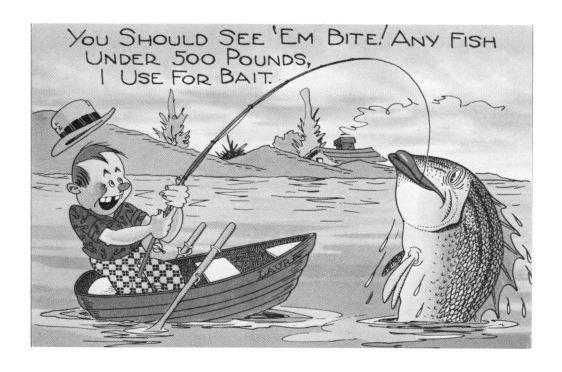

A good many drawn and painted tall-tale postcards were copied from photographic tall-tale cards, again an inexplicable sequence of events, since it would seem more logical for the deceptive photographic examples to have followed the less than convincing drawn models.

This trio of drawings was taken from photographs and was then tinted, probably because of the difficulty and expense of printing colored postcards from photographs. To my own taste, the black and white photographs were more effective and humorous.

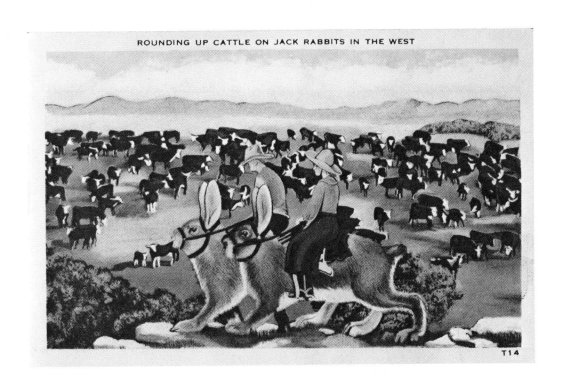

ROUNDING UP CATTLE ON JACK RABBITS IN THE WEST

[229

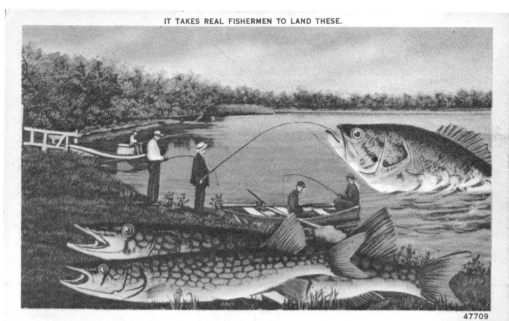

IT TAKES REAL FISHERMEN TO LAND THESE.

47709

Greetings from RINGOES, N. J.

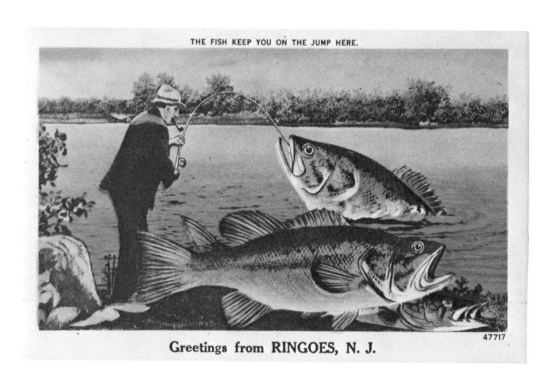

THE FISH KEEP YOU ON THE JUMP HERE.

47717

Greetings from RINGOES, N. J.

230]

An excellently executed drawn card is identified by a signature as having been done by "Witt." The style is close enough to B & S that they can be confused or suspected as being somehow kin, but no B & S cards are signed and no "Witt" cards bear the B & S logo. These cards do not pretend to be imitation photographs but are in reality a genre apart.

These postcards are identified only by the artist's last name—Witt, and that is a pity because he certainly deserves full credit for producing a fine effect with his drawings. They are still, to my taste, not as striking as the photographic forms, but when viewed as a separate or alternative form of humorous postcard they deserve substantial credit as a substantial contribution to the tall-tale theme. The last example of the series is on loan from Mrs. Cecil Schmitt.

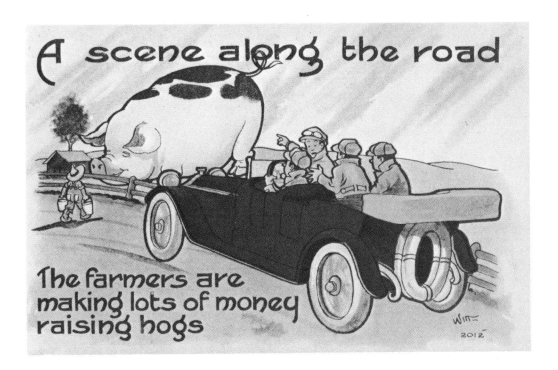

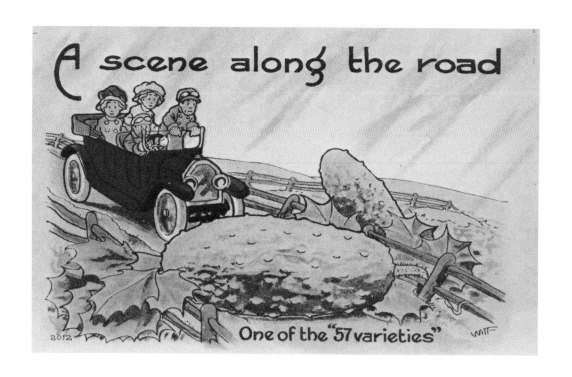

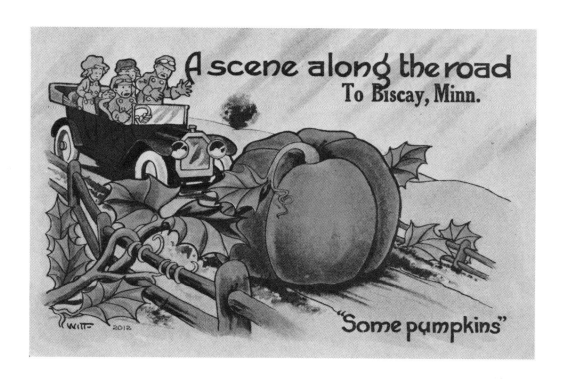

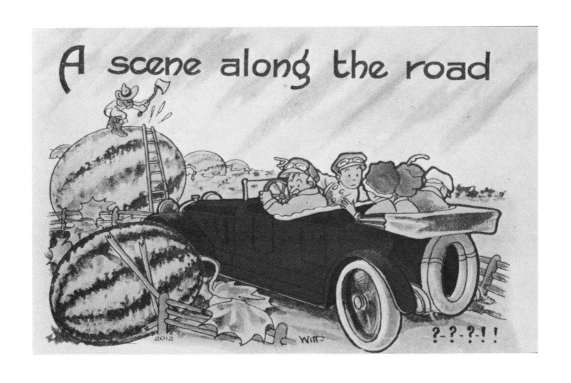

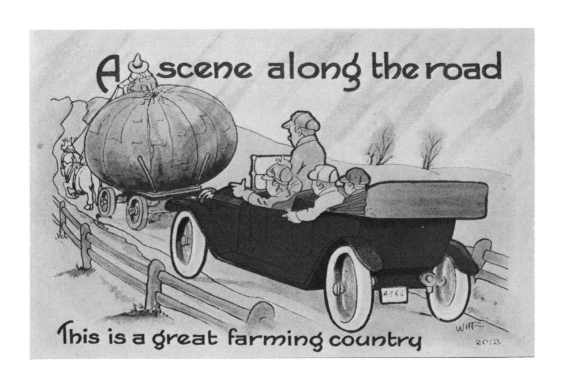

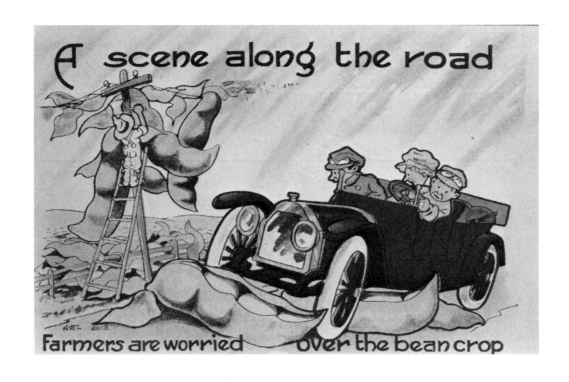

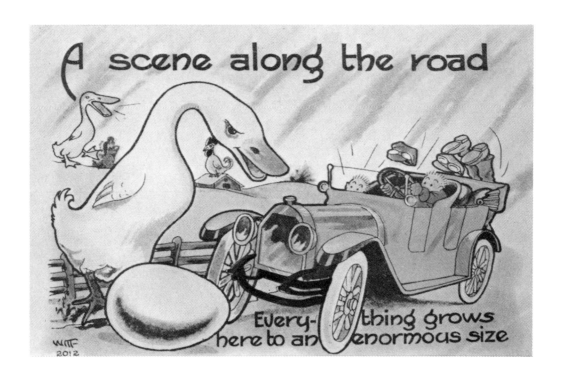

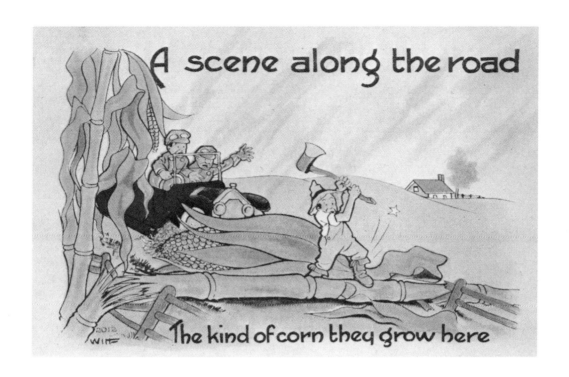

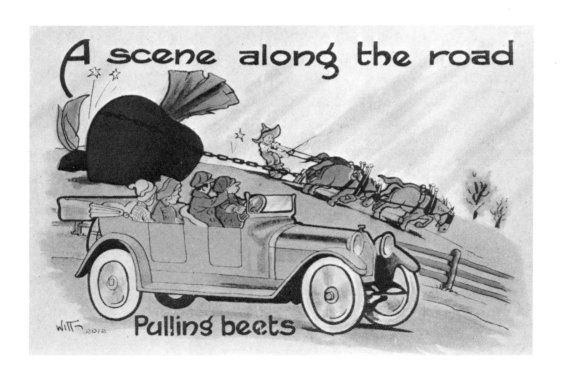

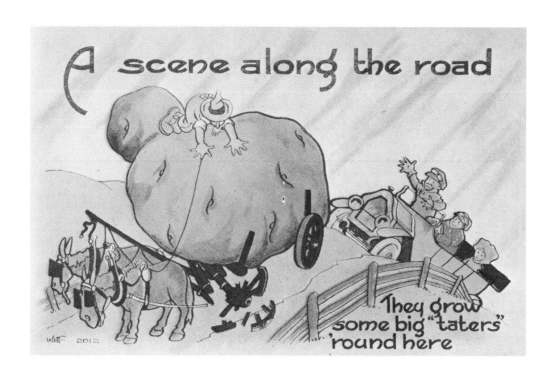

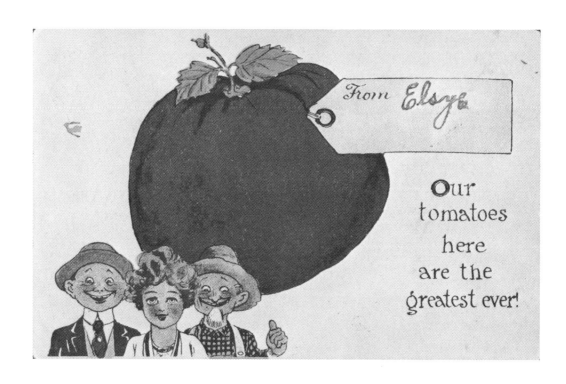

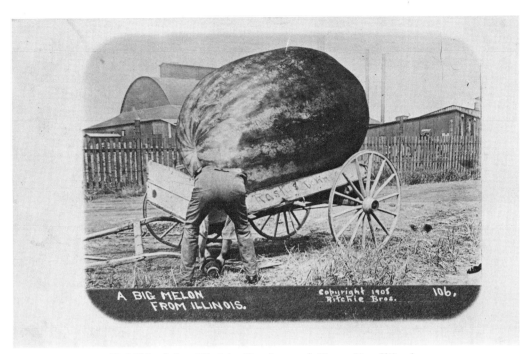

A BIG MELON
FROM ILLINOIS.

Copyright 1908
Ritchie Bros.

106,

Published by Ritchie Brothers of Centralia, Illinois,
in 1908.

Appendix: *Tall-Tale Postcards and the Antique Market*

Suggesting prices for antiques sight unseen is at best a shaky business, and this is certainly true in the case of antique postal cards. However, I will try to offer some minimal advice here for those who are interested in starting a collection or selling cards they might have come across. Although I have paid only five cents each for a sizeable proportion of my own collection, and as high as two dollars for a single card in extraordinary circumstances, I find that most antique dealers are now asking between fifteen and fifty cents each for most standard postcards, including the tall-tale cards as treated in these pages.

Prices on antiques have been on the rise for the last two decades, as any collector knows, and the prices on postcards are also creeping upward as their popularity grows and their availability diminishes. Since they are portable, unbreakable, and relatively inexpensive per item as antiques go, they are becoming ever more attractive to those people who enjoy antiques but are not in a position to buy anything as large as furniture, as fragile as glass, or as expensive as autographs.

Moreover, it is my impression that postcards tend to be more expensive on either coast than they are in the Hinterlands. Photographic cards are more expensive than drawn cards, obviously, in part because the drawn examples are usually much later examples of the type than the photographed cards. This is, as I have stated above, an unlikely cause of development, but the method did clearly decline in quality and antique postcard prices in part reflect the quality as well as the age.

Age obviously has a good deal to do with the value of any antique, but postcards pre-dating 1905 may be at a premium.

Similarly, the condition of the card—its clarity, any folds or wrinkles or bends on the corners, its cleanliness, whether or not it has been used—will bear on the price, although it must be noted that an occasional unusual stamp affixed to an ordinary tall-tale card may considerably raise the price of a card (which can be very frustrating for the card collector who has little regard for stamps!).

Mitchell and Oakes postcards, as mentioned in the text, demand slightly higher prices—up to fifty cents each—probably because they are in color (and are well done in terms of color) and the series is numbered. (The quality of ingenuity, or rather the lack of it, that went into these cards can certainly not be considered cause for these higher rates!)

Sometimes, postcard collectors who concentrate on a genre like the tall-tale postcard find themselves paying for things that are of no real interest to them. For example, often I must pay a premium price for a postcard because the huge ear of corn I am interested in is loaded in the bed of an old Reo truck, which I am *not* interested in, but postcards showing old automobiles, trolley cars, trucks, airplanes, or airships are going for particularly high prices these days.

Postcards showing historical figures, like the Martin card showing Taft, and advertising cards tend to be priced higher than others, again simply because they are likely to be attractive to a broader range of collectors.

Most dealers, incidentally, will offer slightly lower prices or absorb the price of the postage on cards sent on approval if the buyer accepts the entire lot of cards. A collector must take this into consideration. For example, twenty cards sent on approval might cost twenty-five cents each, but if the collector agrees

to accept the lot, the cost might be $4.25, a savings of seveny-five cents. Even if there are four or five cards that are not desirable, it is worth taking the lot because the cost on those unwanted cards is in reality only a few cents each—and they will certainly be worth that on the re-sale market. Moreover, it must be remembered that any cards that are not bought must be sent back, and the postage for the return mail must be taken into consideration on the bargain. There is little sense in saving a dime and then spend-ing fifteen cents to send the rejected cards back to the seller.

At any rate, one of the joys of postcard collecting is that the novice need not lose a lot of money learning the ropes. Tuition here is cheap! Even in the few cases where I feel that I was burned by the seller, the prices now have risen so much on those cards that I am glad I acquired the cards—even if by mistake.

Selected and Annotated Bibliography

Alderson, Frederick. *The Comic Postcard in English Life.* Rutland, Vermont: Charles E. Tuttle Company, 1970.

An excellent book, well worth having for anyone who has a serious interest in the postal card. It restates the common contention that a people's humor is one excellent route to a better understanding of that people and it supports the thesis of this study, that the comic postcard is one very appropriate facet of that sense of humor. The book is slim but is well provided with illustrations, some in color. It is significant for the purposes of this book that not one tall-tale postcard appears in Alderson's entire English corpus.

Burdick, J. R. *Pioneer Postcards.* New York: Nostalgia Press, 1956.

Deals with postcards only up to 1898, which of course predates the tall-tale card by some ten years, but the book is nonetheless an invaluable resource for the early history of postal cards. Brief introductions to the book and to each of the book's major divisions are most useful, while the extensive check lists of pre-1900 cards will be of use only to the specialized collector.

Lauterbach, C., and Jakovsky, A. *Postcard Album . . . also a cultural history.* Translated by Judith Bogianckio-Matthias and Elisabeth Earl. New York: Universe Books, 1961.

A singular, interesting (but not particularly useful) book of postcards. It emphasizes the turn-of-the-century fad of collecting postcards and is not so much a serious study of the postcard or its collecting as it is a scrapbook of the postcards themselves. In short, it is interesting, but that is about it.

Norgaard, Erik. *With Love to You: A History of the Erotic Postcard.* New York. Clarkson Potter, 1969.

A refreshingly frank view of an important facet of postcard history. Since truly erotic postcards were predominantly European in origin and use, the study is less useful for the collector concentrating on American subjects. A good many of the 224 postcards reproduced in these pages are humorous cards (although some may not have been intended to be comic) but none are tall-tale cards in terms of the definition within which I have been working in this text.

Staff, Frank. *The Picture Postcard & Its Origins.* New York and Washington: Frederick Praeger, 1966.

The standard text for the field, in my opinion. No other book on the postcard matches its usefulness as a general reference work. There is neither example nor mention of the very important and broad area of the tall-tale card however.

Welsch, Roger. *Shingling the Fog and Other Plains Lies.* Chicago: Swallow Press, 1972.

Does not deal with postcards at all but does explore in depth the humor of the Plains frontier, especially in regard to its reliance on exaggeration, obviously an analogue to postcard humor and central to the issues of the tall-tale postcard.

Publications other than books.

Periodicals:

Deltiology:

There is only one national organ devoted entirely to the postcard, its history and lore, and it is modest and of questionable security. *Deltiology* is published by James L. Lowe of Folsom, Pennsylvania, presumably every other month. Obviously, it is meant for collectors rather than scholars, but the raw data are there for whatever use the reader desires. I am not, however, aware of any articles in *Deltiology* dealing specifically with the tall-tale postcard.

The Postcard Digest:

There are a good many local, regional, or state postcard collectors' organizations, and some of them have occasional publications. An example is *The Postcard Digest*, which is published by the Bay State Post Card Collectors Club on a monthly basis, primarily on the energies of its editor, Fred Switzer of Boston. Again, like *Deltiology*, it is directed primarily toward collectors, but it did carry an article by this author on the tall-tale postcard in its September 1973 issue.

Articles:

Kaduck, John. "Mail Memories." *The Antique Reporter.* Vol. 3, No. 6 (June, 1973).

"Mail Memories" is a column by John Kaduck in which

he treats the tall-tale postcard, concentrating on its values in the antique postal card market. It is brief and at best sketchy, but in light of the general scarcity of any information whatever about freak cards, it must be taken into account by the collector. In brief, Kaduck states that all such cards are worth about one dollar each, a boon price for the seller, an idiocy for the buyer.

Purcell, Edward L. "Colorful Greetings." *The Palimpset.* (State Historical Society of Iowa). (May/June, 1974). pp. 78-83.

This brief article with sixteen reproductions of postcards from the early years of the century discusses the printing and coloring techniques used on postcards of the period.

Ripley, John W. "The Art of Postcard Fakery." *Kansas Historical Quarterly.* Vol. 28, No. 32. (Summer, 1972): 129-31.

Obviously of central importance to the tall-tale postcard. It should not be assumed, however, that the fakery under discussion is the kind of comic fakery I have dealt with here. The article by John W. Ripley treats only those postcards of historic buildings and sites upon which the photographer or postcard publisher has juxtaposed automobiles and streetcars. It is, however, an interesting adjunct to my work here and also discusses some of the pitfalls of such work in the photographic world.

Index